The Grandmother Book

Also by Patricia Burstein (with Ellen Burstein MacFarlane)

Legwork: An Inspiring Journey Through a Chronic Illness

The Grandmother Book

A Celebration of Family

Photographs by Jessica Burstein

Text by Patricia Burstein

St. Martin's Press ❧ New York

ISBN 1-58238-050-3

First Edition: November 1999

10 9 8 7 6 5 4 3 2 1

For _____

Place your own photo here.

*T*he face of your grandmother tells a story. It is not only hers. It is yours. Look carefully and remember: She had a life of her own. Uncover the baby girl, the adolescent, and the young woman who gave birth to your mother or father. No matter who you are, your grandmother is not just a supplier of ice cream, candy, and hugs. She is a part of you.

Tillie Starr, our maternal grandmother, arrived at Ellis Island from Poland in 1909. She crossed the Atlantic without any family on board to comfort her. She was only fifteen years old.

Two years after moving in with relatives on New York's Lower East Side, Tillie married Joseph Sobel, also an immigrant from Poland. They worked at the same clothing factory. Within a few years, with Tillie's encouragement, Joseph, a gifted designer, opened his own women's clothing company.

Tillie and Joseph raised three extraordinary daughters, one of whom, our mother, apart from bearing six children, became a New York State Supreme Court Justice. Tillie was adamant that her daughters receive a formal education. She, too, attended school to learn English and brought home her spelling assignments for her children to review.

Of course, we did not know our grandparents as Tillie and Joseph. To us they were Nanny and Papa. From a workshop that he maintained at home, Papa created the most beautiful handmade dresses for all his granddaughters. He died when we were very young, and it was Nanny who became the stronger presence in our lives.

Whenever we took a walk with Nanny, she would proudly announce to anyone within earshot, "These are my granddaughters." She might as well have proclaimed, "Ladies and gentlemen, I give you the next presidents of the United States." In her home we watched television, read comic books, and chewed gum to our hearts' content—activities either restricted or prohibited at home. Much to our delight, she would remove her false teeth and make funny faces.

As we grew older, we understood that Nanny was the bearer of tradition and dispenser of wisdom. She instructed us in the importance of respecting one's parents, one's history, and oneself. But her most affecting legacy was her greatest gift: absolute and unconditional love. And thus it is to Tillie Starr that we dedicate this book.

Look at your grandmother. Look carefully. And remember.

\mathcal{C} o n t e n t s

Introduction *11*

Virginia O'Halpin 15

Kayla Chaillot 17

Donna Lee Harrison 24

Rogelia Santos 29

Patricia Moore Watts 35

Tsuyako "Sox" Kitashima 39

Maurine Lipnick 46

Dr. Jimmie C. Holland 50

Arvella Schuller 55

Thelma Mothershed Wair 59

Jan Alley Youren 65

Elissa Epstein 70

Doris Drucker 73

Itaf Fawaz 77

Eleanor R. Montano 81

Penny Chenery 86

Christine Bussey 91

Ethel "Billie" Gammon 94

Ruby Tom 99

Rebecca Merrill 102

Sarah Brave 106

Virginia Lee Morrison 113

Jean Frost 117

Margaret Vargas 122

Jean Schulz 127

Jannie Coverdale 132

Sarah Knauss 136

Beatrice "Bebe" Shopp Waring 139

Sylvia Woods 145

Barbara Martell 149

Sa thi Nguyen 153

Brenda Lee 155

Gertrude D'Amecourt 160

Christine Bradford 164

Sharon Kilbourne and Sharleen Dow 171

Ann Turner Cook 172

Enid Zuckerman 177

Bronislava Israel Chernina 180

Diane Reynolds 184

Dr. Carolyn Goodman 189

Minnie Young Johnson 195

Jean Cutler Nichols 197

Annie McGorman and Josephine Pellegrino 202

Acknowledgments *204*
About the Photographer and Author *207*

Introduction

When we began *The Grandmother Book,* we were deluged with requests from people for their grandmothers to be included. Each person told us a compelling story; indeed, some surely told tall tales to convince us that their grandmothers deserved to be in this book. But no matter the details of the stories, one common thread ran throughout: There is no place quite as loving and safe as Grandma.

We could easily have filled up an encyclopedia with stories of grandmothers. We believe, however, that the forty-five women celebrated in this book capture the spirit of grandmotherhood and represent the special relationship between grandmothers and grandchildren.

Get ready to shed stereotypes. The old white-haired woman in a rocking chair has yielded, in many instances, to a grandmother slaloming down a ski slope, driving a mean truck, hooked on long-distance running, or sitting at her computer to E-mail the grandkids.

As we approach the millennium, America is aging. By the year 2000 there will be 90 million grandparents in this country—fully one-third of the population. And we therefore thought that grandmothers serve as perfect indicators of how we are doing. By all accounts, we are doing very well.

Jan Alley Youren, a rodeo champion in Bruneau, Idaho, has fractured or broken innumerable bones in her body. How does she cope? Well, she's off to the rodeo for yet another competition. Then there is historian Ethel Gammon, in Livermore, Maine. Small wonder that her brothers gave her a boy's nickname, "Billie"; she still walks in snow and ice up to her knees without a shiver of trepidation.

Baby boomers are skipping into the grandmother role—surprisingly without protest! We learned that sixties icons, including Thelma Mothershed Wair, one of the Little Rock Nine, teaches survival skills at a shelter in East St. Louis, Illinois; Brenda Lee, the singer, performs at her granddaughter's school in

Nashville, Tennessee; and Jean Cutler Nichols, a Woodstock alumna, runs the Art for the Heart studio in Penasco, New Mexico, and is still an antinuclear activist.

Octogenarians are living healthier and more productive lives. Witness inventor Doris Drucker in Claremont, California. She still hikes up mountains, swims, and plays tennis regularly. Today, 95 percent of people over sixty-five continue to live on their own in the community, not in nursing homes or with their children.

Teen pregnancies are producing even younger grandparents, and 3.4 million children are being raised by their grandparents. Add to this figure the number of grandparents who have pitched in to help because of divorce and unmarried parents and you have the saying "It takes a village to replace one grandmother."

Jannie Coverdale is an example. She was raising her two grandsons, Aaron and Elijah, only to lose them in the Oklahoma City bombing. Equally affecting and stout of heart is Tsuyako "Sox" Kitashima of San Francisco, who was sent to an internment camp for Americans of Japanese descent during World War II; today she is a leader in the reparations and redress movement. And there is Rogelia Santos of Miami, Florida, who re-created the rich cultural life she knew in Cuba (from which she had fled in 1959) for her children and grandchildren.

While the grandmother role is evolving, it also remains in many respects the same. She is the family archivist who mesmerizes her grandkids with stories about her own childhood as well as the misdemeanors of their parents (her grown children). As the bearer of tradition, one way she transmits her culture and history is through the palate. In our encounters with these women, we savored some very special meals: Itaf Fawaz's Lebanese banquet at her daughter Brigitte's home in Dearborn, Michigan; Christine Bradford's mouthwatering cherry pie in Cynthiana, Kentucky; and Beatrice "Bebe" Shopp Waring's gourmet fish dinner in Rockport, Massachusetts.

While we set out to produce, in photographs and words, a full-scale, evolving landscape of grandmothers, we repeatedly found time-honored portraits of the pure, unfettered, and unabating love between grandmothers and grandchildren. As Virginia Lee Morrison from Natchez, Mississippi, told us, "I don't think you can ever spoil anyone by loving them too much." Off she went on her rounds with grandson Langdon to scout out his favorite Teenie Beanie Bears.

We feel spoiled by the opportunity to have met and spent time with these forty-five grandmothers, and within these pages we share with you the honor and pleasure of their company.

The Grandmother Book

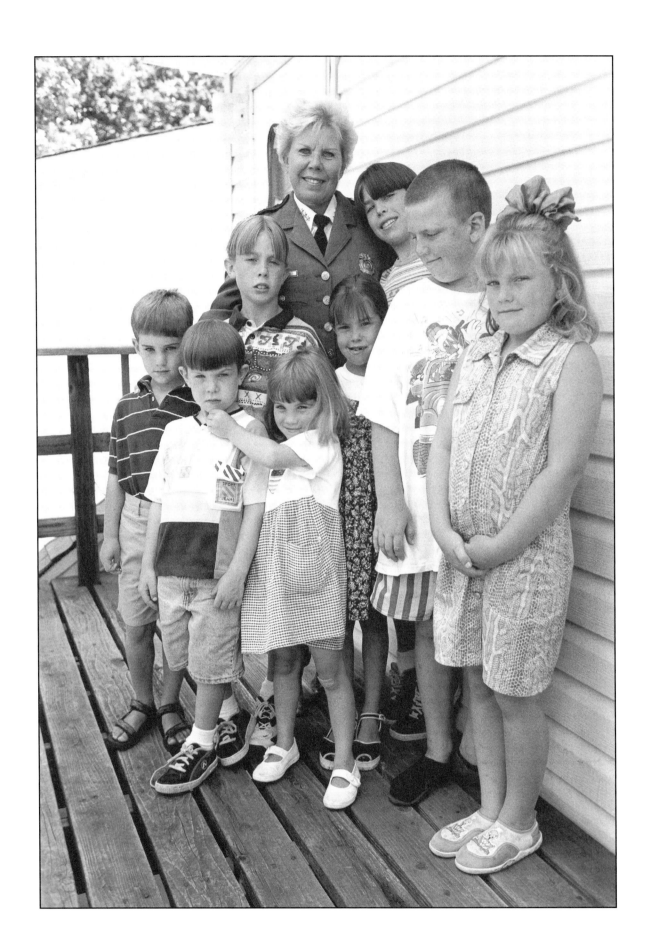

Virginia
O'HALPIN

*Virginia O'Halpin, fifty-nine, is a retired deputy undersheriff and
grandmother of eight, ages five to fourteen. She has five grown children
from her first marriage. She and her second husband, Richard Schmaeling,
fifty-nine, a building manager, live in Miami, Florida.*

Although I was the highest-ranking female law enforcement officer in Nassau County, Long Island, my greatest achievement has been my children and grandchildren. But I never carry pictures of them in my wallet or talk about them because they're mine. They're personal.

If people ask about my grandchildren, I tell them they're as beautiful as my children. I always think how lucky I am that there are no lemons among my kids or grandkids. While I would never say my children were perfect, I will admit that they were lucky and never got caught. I hope my grandchildren will be as lucky.

I was married when I was sixteen years old to my high school sweetheart, Jim O'Halpin, who owns a construction business. I left school to start our family. By the time I completed my high school equivalency diploma at twenty-two, I was already pregnant with my fourth child. The year I graduated from college, my oldest daughter enrolled as a freshman there.

I went into law enforcement because I didn't want to be a secretary. It paid well, and it sounded as if it wouldn't be boring. It wasn't. But I can't say it wasn't difficult being a woman in this field. In fact, in 1972, when I took the test to become a policewoman and passed, I couldn't get hired. I sued the county, and sixteen years later, when the case was finally settled, I was appointed a deputy sheriff.

During those years I worked as a court officer, guarding judges, and returned to school at forty-three

to do graduate work in criminal justice. A year later I became a grandmother. After thirty-three years of marriage, Jim and I were divorced. We are both remarried but remain close friends, which is wonderful for our family. For holidays and birthdays we all get together, Jim and his wife and my husband and I, with our children and grandchildren.

I'm very affectionate with my grandkids, just as I was with my children. I give them lots of hugs and kisses. Occasionally I'll get them in a hammerlock. My fourteen-year-old grandson, Jamie, said he told this girl his grandmother was a deputy sheriff, and she didn't believe him because "sheriffs are only in Westerns." Jamie says sheriffs are sort of mean, and I am too nice to be one.

I don't baby-sit my grandkids. Instead, I take them to the theater and to restaurants and on trips to Washington, D.C. Or they visit me in Miami. One day I'd like to show them London, England, which is my favorite place.

How successful my grandchildren become is, to me, a reflection of how I raised my children. So far they're all progressing very well. I hope when my grandkids grow up they can be anything they want.

Kayla
CHAILLOT

Kayla Chaillot, forty-four, is a grandmother of two, Christopher, three, and Nicholas, five. She has four children, ages fifteen to twenty-four, two from her first marriage and two with her present husband, Bernard, a newspaper reporter and editor. For twelve years she worked in the State of Louisiana's film industry in craft services for movies such as JFK, Mississippi Masala, *and* Huckleberry Finn, *and the television series* The Big Easy. *A decorating and landscaping consultant, she currently runs a bed-and-breakfast that she renovated on the Vermilion River north of Abbeville, in the heart of Cajun country in southwest Louisiana.*

My daughter, Natalie, was nineteen when she had her first child and our first grandchild, Nicky. The pregnancy wasn't planned, and I don't think she was really ready for a child. She didn't know that babies stay awake more as they get older, so it was always, "When does he sleep?" They lived with us for a year, and we got very attached to Nicky, a precious little boy, a perfect joy.

Two years later Natalie had another son, Chris. She is more emotionally attached to him than to Nicky. While she answers Chris's every little cry for attention, she might tell Nicky when he wants attention to go play. You can see his little head droop when he goes off to play with his toys.

We love Chris, too, but naturally I pick up the slack with Nicky, giving him that extra little hug he needs and might not get at home, just as my grandmothers did for me. Chris also has other grandparents who love him, the parents of the boy Natalie was dating at the time, while Nicky doesn't, so my heart goes out to him.

When I was a child, I often wished I had been adopted. It just seemed so neat because someone really wanted you. They actually went out and picked you. I know my parents loved me, but I just needed a few more good strokes. I think I was a gifted child, winning poetry and art prizes in school. They were more interested in my academic grades.

I was the oldest of seven. We were poor and we all always worked. When I was nine, I was cleaning house, ironing clothes my mother took in for extra money, and taking care of my brothers and sisters. My

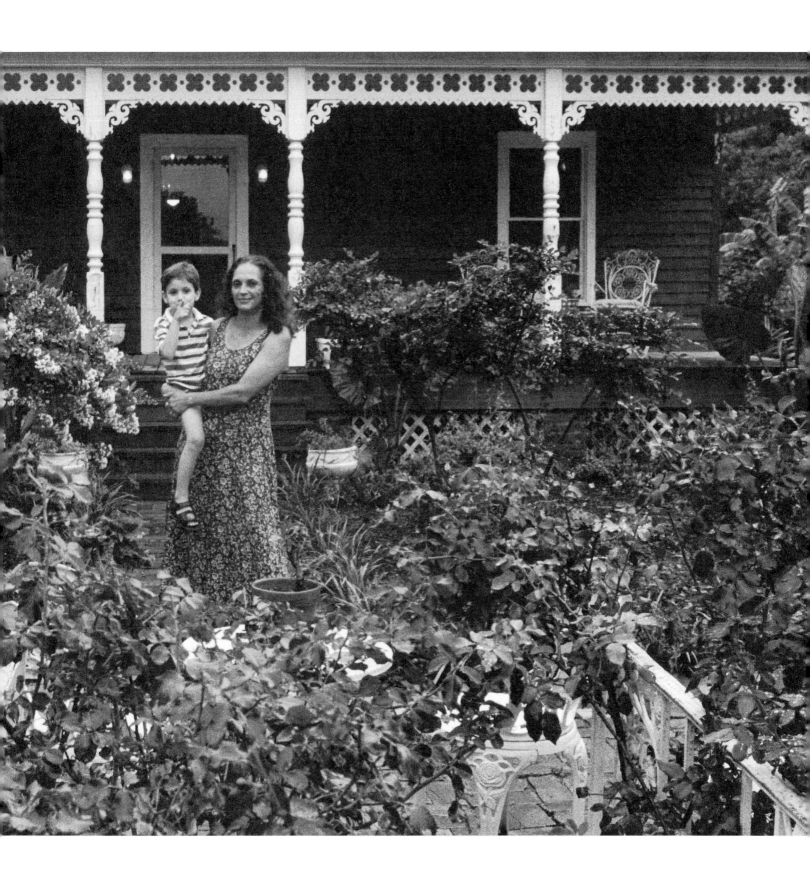

mother worked for a pediatrician, and my father was a clerk in a car parts business. By the time I was eleven I had a regular job in a bakery.

We lived in a public housing project at the time. My mother won awards for keeping the cleanest apartment in the projects. It didn't matter where we lived—we were proud, which is very Cajun—but the apartment was always so cramped that I dreamed of living in a big, old, rambling country home someday.

Back then the old ways were discouraged. They spoke English around the house, not French, their first language, because when they were in school it was forbidden to speak the Cajun tongue. They were punished if they did.

That carried over to my generation, so we lost part of our heritage. French wasn't even taught as a second language in school as it is now. I plan to learn to speak French so I can teach it to my grandsons and regain what was lost when I was little.

My family name is Gauthreaux [pronounced *go-troh*]. In grade school that became a joke with the other children. They'd say, "Go tro up," and "Go tro yourself in the bayou." I often felt like an outcast, like my ancestors, the Acadians, the French-speaking Catholics who had been evicted from Nova Scotia in the late 1700s for their religious beliefs. Cajuns are the descendants of the Acadians. The word "Cajun" is a colloquial form of Acadian.

When Cajuns got to Louisiana, they had no money or housing and very few possessions, and they had to learn to live off the land. They cut down trees along the bayous and built their homes with cypress logs. They were a strong, proud people who learned to make do with what they had and to improvise.

In many ways I think our home is an embodiment of that spirit. We didn't have much money, so we tore down old houses and barns to get our materials. We bartered for most of the materials, including cypress boards for walls and floors, beaded boards for the porch ceilings and floors, bricks from the old fireplaces for our fireplaces, patios, and sidewalks. We moved an old house and attached it to the back of an existing one. Then I went to work on the design, and it all came together.

I think my grandmothers would be very proud of what we've done here. It was from them that I learned to quilt and cook. I once traded my mother three blankets for one of my mawmaw's [grandmother's] quilts, then I cut it into four pieces, one for each of my children, so they would never fight over it when I was gone. I put new borders, a little bit of myself, into each one.

My father's mother was a *traiteur*—a folk healer. We went to her for everything: fever blisters, chicken pox, measles, headaches, depression. Lots of people around here still go to

traiteurs, especially the older folks. They pray over you in French and can't accept payment for their services. The healing powers are passed from person to person and, according to superstition, only from older to younger and man to woman, or vice versa.

I believe I have some extrasensory powers, but not to heal. Since I was very young, I have often known in advance when certain things were going to happen. I used to think I was a freak because of that. Bernie tells me I should put a sign out front to read cards or palms, but I don't want to. I think it would be playing in the devil's backyard.

I didn't get the *traiteur*'s art from my grandmother, but I did get a lot of her recipes that I still use to this day. I love to cook. I've taught all my children to cook, and I plan to teach Nicky and Chris. Some people from other parts of the country think Cajun cooking is some kind of a gourmet thing. It's not. It's simple country cooking, using fresh, quality ingredients and a combination of seasonings. That's the key. No one seasoning overpowers the others. You just can't use a lot of cayenne pepper and call it Cajun cooking, as some people try to do.

In the early days and sometimes even today, Cajuns would eat a lot of things other people would not think of eating, such as raccoons, squirrels, or even armadillos. To some people, eating crawfish is strange, but boiled crawfish are great. Bernie used to come home sometimes with a coon purchased at a little country store, and I'd cook it with sweet potatoes. The people at the store would leave a paw on so you'd know it wasn't somebody's dog. Isn't that wild? At work I'd tell people I was cooking roadkill for dinner because it was a good way to stretch my budget. I'll cook anything even if I don't necessarily eat it.

When I was a child, we went every Sunday to one of our grandmothers' homes for dinner. Every five years we'd have a reunion. That stopped after my paternal grandmother died twenty-five years ago. So one day a few years ago I went to a funeral and told my cousins I was going to have a reunion because it was a shame the only time we saw each other seemed to be at funerals—unless we were lucky enough to go to a wedding.

At the reunion a neighbor of mine came over, and when someone asked who she was related to, she said, "Nobody. I just came down the road to bring some jambalaya." She ended up staying all day and into the night, just like a member of the family. That's how Cajuns are, friendly people who love to talk and make people laugh.

My grandsons love to come over to our home in the country, especially to parties, when we hire a Cajun band with an accordion and a fiddle player. When it's just a regular weekend

visit, I love to be outside with them in the garden. They are very different little boys. Chris loves creepy crawlers and all kinds of critters, but Nicky doesn't. He wants to know all about the pretty plants. I think he's more artistic, as I was. We have more than fifty rosebushes and all kinds of flowering plants on the property. We have banana trees, elephant ears, and lots of trees, including moss-covered oaks and big cypresses in the back by the river.

We have lots of toys for the grandkids, but because they are siblings, they sometimes fight over them. When they do, I put all the toys away except for the one they're fighting over and then tell them to figure it out. They usually learn quickly how to share and get along. Nicky is also interested in school and loves to learn about numbers and the letters of the alphabet. He's very smart.

Like all grandparents, I want my grandsons to grow up and get good educations. Cajuns used to survive by hunting and fishing off the land, but that kind of life has mostly disappeared. New immigrants who have moved in, such as the Vietnamese, fish for a living, but fewer and fewer Cajuns are doing so.

I would like them to preserve some things about the Cajun way of life, such as the food, music, and French language. I think they absorb some of that just by being around us. Our oldest boy from my first marriage, Jacob, a carpenter, is having a baby with his girlfriend. We're hoping for a granddaughter this time. If it's a boy, we'll dress him up in bonnets and call him Sue.

I guess I take my role as a grandmother seriously because of what my own grandparents meant to me. I want to watch over my grandchildren and make them feel special, partly because of my own feelings that I missed out on a lot as a child. I want them to enjoy their childhoods and become productive adults, and I want to be there for them when they need me.

Donna Lee
HARRISON

Donna Harrison, sixty-four, is a grandmother of nine, ages one to nineteen. She and her husband, William, seventy, a retired plumber, raised five sons and one daughter. They live in a mobile home park in Surprise, Arizona, bordering on Sun City.

I always hoped that after we raised our kids, my husband and I would have time for each other. My dream was that we would settle in a mobile home park and make our own friends at this stage of life, that we would simply be two married people—Donna and Bill—and the neighbors would know us as such. And then when one of us dies, the other would be able to share memories about a spouse others knew.

Both of us came from Round Lake, a small Illinois town thirty-five miles north of Chicago where three generations of our families lived. All my life I was somebody's granddaughter, daughter, daughter-in-law, or mother. Never just Donna. I met my husband when I was eighteen and a secretary for an insurance firm where he had a claim pending for several weeks. He was very frustrated, and one afternoon he came by my office and said, "Do I have to take you out to get my check?" And I replied, "Why don't you try it?"

Three weeks after our first date, we became engaged. Three months later, on my nineteenth birthday, we were married. In between, his insurance check arrived. Bill, a skilled tradesman, has worked very hard his whole life. Within twelve years I gave birth to six children. I stayed home with them until the oldest went off to college and the youngest started school. I was thirty-eight. Then I did secretarial jobs.

Bill and I retired in 1990 to Arizona because we felt the dry climate would help his arthritis, and our only daughter, Janet, was living here. In all we have nine grandchildren, four of them from our daughter. Once or twice a month they stay overnight with us, and we may go bowling or take them to a show and

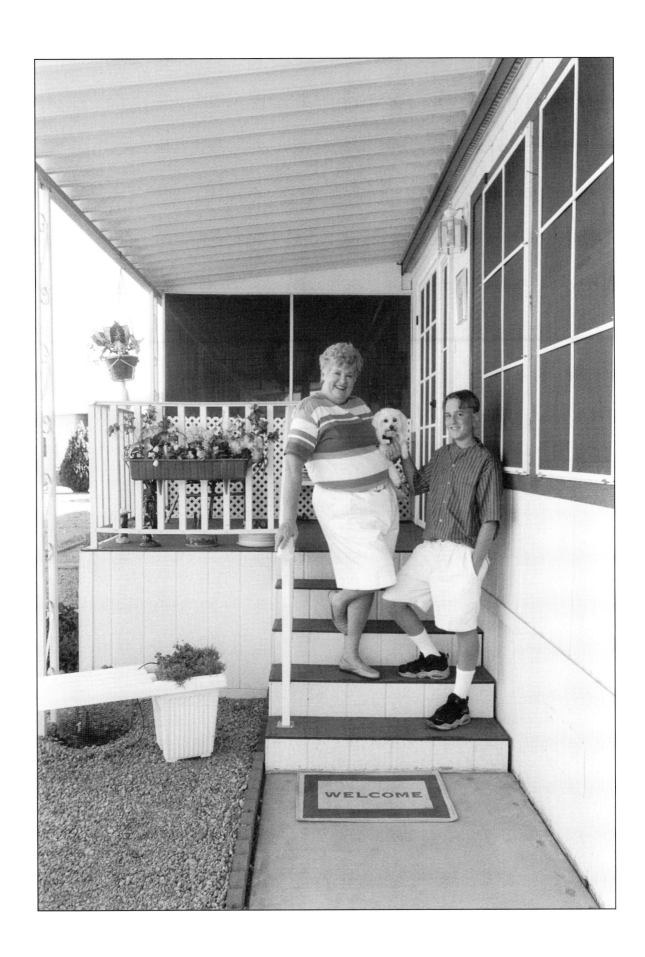

out to eat. We visit our other grandkids, who live in Illinois and Pennsylvania, once a year. Our grandchildren love to play cards, and I teach them new games. Because I never lose, the challenge is always, "Let's beat Grandma."

Two years ago we moved into this mobile home from another one in the same park. It just felt right from the minute I saw it. I'm a hobby organist, and there's an alcove for my organ. I've turned the alcove into a kind of shrine to my son Billy who died at thirty-two from AIDS. I put up photos of him; a sculpture of a saxophone, which he loved to play; his master's degrees in theology and psychology; and angel figurines because he was deeply spiritual. Often when I am sitting here and playing the organ, I can feel his presence.

Billy was a minister at a Chicago university and a remarkable human being, very caring and loving. He was particularly close to my mother. After his AIDS diagnosis in June 1995, he asked me to tell the family that he was gay. Only my husband and I knew at that point. My mother, who was eighty at the time, said matter-of-factly, "Oh, a friend of mine has one of those." She was a real trouper, cooking all his favorite meals right up to the end. She passed away a month after he did.

Billy came to our home to die. We had hospice, and our grandchildren here were brought into this, too. Within a week of bringing our son back here from Chicago, he went blind and was partially paralyzed on one side. Cody, our thirteen-year-old grandson, watched *Wheel of Fortune* with him and marveled, "He can't see, but he heard three letters and knew the answer." Little Megan, seven, gave Billy water through the bed railing. "Am I doing it right?" she'd always ask. And Bridget, our ten-year-old, read to him.

Three nights before our son died, our daughter Janet gave birth to our grandson, C.J. While Billy lay in a coma, she brought the newborn to him and Billy grabbed his finger. So God gave our family a new life. One came in and one left us. Billy died on December 2, 1995.

There is a lesson for our grandchildren, I hope, in our son's death—that if they are good and honorable, they will always be able to look in the mirror and say to themselves, "It's okay who I am," and never feel ashamed, regardless of what I or anybody else thinks. And they will be aware and accepting of other people. This is not just about gays; it holds true for everything. Everybody is a human being. Everybody is someone's child. Then, to me, my grandchildren will be rounded, whole people.

In the beginning when I became a grandmother at forty-seven, I wanted to be a doter. But that isn't me, and I kind of like it the way it is now. I don't live through them because I did my thing with my own children. Sometimes it makes me angry when people go on all the time about

their grandkids and tell you every detail. I want to say to them, "Is that all you have to talk about? If you look around this room, everyone is a grandmother."

I don't see the need to be praising my grandkids every second. I *expect* them to be decent human beings. Each of us is an individual and we're unique, so it's a given that our grandkids are, too.

My husband and I have been married for forty-five years, and we have a wonderful relationship, one of great love and respect. To me it is just wonderful and special to find another human being to love.

Living in this mobile home community is everything I dreamed it would be. Most of the residents are working-class people. There is no putting on the ritz. It's very comfortable. We bowl, line dance, play mah-jongg, and attend once-a-month potluck suppers. I'm taking computer classes and lessons on my new organ. I wrote the finale to a skit, *Red Hot Mamma,* for a recent entertainment night here.

I love sewing clothes for my grandkids and making mustard pickles—their favorite treat—for them. But they have their lives, and my husband and I have ours. I don't have the responsibility a parent does, but I do have the awareness and experience to *not* think that everything they do is such a big deal.

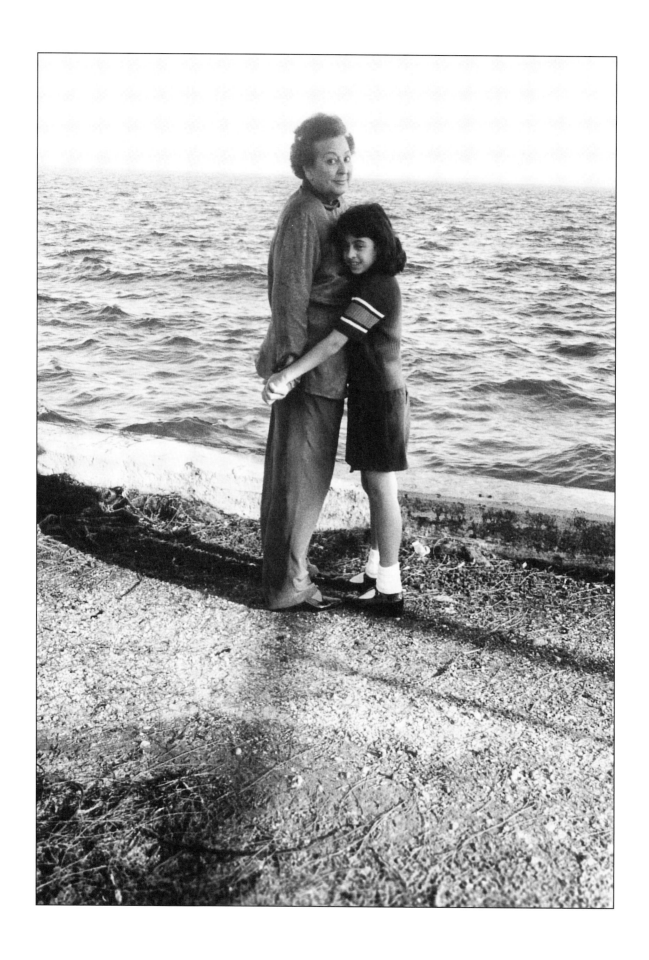

Rogelia
SANTOS

Rogelia Santos, seventy-three, fled Cuba with her family in 1959 after Fidel Castro came to power. Although she had been educated as a teacher and lawyer in Havana, she worked as a cashier, among other jobs, to support her family in the United States. Santos has two grown daughters from her marriage to a former Cuban police colonel who died many years ago. A brief second marriage ended in divorce. Santos lives in Miami, Florida, five minutes away from her grandchildren—Stephanie, nine, and Sacha, twenty-three—whom she sees every day. Now retired, she likes to paint and write.

Every Christmas we would say, "Next year we'll celebrate in Havana." Almost forty years have come and gone. My husband is dead thirty years. Now my best hope is that my grandchildren will be able to go there one day.

I had a beautiful life in Cuba, where I was born, the second of three children, in Havana. My first memory, at age seven, was of my father reading to me all the greatest books, including *Don Quixote.* My father, a person of high culture, was second in command of the presidential palace security, which was like the Secret Service.

We went frequently to the ballet, the museums, and the symphony. My country was known to people all over the world for its arts, university faculties, and great men of medicine. I was always a dreamer and a friend to many poets and writers. One boyfriend, who knew the American writer Ernest Hemingway, invited me to meet him at the Floridita Bar in Havana. Hemingway always sat in the same corner and drank daiquiris. He loved Cuba and everything Cuban.

During the day I attended law school at the University of Havana. At night I taught English, history, and geography classes for the working people—the gardeners and maids. Then it was possible for everyone to get an education. If someone couldn't afford the tuition, the government paid it. So it is a lie to say that such things didn't exist in my country before the Castro revolution.

After I received my law degree, I married a man fifteen years older than me. It was love at first sight.

I was twenty-two; he was a colonel in the national police. I never practiced law because I decided to stay at home to raise my children and do charity work. Four years later I had my first child, Ninoska. Another daughter, Rogelia, was born five years later.

We were a very important and respected family in Cuba, but it was not possible to remain when Castro took over. I didn't understand the big celebrations. The idea that they would take from the rich and give to the poor made no sense because the revolutionaries took everything and poverty became worse.

It happened very suddenly in the early morning of January 1, 1959, when my husband, the police colonel, said we had to leave Cuba immediately. I put his passport in his pocket and said, "You are in danger because the Castro people are going to kill you. You'd better go. They are not going to kill me." I wanted to wait until my family could all leave together.

Those were torturous times. Castro's firing squads killed many people, and his thugs ransacked homes. They always took inventory at people's houses and then grabbed what they wanted. One time an army captain appeared at my house and drove off with my car. He said that the revolution needed the car; he needed the car for himself.

They pushed my mother out of her house because the mother of a commandant wanted to live there. We asked them only for a box of memories that included letters my father had written to my mother when they were dating. They burned the box in front of her house.

My sister was detained briefly by the police. My brother was a political prisoner for six months. Whenever we went to visit him in prison, the guards made us stand on line outside, from seven o'clock in the morning until four o'clock in the afternoon. Some days it would be pouring rain or the sun would be scorching. Then, after waiting all those hours, they might announce that there would be no visits that day and order us to leave.

Che Guevara was in charge at the prison. He was not the romantic character some people imagined; he was instead a sadistic and violent man. Once when he whizzed by in his jeep, my mother, who was very hot-tempered, poked him with an umbrella. He grinned and said, "Even if my own mother was standing on line, I wouldn't let her go in."

Finally, in June 1959, after my brother was released, we left Cuba. Although we had visas from before, our bank accounts had been frozen. We raised the $500 per person we were allowed to carry out by selling our paintings, silver, and linens to other Cubans and foreigners. We were permitted only two suitcases each. Through a

diplomatic contact my mother managed to smuggle out a big trunk with family linens, including an embroidered dress, custom-made in Paris, for my daughter Rogelia's baptism.

First we lived near the Miami River, where many Cubans settled, in a small house that a friend of my husband gave us, rent-free, for six months. There were fifteen of us in the house. My husband, who was forty-eight, couldn't find a job and ended up doing errands, painting houses, and chauffering people. For the first time in his life he could not support his family. Later on he was hired as a store security guard. He was very damaged by this experience and died of a massive heart attack in 1968, nine years after being forced out of Cuba. He was only fifty-seven years old.

Being younger, thirty-three, when I left my country, I saw starting a new life here as a challenge. Together with my sister, who got a job in a cushion factory, I supported our household. I was hired as a cashier at a supermarket. We were lucky that our mother could look after the children. Mine were small: Ninoska was seven and Rogelia one and a half.

I worked, sometimes fifteen hours a day, seven days a week. Nights, when it was possible to leave earlier, I took classes in English and computers. My dreams for my children gave me my energy and spirit. I wanted them to have the best, the future they lost when we had to leave Cuba.

One time at work I saw a woman I recognized from my last days in Cuba. She was desperate. She said that she had come to the United States in order to survive with her children. Her husband, who had fallen out of favor with Castro, was now in jail in Cuba. He was the army captain who had stolen my car. I gave her food and $5, which was a lot of money to me then. I never wanted to feel bitterness in my heart. To me a Cuban is a Cuban, and to the last day of my life I will always love Cuba and the Cuban people.

After four years at the supermarket I was hired by a bank that was computerizing its whole operation. I earned so much overtime that I was able to move with my mother and children to another house and send my daughters to private school. I wanted my children to be proud of me. I never took any money from the government or anybody else. Many nights, after stopping work at three in the morning, I'd get a few hours' sleep at home and then drive the children to school on the way to my job at the bank.

I stayed at that job for seven years, until 1970, when I married a Cuban-American businessman. We moved with Rogelia to Spain, where she finished high school. Ninoska stayed behind with my mother to complete her university degree.

The marriage ended in divorce in 1975, the same year Rogelia, who was by then married, gave birth to my first grandchild, Sacha. She was baptized in the dress my mother had packed in the trunk when we left Cuba.

I went to work for Immigration. This was the greatest job of my life, helping people from my country. I was shocked at how many of them didn't have any values or beliefs. I saw how Castro had destroyed them. When you take a person's wallet, religion, and hopes—everything—you leave them shipwrecked morally and spiritually. I tried to show them how they could lead lives with dignity, honor, and hard work.

Five years later, in 1980, an immigration lawyer hired me as a private consultant to his clients. Before, I knew what to do, how to fill out applications; in this job I learned how to fight Immigration. In 1989 I was blessed again with another granddaughter, Stephanie.

In 1992 I had coronary bypass surgery; I returned to work six weeks later and stayed until I retired in 1996. That year a spinal cord infection left me paralyzed, and doctors said I would never walk again. I tried little by little in physical therapy. The first day, one step. The next day, a second step. I am not someone who ever gives in or gives up. Within six months I was walking like before.

Really, I have so much to live for, especially my wonderful family. And I have my interests. I paint, which has always been my therapy. I never saw a psychiatrist; I just took out my easel and my palette. For some reason I start with many colors but end up using the color rose. When my children were little, I taught them to paint. I also write. And in 1994 I won third place in a short story contest in the Spanish-language edition of *Marie Claire* magazine. I didn't go to the awards ceremony because it was held in Mexico, which had relations with Cuba.

My grandchildren live five minutes away, and I see them every day. My nine-year-old granddaughter, Stephanie, is a very good writer, and I like to go over her compositions with her. Sacha, who is twenty-three and completing a master's degree in special education, gave birth to my first great-grandchild, Natalia, now four months old. During the day Sacha and her husband leave Natalia with me, and I am full of joy to have her for all these hours in the day.

We do everything together as a family. Ninoska and her husband, who was a political prisoner for twenty-eight years in Cuba, live with me. She is the voice of the Cuban-American National Foundation. She broadcasts two programs daily, one to the Miami area and the other to Cuba.

I take my grandchildren to the Cuban-American—never the Cuban from Fidel—ballet, museums, and symphony, and to listen to speakers whose words are important for them to

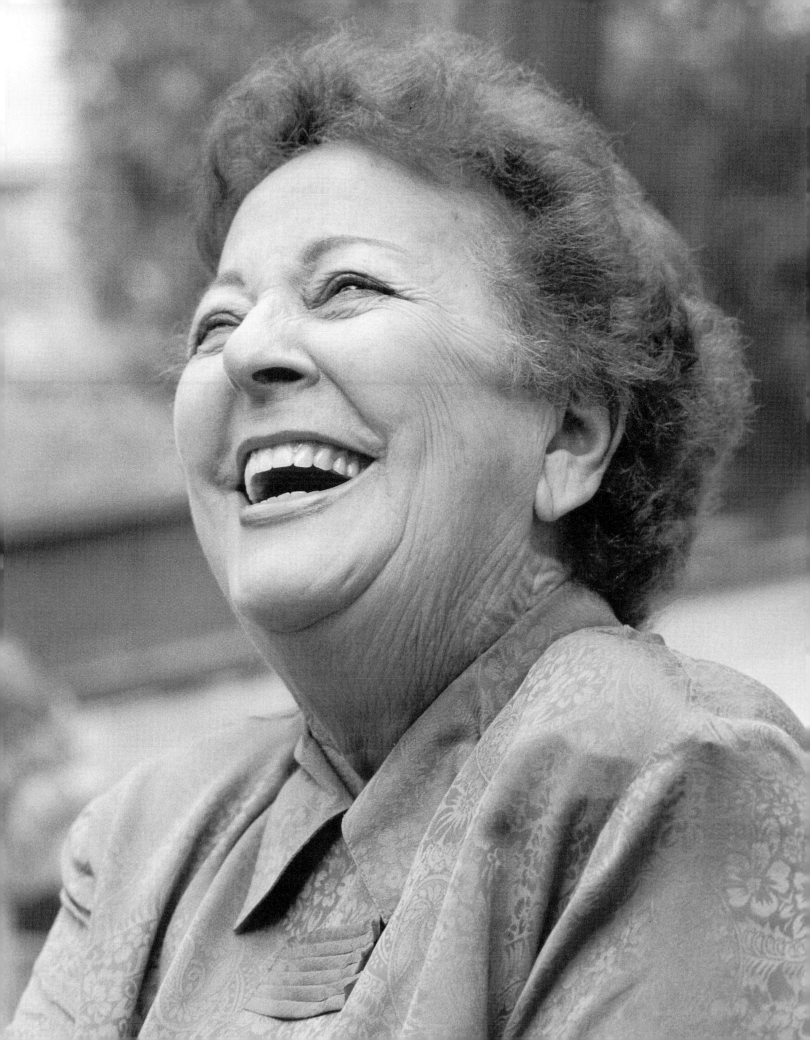

hear. I try to reproduce for them the life I had in my beloved Cuba. They can speak only Spanish to me. Language, I believe, is the most important way to keep the tradition. We go on marches together and shout, "Free Cuba!"

We went to the dedication of the Freedom Tower in the center of Miami. It is our Ellis Island, the place where we were processed when we arrived here. When it is finished, there will be an exhibit, like the AIDS quilt, with the names of the thousands of Cubans who have died at the hands of Castro's regime.

One of my favorite places to take my grandchildren is to the shrine of the Virgin de Caridad, the patron saint of Cuba, by Biscayne Bay in Coconut Grove. It is believed that she will watch over the safe return of our people to Cuba. Our community built the shrine, penny by penny, from the time we came here. The first bank deposit, we like to say, was thirty thousand pennies.

In the back of the shrine is a seawall that faces south to Cuba. It touches the water between our adopted home and our homeland. When we sit or stand by the wall, I sigh and think, "Ninety miles to Cuba . . ."

When my granddaughter Sacha was fifteen, I took her to Paris. I wanted her to be able to say one day, "My grandmother showed me Paris." Being a dreamer, I hope one day, while I am still alive, that my grandchildren and my great-grandchild will be able to say, "Our *abuela* [grandmother] brought us home to Cuba."

Patricia

MOORE WATTS

Patricia Moore Watts, fifty-eight, is helping to raise her ten-year-old granddaughter, Samantha. A former model, Watts is a waitress. She lives in a New York City apartment with her son, Sean, and Samantha.

My granddaughter is a gorgeous little girl, bright, happy, and with a real personality. Her beauty comes from the fact that she is the daughter of an Irish-American father and a Jamaican-American mother. We all know the obstacles we can meet on the road of life, so I have tried to make sure that she is exposed to the correct things, speaks well, and has good self-esteem. That way she'll be one step ahead.

Growing up in an Irish Catholic family in the Bronx, New York, I was not exposed to very much. My father was a fireman, and my mother was a telephone operator. Although they worked hard and tried their best, there was never extra money for luxuries such as piano lessons.

After graduating from a Catholic high school, I went to Fordham University to become a teacher. At the end of my freshman year, when I was crowned Miss Fordham, I dropped out to become a Ford model. In the beginning it was exciting and glamorous. My first photo shoot was with Milton Greene for *Life* magazine. Although I worked with the top fashion photographers—Scavullo, Penn, Avedon—I always just missed getting on a magazine cover. In those days, the late fifties and sixties, you got an hourly modeling fee. I was earning $60, which was the top print fee at the time, and doing commercials and a little acting. At twenty I married a writer who was also an actor and a model. Within a year we had a son, Sean. Four years later I got a divorce.

When my son was a teenager, I wanted him to leave the city on summer weekends. I used all my savings for a down payment on a tiny house in the Hamptons on Long Island. I started working as a waitress

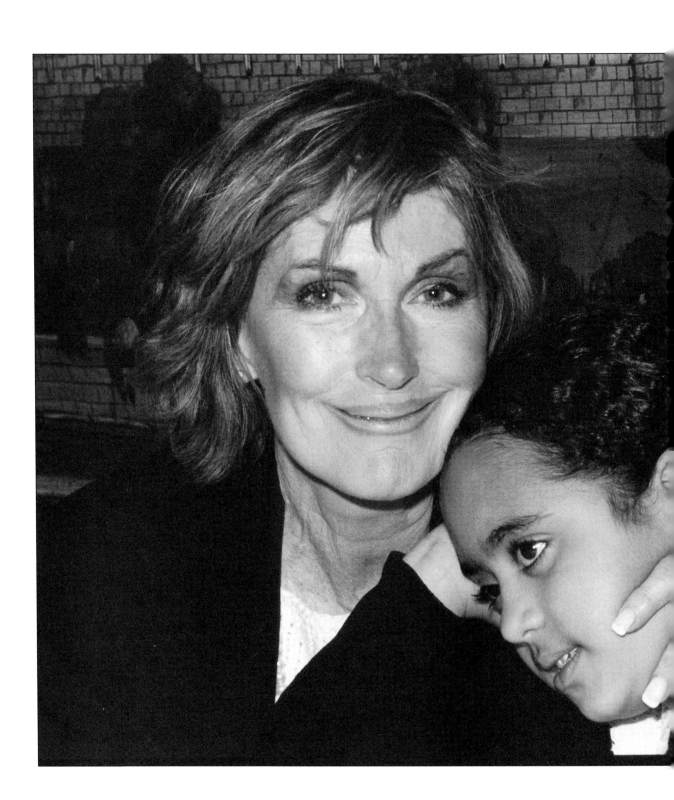

weekends out there and weekdays in the city, in addition to modeling. I gave up modeling when I reached my late thirties.

My son is also a waiter. He dropped out of college after two years, got married, and got divorced soon after Samantha was born. Originally they shared joint custody, but not long after, by mutual consent, he took custody.

I let Samantha call me whatever she wants. She knows I'm her grandmother, not her mother. She calls me "Mom," "Grandma," and "Grandma-me."

Samantha is a gift because I always wanted a daughter to pick out frilly, pretty outfits for. I get her dressed for school every morning.

My son is really the hands-on parent, taking her to and picking her up from school, helping with homework, making dinner, and getting her ready for bed. He works a lunch shift so he can be available to Samantha.

I try to do all the extras for her: tennis, horseback riding, ballet, and ice skating lessons. When Samantha took first place in a horse show, to me it was as if she had won the Olympics.

Samantha's education is the most important thing, because I regret not finishing college. My late mother used to say I was like Scarlett O'Hara because whatever happened, I'd always say, "I'll worry about it tomorrow."

Tomorrow, I've since learned, always comes. Now I am a perennial worrywart. I even worry before anything happens. I went through so many struggles that I want my grandchild to be comfortable and happy and self-sufficient and to never have to worry about money.

All I want from Samantha is for her to tell me always, "I love you, Grandma."

Tsuyako "Sox"
KITASHIMA

Two months after the Japanese attacked Pearl Harbor, Executive Order 9066 was signed into law by President Franklin Roosevelt, on February 19, 1942. Anyone with one-sixteenth or more Japanese blood was labeled an enemy alien and sent to an internment camp. Tsuyako "Sox" Kitashima, then twenty-three, was one of the 120,000 Japanese Americans incarcerated during World War II. It would take the United States government forty-six years to apologize and agree to pay reparations. Kitashima, eighty, the San Francisco Bay area liaison for the National Coalition for Redress and Reparations, lectures frequently at schools and colleges about her internment. A widow and retired civil servant, she is the mother of forty-seven-year-old Alan, a social worker, and the grandmother of Aaron, fifteen. She is a volunteer and board member of Kimochi, Inc., a senior services program in San Francisco.

My grandson, Aaron, and I are very close. Until he started high school, I looked after him every day while his parents worked. When Aaron was two months old, to make things easier for his parents, I bathed and put freshly laundered pajamas on him and gave him his bottle before they picked him up. At three and four years old, he went to a day care center next door to my home. Later on, he did his homework at my place after school.

I've talked to him about the camps, but I haven't gone into a lot of detail because he's still young. Many Japanese Americans my age don't want to speak about the camps. They're either ashamed about not resisting or in too much pain about their losses. But it's history, and we have to talk about it so that no one ever forgets. In my speeches I tell everything.

On May 9, 1942, I was herded into the Tanforan racetrack south of San Francisco with my mother, two sisters, and three brothers. Our father had died the year before. I was twenty-three years old. We were allowed to take into camp only what we could carry in two hands. The military police searched us like criminals, turning suitcases upside down to look for knives and guns. They said it was for our own protection.

Lunch, right after the inspection, was discolored cold cuts, overcooked Swiss chard, and moldy

bread. I refused it because a few hours earlier I was eating breakfast in the very nice home of our landlady. My older sister was her housekeeper and raised two of the woman's children. She did everything for their family, so I guess the lady felt that she owed it to my sister to do something for us. Afterward, she drove us to the schoolyard where the military police came for us.

Even more traumatic than the lunch were our living quarters. They were horse stables. Our stable consisted of twenty stalls, ten on each side. There were no steps or ceilings because, naturally, horses didn't need them. Nineteen other families lived in the same stable. All night long you could hear couples arguing, babies crying, and people being sick from all the stress.

Our beds were folding cots. Each of us was given a sack and told to go out back and fill it with straw. That became our mattress. There was a makeshift toilet in the passageway leading to the mess hall. It had no door. This was one of the ways they harassed and humiliated us. One internee donated his precious underwear, which he hung up like a curtain for privacy.

Everyone in my family was so devastated and shocked, no one said anything. I remember thinking that first night, while trying to fall asleep on the straw, "Why are we being treated like this without any due process of law?" No one even asked us a question about our past or anything. It was simply, "You look like an enemy, so you are an enemy." I couldn't believe this was America and I was living in a shelter where they used to keep animals.

Like almost everyone else, my father came to America in 1905 looking for gold, the good life. My mother followed the next year. She was a "picture bride" and was detained briefly on Angel Island. In those days the man would arrive first and send his picture home to the woman he hoped to marry. My mother always used to kid my father that he took the photo from the waist up to make himself appear taller. He ran a successful American-style restaurant at Fillmore and Eddy, an area of San Francisco known as Japan Town. The thing that amazes me is how he was able to order things for his business when he knew so little English. You have to give him and other first-generation Americans credit.

After some bad guys tried to shake him down to buy protection, he closed the restaurant. That and the 1906 earthquake made him decide a year later to move to the country and become a strawberry farmer. Both my parents came from the same farm region, Yamaguchi, in Japan.

I was born on July 14, 1918, in Hayward, California, east of the city. We moved around a lot because strawberries ate up the good soil after three or four years. My father would lease ten or twenty acres at a time. I helped on the farm after school, summers, and weekends. Dur-

ing the off-season I worked as a domestic, baby-sitter, and doctor's receptionist.

At the internment camp, surrounded by barbed wire and with military police in guard towers above, we had jobs just like on the outside—except that the pay was only $16 a month; if you were a professional such as a doctor or lawyer, then it was $19. The camp was administered by Caucasian civilians.

One of my brothers was a dishwasher, another a waiter. I didn't go to work because I needed to get up early to do laundry while there was still hot water. In those days there were no disposable diapers, so washing clothes was particularly hard on mothers.

When we weren't working, we just walked around outside. You couldn't stay in those smelly stables all day. They had only recently moved the horses—there was manure on the floor and horse hair on the walls. At night a Japanese singer and piano player entertained at the grandstand. Without the music we wouldn't have been able to face the next day.

After four months at Tanforan, we were transported by train to Topaz, Utah. To this day I have no idea how long the trip took. It felt as if we were riding on square wheels even though they were round. We were ordered to keep the shades down until we reached Salt Lake City because it was thought there might be snipers en route. There was so much hatred for us in California, where we were largely concentrated, after Pearl Harbor.

Back at Tanforan, there was a rumor going around about a plan to move us all inland and drop a bomb on us. I didn't tell my mother. Why worry her when we couldn't do anything about it? I was so proud of my mother because she never grumbled. She took it on the chin. Her main fear was that they might segregate the older internees from the younger ones and our family would be split up. They didn't, so she was okay.

The nearest place to Topaz was Delta, a "Zane Grey town" sixteen miles away. Summers, the temperature could climb to 100 degrees Fahrenheit; winters, 20 below. They withheld coal from us, and a shortage of formula caused the deaths of several babies.

The barracks were brand new, so I figured we were going to be there a long time, which turned out to be three degrading years. I decided that I had better do something to keep my sanity. One of my friends was a block manager, and he needed an assistant so that he could go out of the camp to work in order to support his wife and three kids. Farmers in the area needed help harvesting crops. Legally, he was still an internee, but the administration gave him a seasonal pass. I got paid a professional salary, $19 a month instead of $16, although you couldn't do anything with so little money anyway.

Two hundred people lived in my block. In the beginning they fed us innards of animals: liver, gizzard, tongue, and brain. If you lived in a block where a farmer was designated as the chef, you had it tough. We were lucky because my brother-in-law had been a baker for the railroads, and he made us cornbread and special cakes and knew how to smother the innards in teriyaki and other sauces. Later on, after a lot of protesting at block meetings, they upgraded the meat.

We ordered food and clothing from Sears Roebuck and Montgomery Ward, which made a financial killing from the camps. Their catalogs were plentiful, and everyone ordered from them. I'd like to praise the Simmons Mattress Company because later on they hired 75 percent of the Japanese Americans who came out of the camps.

At some point in 1943, during our internment, Japanese Americans were once again allowed to volunteer or be drafted into the armed services. Under Executive Order 9066 the previous year, our men had been reclassified from 1A to 4C, making them ineligible. I guess the government realized how valuable we were because those who had served before and who were from Hawaii had such a great record—especially the 442nd unit, 100th battalion, ten thousand strong, who fought the Nazis. The military needed our *samurai* spirit and talent.

In order to serve, we had to fill out loyalty oaths, which created a lot of emotional turmoil in the camp. If you said no, you could be sent to maximum security at Tule Lake in California, the only camp with a stockade, or back to Japan, which was suffering from the war. Many wanted a guarantee that if they served, their families would be released from the camp. Without it, they declined.

It was second-generation Japanese Americans like myself who felt this was our country, and even if we were behind barbed wire with our families, we had to serve to prove our loyalty. Broken and defeated, many older parents cried when their children volunteered; they didn't know how they would survive without their help. I volunteered for the Women's Army Corps, but I was too short to qualify.

January 20, 1945, was the day the camp gate opened. They didn't shove us out. Many people were afraid to leave because of the hatred against us. The war was still going on. They also felt there was nothing left. The land we had worked so hard to cultivate, sometimes ten hours a day in the hot sun, now belonged to others.

I didn't leave camp for eight more months, until September 1945. The previous month I had married Tom, another internee, who came from my hometown and used to work for a potato farmer. Although I was offered a civil service job, helping to close down the camp, I refused it.

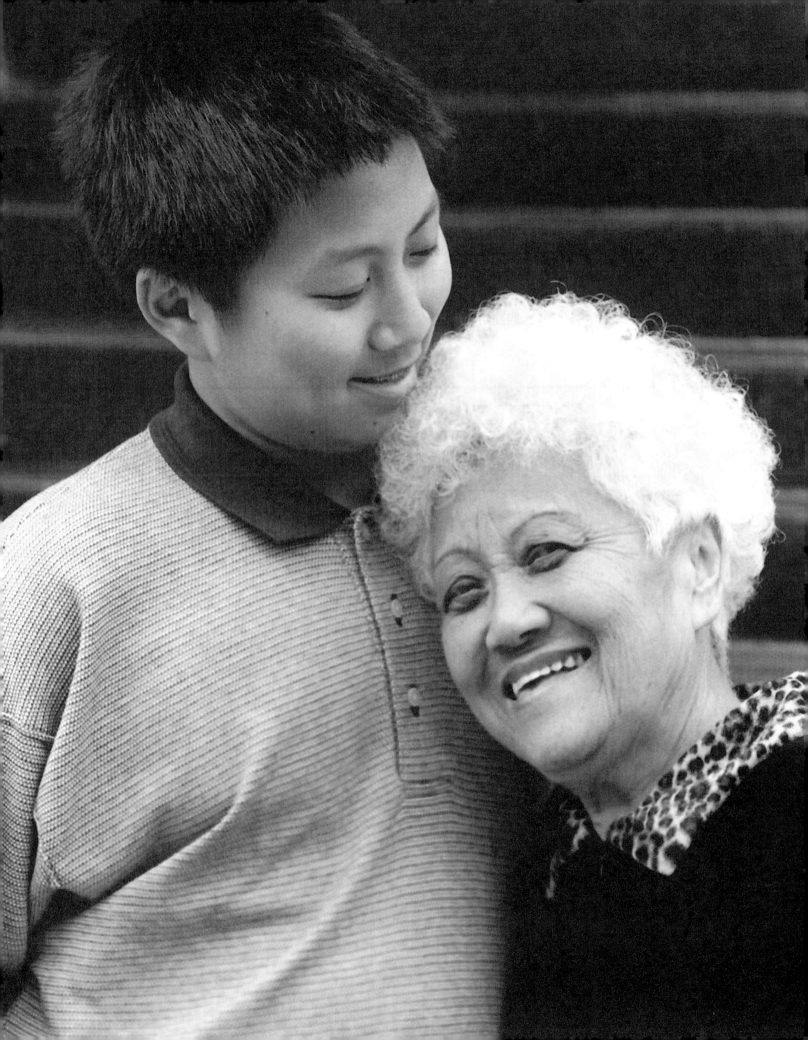

Being more aggressive than my husband, I figured that it made more sense for me to go out with him from the camp to get us resettled. We left camp together.

I was twenty-seven. A supervisor at Topaz recommended me for a job in San Francisco with the regional office of the War Relocation Authority that helped people coming out of camp find housing and work. Tom, thirty-one, worked in a hotel maintenance job and then, many years later, for a plastic company that made aircraft casings. My next job was secretary to the director of sugar rationing. Four years later, in 1949, I gave birth to our son, Alan, who would be the first person in my family to go to college.

Eventually, after passing a civil service exam, I went to work at the Veterans' Administration Hospital, first in tabulating and afterward as a medical receptionist. My husband died in 1975, and six years later, in May 1981, I retired with a pension. It was then that I got involved in the reparations movement.

The third generation of Japanese Americans, college-age kids who were already involved in the movement for a good two years, really inspired me. They told us older people that we had to fight for our rights. It wasn't a military necessity for us to be sent to the camps; it was racism and greed, and we should fight for an apology.

They didn't get one penny out of the struggle. They did it for us and their future. They were the ones who pressured President Carter to create a nine-man commission in 1981 to hear our testimony. We pooled our money for paper and stamps. For years we folded and addressed letters, over twenty-five thousand, to President Ronald Reagan and Nancy Reagan as part of our push for reparations. I'd try different handwriting, slanting it this way and that, so it didn't look as if the same person was behind all the letters. I even got stamps that said "love"—anything to get their attention.

It was a real struggle. In 1984 I went to Washington, D.C., to lobby Congress as part of a delegation of six. We were all greenhorns. We just knocked on doors and hoped a nice, friendly person would greet us instead of someone growling, "What are you doing here?" Twice we tried and failed to get a reparations and redress bill through Congress. They were too busy signing away fortunes for Reagan's military buildup to get interested in our issue.

On our third attempt, four Japanese Americans in Congress pushed a bill through, but only by making it an entitlement program, like Social Security or Medicare. On August 10, 1988, Reagan signed into law the Civil Liberties Act, admitting the government's wrongdoing and agreeing to pay us reparations. It took another two years and over four hundred mailgrams to President Bush to get the first payments. They went to the nine oldest survivors, including a

107-year-old man, all of them in wheelchairs. At a ceremony in the Hall of Justice in Washington, D.C., Attorney General Richard Thornburgh bent on his knee before each wheelchair on stage and said, "I'm sorry it took so long." I was bawling. It was so emotional.

I was paid in 1991. Each of us got $20,000 out of a total of $1.65 billion, which still falls far short of compensating us for the billions of dollars in assets that the government confiscated as well as the loss of our human and civil rights. As an intermediary for the Justice Department's Office of Redress Administration, I have sought out victims in veterans hospitals and elsewhere to make sure they got their payments. When the reparations program ended in September 1998, only 81,278 internees out of 120,000 had been paid.

I'm a person who, when I start something, I like to see it through. My favorite word is *gambare*. In Japanese it means "Don't give up! Go for it! Hang in there!"

Ten years ago when a member of the presidential commission hearing walked out in the middle of the testimonies, I should have stood up and asked the judge why this man—California Attorney General Dan Lungren, a staunch opponent of reparations—was allowed to leave.

I learned then that silence gets you nowhere. I gave my grandson, Aaron, half of my reparations payment because I wanted to leave him a legacy. I've told him that greed and hate caused the internments. There is no other way to explain it. He is interested in computers, and whenever he reads anything about me regarding the reparations and redress movement on the Internet, he lets me know and makes copies of the articles.

When Aaron is older, he will understand more about what happened and speak out not only for Japanese Americans but for any group whose liberties are threatened. I want my grandson and his generation to share in the responsibility of safeguarding the Constitution so that it works for everybody.

Maurine
LIPNICK

Maurine Lipnick, eighty-four, is part of the Jewish mercantile tradition in the South. She and her husband, Melvin, are retired from their children's specialty clothing store, begun in 1909 by her parents as a men's haberdashery, but she still teaches Latin. Lipnick, the mother of two grown daughters, has one grandson and two granddaughters, ages seventeen to twenty-two. She was the first woman president in the 130-year history of a temple near her home in Indianola, Mississippi.

My oldest grandchild, Brett, made a remark to me that I really appreciated. She said, "Nannie, you're just like our second mother." And I said, "I am, I really am, and I consider myself as such."

If our grandchildren can't reach their parents, they call Melvin and me to let us know where they are. Sometimes my disciplining them is more effective because their parents are ding-donging them every day. And I think the grandchildren want to please me more.

Whether it was a basketball game, a dance recital, or an awards day, Melvin and I were always present. It meant something to them and to us. Whatever we do for one grandchild, we have to do for the others. Sometimes Nannie has a hard time remembering: "Now, what did I do for that one's last birthday?"

I talk to my grandchildren a lot about living up to our Jewish tradition and being loyal to family. "There's nobody on this earth as interested in you or would take care of you as your family," I am always telling them.

Melvin and I are so fortunate that our children and grandchildren live right here and our daughters married Jews. They've known their husbands all their lives. It's just wonderful—it really is! So many of our friends don't have that. Their children live way off or married out of the faith.

It was important to Melvin and me that our children and grandchildren were raised Jewish. It doesn't happen automatically. We never had a temple in Indianola, but in the Delta area, where many

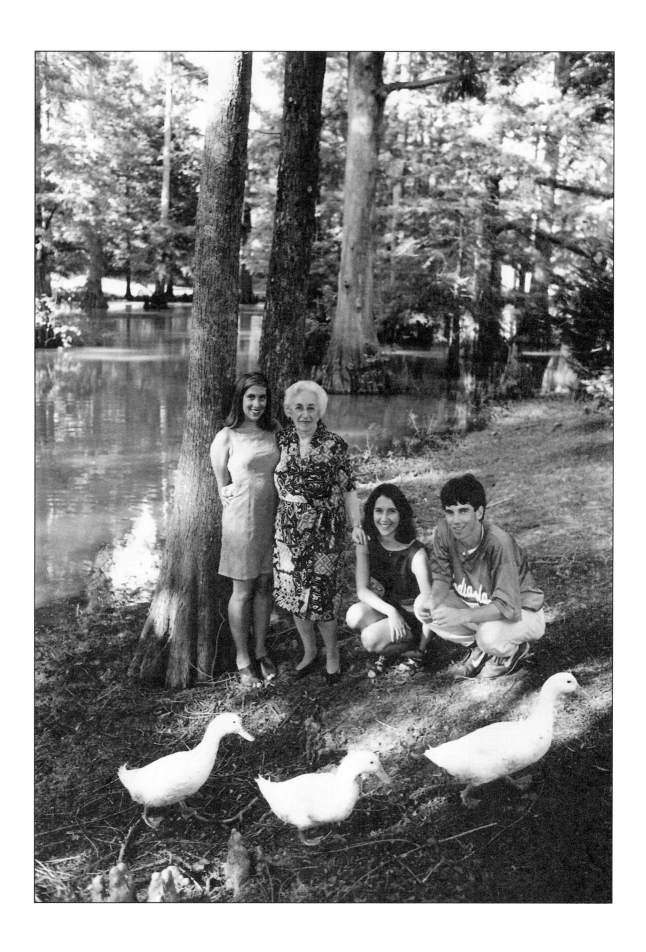

Jewish merchants settled at the turn of the century, there are temples in three surrounding communities.

In the South, Jews have always affiliated because the synagogue was a place where we could go to meet and interact with people of our faith. I was surprised when I learned how many more of us here do so than in urban areas of the North with much larger Jewish populations.

Tradition and family mean a lot to everybody here, not just to Jews, and Jews have always done their part in the community. I have served as both election commission chairman and Chamber of Commerce president. Being involved in community activities does not preclude me, however, from feeling the utmost importance of my Jewishness and wanting to pass this heritage that I love on to my family. So we put forth the effort for our daughters, and it took. We saw to it that our children got to Friday night services and Sunday school, just as they have done for their children, our grandchildren. I taught Sunday school and was a youth group adviser and leader, taking the teenagers to conclaves in Arkansas, Louisiana, Tennessee, wherever one was held.

It wasn't easy because I have always worked. As with any family-owned business, Melvin and I had to mind the store six days a week. As well, I taught a Latin class early in the morning at Indianola Academy before joining my husband at

work. From the time I was a little girl, standing on a crate to see over the counter, the store became a way of life for me.

In 1932, when I was away at the University of Mississippi in Oxford, a fire burned the store. My parents remodeled it, but it was the Depression, and I can remember my mother calling and saying, "Don't write any checks. The banks have closed." To this day I have never understood how my family kept me in school at that time.

I graduated in 1934 with honors in liberal arts. I studied Latin, English, Spanish, mathematics, and music, and I have a license to teach all those subjects, which I did for over a decade.

Melvin and I were married in 1947 after he returned from the war. His unit helped liberate the German concentration camp at Dachau, and he also served in the Pacific operation. We knew each other all our lives, and our families were friends. In fact, Melvin's father had been a groomsman in my parents' wedding. Within a year of our marrying, my father became ill, and Melvin came over from his family's grocery, furniture, and hardware store to our business. For the next fifty years we became a team, outfitting generations of children in the county.

In 1997 we closed our store and sold the building. My husband wanted to play golf, and the store was interfering with his game! I like to think I'm indestructible, that I could keep going, but I finally let Melvin persuade me to retire. We

realized that we were just too tired at the end of the day—but I still teach two Latin classes a day at Indianola Academy.

When I was growing up, all the downtown stores on Indianola's Front Street were Jewish-owned. Only one remains. Our daughters have retail clothing stores, but one is on the highway and the other in the next town. I wouldn't be upset if our grandchildren found some other work they could make a good living at and enjoy that wasn't six days and holidays. With the chain stores coming in and children no longer dressing up, it's become increasingly difficult to be in the kind of family retail business we had.

For the first time one of our family, our twenty-two-year-old granddaughter, Brett, who just graduated from college, is moving away. She's going to live in Atlanta because that's where many young Jewish people are. Back when our daughters were growing up, there were about fifty Jewish people in town. Today we are one of only two Jewish families left.

We are immensely proud of our grandchildren. When they were little, Melvin and I always made ourselves available for baby-sitting. It used to make me so angry when I heard some of our friends say, "I raised my own children. Now let them raise their own." I wanted to tell them, "My heavens, you're missing the most wonderful part of your life!"

Their love for you makes it wonderful. They may not always say so, but they do. They're very solicitous of me. I am not, by any means, unable to get around by myself, but I'm not as sure on my feet as I was, and they are very protective of me.

Dr. Jimmie C.
HOLLAND

Dr. Jimmie C. Holland, seventy, is credited with founding the field of psycho-oncology—the specialty in cancer concerned with the care of the "human" side of patients, the psychological problems caused by cancer and its treatment—at Memorial Sloan-Kettering Cancer Center in New York. She is married to oncologist and pioneer chemotherapy researcher Dr. James Holland, seventy-three. They have six grown children: James Holland's daughter and five of their own. There are five grandchildren, ages three months to nine years, with another on the way. They live in Scarsdale, New York.

I was so sure I wouldn't be like those grandmothers I've seen who are so silly, but I find I'm just the same. When I held Jennifer, my first newborn grandchild, in my arms, it was so moving that I almost cried. It was like holding her father, my oldest son, Steve, in my arms again.

As a grandmother, less weighted with responsibilities, I can just enjoy the pure pleasure of their childhood, and I love to play with them—on the floor and acting their age. It is so wonderful to see their developmental milestones, especially learning to walk and talk, and to remember my children going through the same stages.

With grandparenting, there is this wonderful sense of continuity with the future. Here are my children's progeny, and what a marvelous thing that is, particularly as I grow older. They are my connection to the future; I am their connection to the past. Grandparents are good at enabling grandchildren to learn and know about the past.

I'm a big collector of antiques that have sentimental value: things my grandmother had on her dining table, things my mother used. Small dishes and furniture can reveal much of a family's history. For example, I have the butter mold my mother used when she churned the milk and shaped the butter into a pound mold to sell during the Depression. But along with the serious stories, I try to tell my grandchildren funny stories about my childhood in the black soil, Bible-totin' part of rural Texas where little

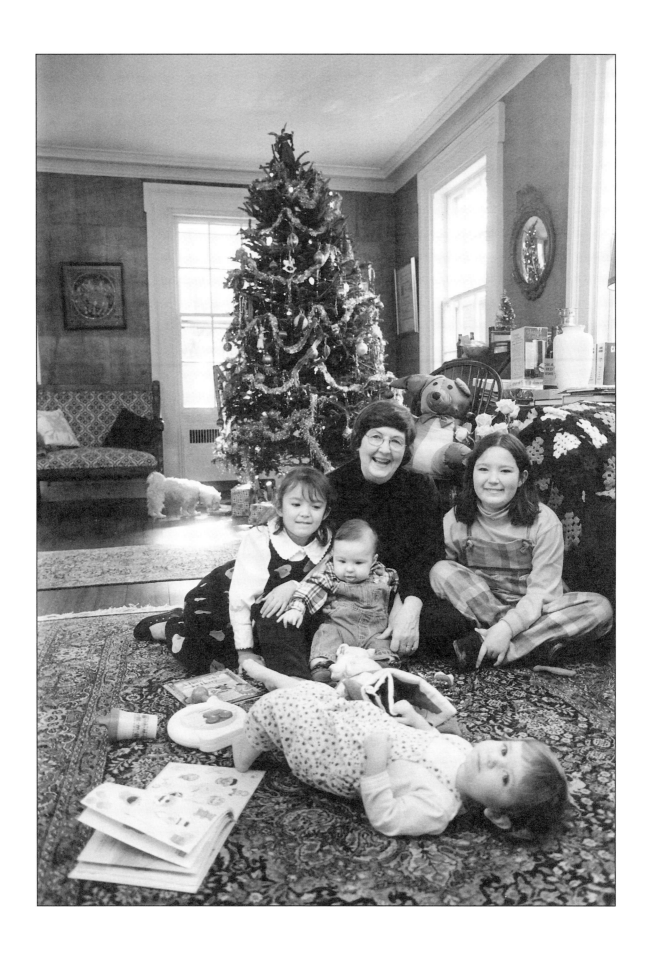

girls are named Jimmie, Billie, and Bobbie. It was classic 1930s Texas. The movie *Places in the Heart* comes close to describing it.

I had a lonely time as an only child growing up on a farm four miles from a "town" called Nevada, which had about fifty to a hundred people. I loved my mother's large family, and it was always fun to go to my grandmother's house where there were loving aunts and uncles and kids who liked to tell jokes and enjoyed holiday meals together. I think in my desire to have a big family I attempted to re-create the family my grandmother had.

Neither of my parents finished high school, but they very much wanted me to have an education. I always knew, from the time I was little and saw the wonderful, interesting things our old family doctor did, that I wanted to take care of people as he did. I didn't know if a woman could be a doctor, but once I got the idea it was possible, I started saying, "I'm going to be a doctor." That became my goal, and it never changed. I've never regretted it.

I went to Baylor University in Waco, Texas, and later graduated from its medical school in Houston. During my internship and residency in St. Louis and later at Massachusetts General in Boston, I became fascinated with knowing more about my patients as people: How do you cope with illness? How did this happen to you? How are you managing? How do you see the future?

And that became more interesting to me than handing out drugs for cardiac failure. So I decided to combine medicine and psychiatry, and work with the psychological problems of people with life-threatening illness.

During the final year of my residency, I met James Holland, who was chief of medicine at Roswell Park Institute in New York, the state's cancer institute. In 1956 we were married and moved to Buffalo, where our five children were born over an eight-year period. It was both chaotic and wonderful! I worked part-time in the Department of Psychiatry at the county hospital, starting their first psychiatry consultation service for patients on the medical floors. I had a wonderful housekeeper who made it possible for me to work and whose two children remain a part of our family.

Coming to Memorial in 1977 was the right time and the right place to begin to study the emotional lives of patients. Advances in cancer treatment were beginning to result in many more survivors. There was more optimism, and Memorial was and remains the flagship of cancer centers, making our work a ready model for others. The basic, painful emotions associated with cancer haven't changed, but new and challenging psychological issues have arisen: genetic testing and the fear that you can carry a cancer gene; how to educate about the dangers of smoking, especially to teenagers; how to assure maximal

quality of life for those who are receiving palliative, not curative, care.

I suppose that I get reminded every day about death in my work. That, of course, makes my husband, children, and grandchildren all the dearer. From my vantage point of age, I can step back and think of my parents who have died, of myself at seventy, and the children and their children. I am privileged to be a link between past and future, providing a sense of continuity between the generations.

Erik Erikson called this stage of the life cycle one in which generativity is the goal—an ability to place personal ambitions aside and to take pride and joy in mentoring and sharing one's knowledge and values—and hopefully wisdom—with one's children and grandchildren. And the feeling of generativity extends to one's professional life. I am most interested in encouraging the young people I have trained in developing their careers so they can carry forward the work that we have begun. They are my professional progeny.

With my children and grandchildren it's a personal feeling that I can look toward the wonderful things they're going to accomplish in their lives as well as their carrying on the traditions and values Jim and I have tried to pass on to them. There are traditions I hope they will remember, such as celebrating Christmas together in Scarsdale with Santa Claus and spending two

weeks in August each year in Maryland, where everybody in the family vacations together. For the last three years we've rented a big, old farmhouse with six bedrooms on Chesapeake Bay. Two of our children live in the Washington, D.C., area and the rest are scattered, in Boston, San Francisco, and Moscow. At least one night out of the two weeks *everyone* is there.

Our children and their spouses are wonderful parents. They are teaching the right values to their little ones. Grandparents need to be supportive of how their children are raising their kids and avoid criticizing them. They are struggling so hard to do it right and worry so much about "how the children will turn out."

I worried, too, and I came to realize that parenting is about patience and having an abiding faith that they will turn out well. I have found helpful a quote from the president of Bard College, Dr. Leon Botstein, who said when our next to the youngest son, Peter, went there: "You know, your children will turn out to be more like you than you ever hoped—or feared."

I think kids sense from grandparents a universal love that is truly unconditional and pure, and without a negative piece to it. I am afraid I am as indulgent with the grandchildren as I was with my children. There is a cartoon that says, "What do you do when Mom says no? Call 1-800-GRANDMA." I say no only if they do something that is inappropriate or could get them into

trouble. Their parents understand. They know I'm a softy.

Food is a great medium for maintaining traditions. I can smell something cooking and be right back in my mother's kitchen. My children were enormously attached to my mother until she died in 1989. They adored each other. I've collected recipes for years from my aunts, mother, and grandmother, and Jim's, and put them into a *Family Cookbook* for my children and grandchildren. When using a recipe—for example, my mother's fried chicken—they can read and remember some of her favorite expressions about her cooking and life in general.

I love reading to my grandchildren, especially Dr. Seuss books that have wonderful morals, putting humility back in its proper perspective, and stories that were read to me as a child. *The Adventures of Mabel* is a classic from 1909 that Jim's aunt Mabel read to him and his brothers.

At the farm in the summer I try to give them a real love of nature. We made a makeshift tent in the bushes under two big trees this past summer. Jennie (six), Madeline (nine), and I tried to sleep out there one night. When I lay down with them, I said, "Okay, you've got to be *very* quiet and just listen to nature around you. Look up at the stars."

A few minutes later the silence was too much for them. One said, "I'm bored," and then the other said, "I want to read a book." Hoping they'd fall asleep, I said, "No, you have to listen to nature. You don't want to miss hearing the crickets. It's wonderful."

Well, it worked for a while, and then we all went back inside to sleep. The next day Madeline wrote a play that she called *Grandma and Listening to Nature,* recounting their boredom and my insistence on silence. Children say such wonderful things—and so honest! Jennie loves to feel the wrinkles on my arms and says, "You're my wrinkly-pinkly grandma."

Grandpa takes them horseback riding, fishing, and crabbing. Jim has a very important role for them. Kids get connections to one grandparent, and two-year-old Delia is especially devoted to Jim. She made up her own name for him: "Peepaw." Delia likes to cook now. She recently told me, as I finished doing the dishes, "Good job, Grandma." They think of us as always being together. If Jim's not there, they'll ask me, "Where's Grandpa?" or, in my absence, "Where's Grandma?"

My hope for my grandchildren is that they all grow up in good health; that they love and are loved by another to form a bond of marriage or partnership; that they find work which is both satisfying and as much fun as mine has been; and, perhaps most important, that they share the sentiment given to me by my mother—try to make the world a little better place.

Arvella
SCHULLER

Arvella Schuller, sixty-nine, author, television producer, and a former organist, is the wife of the Reverend Robert H. Schuller, pastor of the Crystal Cathedral in Garden Grove, California. Active in the ministry, she produces the Hour of Power *broadcast of her husband's sermon, oversees a performing arts academy at the church, and began support groups for women in all stages of life, which are still functioning today. She has received a Religion in Media Book Award as well as the Hollywood-based Gold Angel Award for her television work. Married for forty-eight years, she and her husband have five children and seventeen grandchildren, ages three and a half to twenty. They live near the Crystal Cathedral.*

Six years ago during my morning meditation, all of a sudden I felt God talking to me without actually hearing His voice, and He put this thought in my mind: "Arvella, as a mother and a grandmother, you have to pray for your family, one by one, by name." Oh my goodness, I thought, it will take all day. I have five children and their spouses, which makes ten, plus my husband and seventeen grandchildren.

I would be really afraid for our children and now our grandchildren if I didn't believe in God as big, powerful, kind, and loving enough to be wherever they are—on the freeways or just out at night—keeping them safe. I don't know how people live without that belief.

I grew up on an Iowa farm, the oldest of seven children, in a devout Christian family. Everyone in our small community was named after a grandmother or grandfather. My mother said it was too confusing, and she came up with "Arvella" for me. My parents, who were from Holland, belonged to the Dutch Reformed Church. From the age of twelve I played the organ at worship services.

We were very poor, but food wasn't a problem because we got it from our vegetable garden and farm animals. My childhood was very loving and culturally rich. I milked cows to symphonies. Contemporary music was a no-no. I enjoyed reading novels, everything I could find in the school library, and playing the piano and organ. I attended a small rural school with only eight kids in grade school and sixteen in high school.

My dream was to wear a red dress and red shoes and play organ concerts up and down the land. I

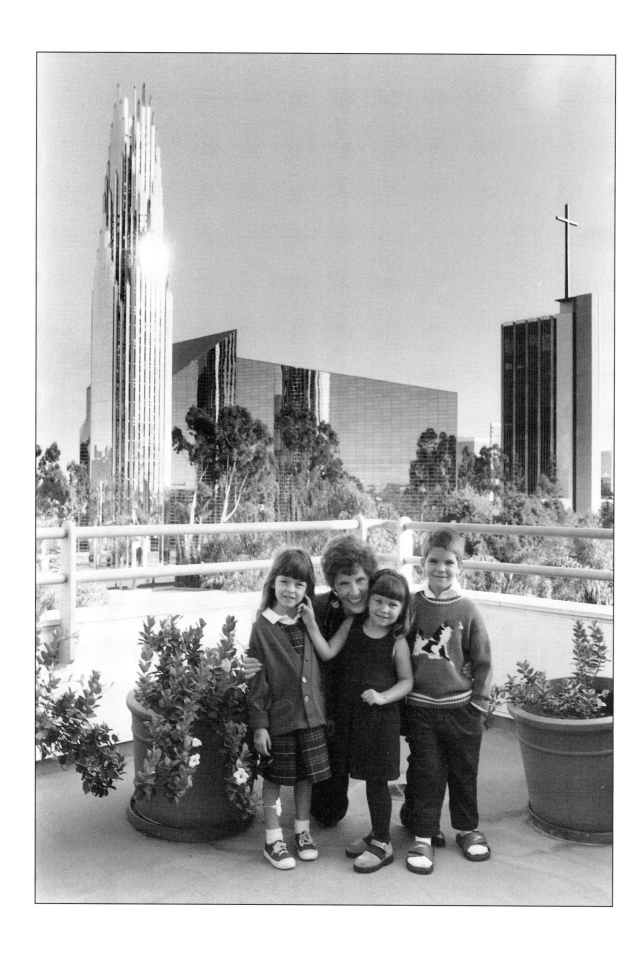

wanted to go to college for a music degree, but my parents couldn't afford it, so I cleaned houses to get the money. After two years I had earned enough to enroll in a music college.

At the end of my first year, in the late spring of 1948, I met my future husband, Bob Schuller. Then a seminary student, he was speaking at our church where I played the organ. Actually, we had grown up only seven miles apart and attended the same high school, but we hadn't met before because he was four years older than I.

We were immediately drawn to each other, and when he left on a mission, we began writing to each other. Within the year we were engaged and the next year, 1950, we were married. His first assignment was in a small church outside Chicago. There were about thirty families in the community who accepted us with open arms. During our five years there we had our first two children, Sheila and Bobby.

It was much easier than our arrival in Garden Grove, California, where in 1955 my husband was designated as a leader to open up a church. He described it as "a paradise next to Heaven, green grass, orange blossoms, sunshine, near the ocean and the mountains." What a shock it was to arrive at this little house in the middle of a tract of 150 homes with no streets or trees. The ground had been leveled. I didn't know anybody, and I became homesick. We couldn't even find a hall to begin services, so we hitched up a

trailer with the organ and hauled it to a drive-in movie theater.

Things were so bad our first year that we didn't have money to buy milk for our two babies. Bob's mother sent $5 every few weeks to help us, so every year we now give each grandchild a few dollar bills in an envelope for Christmas.

The church was so tiny that my husband's office was in one of the bedrooms, and we were awakened by congregants at all hours of the night. Within twelve years our family grew to include three more daughters. Our children saw people, broken and hurting, in our living room, so they have lived with it and seem to be proud of us. Most of them are active in the Crystal Cathedral Ministry today. Our oldest grandchild attends Oral Roberts University in Oklahoma. She has such a beautiful faith.

So here we are, forty-eight years later. Inch by inch the Crystal Cathedral came about. Looking back, it seems as if we've lived so many different lives. Bob and I reside a few miles from the cathedral in a house that we moved into twenty-five years ago, on almost two acres. Two of our daughters, Gretchen and Carol, live on either side of us, so we're all in a little compound now. Between them there are six grandchildren: four on one side and two on the other.

Friends of ours thought it was not a good arrangement. "You're not going to have any

peace of mind," they said. But we just love it. Of course, we do have rules; they cannot just come knocking but must call first. Our grandchildren often come over on Sundays for dinner. Our entire extended family gathers for the holidays.

When our children and their spouses have date nights, Bob and I baby-sit the younger grandchildren. One time when we were watching our grandson Nicky, who was two at the time, our daughter Sheila told me to make sure I gave him his medicine before bedtime. I thought I heard her say it was on top of the refrigerator, but she had said it was inside. After I got Nicky ready for bed, I fetched the little bottle of medicine and gave him a teaspoonful. He refused to swallow it and spit it out. I tried again and only managed to get a tiny dose into him.

I thought to myself, "What could taste so terrible?" I looked at the bottle, then I panicked. The dog's name was on the prescription label. I called poison control and the veterinarian while my husband got the car to take Nicky to the emergency room. The vet called back immediately, saying, "Don't worry. The medicine is just a vitamin supplement. Nicky may have a little diarrhea in the morning, but he'll be fine." I was a basket case by the time my daughter and her husband returned home.

The following morning when my daughter called, I asked, "How's Nicky?" She said, "Well,

I'll tell you what. He's on all fours on the kitchen floor and saying, 'Woof, woof.' "

Nicky, I am glad to report, is now twelve years old and very healthy and strong. But that's a grandmother story for the history books. You know, a grandmother is supposed to know everything and take better care of your babies than anybody else.

As much as we love our children and grandchildren and being with them, Bob and I need our own time. We have a phrase, "People tired." When we're with people all the time, we just want to be alone. We can be in the same room; I'll be reading and he'll be reading, and we just enjoy being alone with each other.

I feel that God is everywhere, which to me is a tremendous comfort, and He has my life and my husband's life planned. In 1979 I had breast cancer and this past year a serious heart attack. The previous year Bob had a heart attack. We're both doing super. I have seen and experienced many miracles.

I say a prayer every night for each of my seventeen grandkids, and my last prayer is that God will use what I did today and bless me for what I was able to do, correct what I didn't do correctly, and forgive me for what I should have done.

In the morning I say, "Okay, God, here we go again."

Thelma
MOTHERSHED WAIR

In the fall of 1957, Thelma Jean Mothershed, a fifteen-year-old high school junior, and eight fellow black students stepped across the threshold of all-white Little Rock Central High School and onto a page of history. The group, which became known as the "Little Rock Nine," were cursed and spat on. Undaunted, they kept on walking. Today, more than forty years later, Thelma Jean Mothershed Wair, fifty-six, is a retired schoolteacher and counselor who teaches survival skills at the Second Chance Shelter in East St. Louis, one of the nation's most blighted urban areas. She and her husband, Fred, a science teacher, make their home in nearby Belleville, Illinois. They have one son and two grandsons, Gabriel Scott, five months, and Brennan Dallas, three.

I was home-schooled from third to fifth grades because of a bad heart. I missed the other boys and girls. I never rode a bicycle, skated, or played softball. Instead I sat on our porch and played jacks and made paper dolls. When my doctors felt I could look after myself better, I returned to school but attended special education courses because I couldn't climb the stairs to regular sixth grade. So, as you can imagine, a classroom has always been a beautiful sight to me. I decided when I was eleven to become a teacher.

My parents believed in education. They met at Jarvis Christian College in Texas, where Daddy was from. He was a math major, and my mother studied home economics. He interrupted his studies for two years to join the Army during World War II. Afterward, he completed his degree at a college in Little Rock, Arkansas, my mother's home state, where I grew up.

I was one of six children. My mother, who never finished college, worked as a seamstress, milliner, and ceramics maker. Daddy, having served in the military, was a psychiatric aide at the Veterans' Administration Hospital.

In the fall of 1957, when I was fifteen, Little Rock voters decided to begin the integration process after the historic United States Supreme Court decision *Brown vs. The Board of Education* three years earlier. It abolished the "separate but equal" doctrine. Originally, more than one hundred black students

wanted to register for Central High, but when they found out they couldn't take part in choir, band, football, or any other extracurricular activity, the enrollment dwindled to nine.

There were eighteen hundred white students and the nine of us. My parents worried that, on account of my heart, I wouldn't be able to get around the big school or physically tolerate the stress. But whatever I decided, they assured me, I would have their full support. For me there was no turning back. The other eight kids made the commitment, and I didn't want to be the first to bow out. Years later, Jefferson Thomas, one of our group, told an assembly that he had wanted to quit, but "if the girl with the bad heart stayed," he couldn't leave me.

I wanted to go to Central High because I felt that I could get a better education there than at the all-black Horace Mann School. My decision was as simple as that. I was a very good student, having been elected to the honor society in the eighth grade and its president the next year.

As we tried to enter the school that first day, a bottle-throwing mob of more than a thousand whites shouted racial slurs and screamed, "Go back to Africa!" They came not only from Little Rock but from other counties and states, where it was feared that if integration worked here, their lily-white schools would be next. We left with our parents and drove to a safe haven at the home of Daisy Bates, the Arkansas NAACP president.

For seventeen days, under Governor Orval Faubus's orders, the Arkansas National Guard surrounded the school to prevent us from entering. Only after President Dwight David Eisenhower received a promise of cooperation from Faubus—who later reneged on it—did we return. A riot ensued. Several white students went outside to report that "the niggers are inside." They threatened to blow up the building, which we believed they might do. Now that I'm older and wiser, I kind of doubt they would have blown up eighteen hundred whites to get nine blacks. We left school that day under police guard.

Three days later President Eisenhower sent in the 101st Army Division, one thousand troopers strong, from Fort Campbell, Kentucky, to escort us to school. That he did this was the thrill of my life. The nine of us rode in an Army station wagon, with Army vehicles in front and back, while helicopters flew overhead. Each of us was assigned a soldier, who took us to classes and waited outside in case of trouble.

A month and a half later, when things appeared to quiet down, President Eisenhower recalled the troops and left us in the hands of the Arkansas National Guard. Many of the guardsmen had recently graduated from Central High

and didn't want us there. They were definitely not in our corner.

The nine of us endured taunts and cruelties all year from the white students. They attached open safety pins to the edges of their notebooks so they could poke us from behind. I watched as a boy poured a bowl of soup over my friend Minniejean Brown's head. One of them threw black ink over my white blouse. Another girl falsely accused me of kicking her while we were going up a stairway—even though I was in front of her. The vice principal forced me to apologize to her. Then the girl went on the evening news to tell her lie. I thought, "What a pitiful girl!"

Many mornings I would wake up with a lump in my throat about having to enter that place. But I never once cried. I finished my junior year. The summer before my senior year, Governor Faubus warned on television that if integration proceeded any further, blood would flow in the streets. He ordered all of the high schools in the county closed.

My senior year I took high school correspondence courses to complete my Central High diploma. It didn't arrive in the mail for another two years. Next I went to Southern Illinois University in Carbondale, where in 1964 I graduated with a teaching degree in home economics.

At college I met my future husband, Fred Wair. He came to visit me in Little Rock, where I was working as a substitute teacher while taking business courses. We got married four months later, in the winter of 1965, and then went to East St. Louis, Illinois. He was teaching high school science, and I got a job teaching home economics.

A few months later, after falling over and turning blue one day, I was flown in an emergency-equipped Air Force plane to Houston, Texas. There, surgeon Dr. Denton Cooley patched up two holes in my heart.

Eight years later, in 1974, my husband and I adopted a son, Scott Frederick. I continued teaching while studying for a master's degree in counselor education and then switched to counseling. I went around to nine elementary schools trying to teach the children self-esteem and a work ethic.

When our son, Scott, turned eighteen and said he was getting married, I said, "Why in the world would you want to get married at your age? You're in the Marines. You'll travel the world and meet all kinds of people. Eighteen is too young to marry." He said, "Because we're in love," which I repeated in a kind of sarcastic tone. Against my advice he got married, and two years later, when he said they were having a baby, I scolded, "I'm old enough to be a grandmother, but you're not old enough to be a father."

Because my son and his wife are Dallas Cow-

boys fans, they named their first son Brennan Dallas. My second grandson arrived three years later. His name is Gabriel Scott. So I have a cowboy and an angel for grandchildren.

Happily, my son's life has worked out well. He left the Marines after three years when he hurt his leg, and he went into the computer business as a troubleshooter. His wife, who is part Filipino and part Native American, is a very good lady. Once in a while she'll curl her hair in the morning, and by noon it's back to being straight. My older sister also married out of our race. Her husband is a Dutch businessman, and they live in Holland with their two grown sons.

People should just accept each other—even if they're different. You can't judge someone by their color or hair texture. What took place in Little Rock should never have happened. My parents, who are retired, still live there. My daddy is eighty-two and my mother is eighty-one. They've been married for sixty-two years. A few times a year our whole family gets together. That way my parents can spend time with their great-grandchildren.

I attended both the thirtieth and fortieth anniversaries of our struggle for integration at Central High. At the first event, Bill Clinton, then governor of Arkansas, invited us back to the mansion. There, the future president of the United States served me a soda on a silver tray.

He spoke at our last anniversary, in 1997, when students at Central High greeted us with cheers and a band. The filling station across the street, where the white kids used to hang out and pick on us, is now a museum with our pictures and our story in it.

I feel proud because I was part of something truly worthy and important, not just for blacks but for the nation. Although I've never received an individual, direct apology from any of the white students with whom I attended Central High, a few years ago three of them appeared on *Oprah* with seven of us from our group. They apologized and cried over how badly they treated us. Because there were eighteen hundred white kids in the school back then, we didn't know or remember the ones on the show. But they seemed sincere.

In 1994 I retired after twenty-eight years in the East St. Louis school district, and I thought, "How can I spend my time well?" I didn't want to just get in with a group of people learning bridge. So I taught women in jail about child care, and parents with limited incomes on how to budget, cook sensibly—steaming, not frying—for good nutrition, and shop alone, because if you take children along, they'll ask for too much and you'll end up buying more than you need.

Today I teach survival skills at a shelter for people down on their luck. It is funded by the

Ministers United Against Human Suffering and run by the Red Cross. I was raised in the Disciple of Christ Church, and I've always been religious. My husband wanted me to convert to his faith, Baptist, but they're livelier than what I am accustomed to.

Since the operation thirty-two years ago, my heart has remained young and strong, but I found out twelve years ago, after seeing double and falling, that I have multiple sclerosis, a degenerative disease of the central nervous system. I use a cane to walk long distances or climb stairs, but as I'm still standing, I don't go for any medical treatments. I'm too busy fixing my teeth. Last summer I got braces, upper and lower. Some of my teeth were lying down or overlapping others. My husband asked me why I wanted braces at my age. I told him, "I don't want to die with crooked teeth."

I am still very active in the community. What I try to get across in speeches to black people is that you cannot expect anybody else to raise your children or give them anything. You have to get what you want for yourself—but not violently. People just have to realize the safety net is gone. I know this is kind of rough, especially on children, but in another way it's a good thing because parents will think, "I have kids. I'd better get a job."

I plead with them to get an education and learn what they need in order to survive. I didn't join the Little Rock Nine to get in the history books. I did it because I wanted the best education I could get.

My grandson Brennan is already three feet five inches and is only three years old. His doctor says that he will be over six feet four inches when he is fully grown. By the time he reaches sixth grade, he might be taller than his teachers, so I told my son, "Don't let Brennan become a bully." When my grandson is four, he is going to study martial arts to learn about self-control. Thank goodness his baby brother, Gabriel, is going to be short and husky like his father.

Education is the key to everything. I tell every young person, "Stay in school!"

$\mathcal{J}an$

ALLEY YOUREN

Jan Alley Youren, fifty-four, is a four-time world bareback riding champion in the Women's Professional Rodeo Association and a member of the Cowgirl Hall of Fame. She and her husband, Jim, sixty-five, have fifteen children (seven each and one together). Between them there are fifty-two grandkids and one great-grandchild. They live in both Bruneau and Garden Valley, Idaho, where she runs rodeo schools.

I've taught my grandkids to rodeo, and they've won lots of saddles and belts. Even the four-year-olds, J.W., Kaylie, and Chance, compete in goat-tying. They all do barrel racing, pole bending, team-roping, and calf-roping. Two of them, Tavia (fourteen) and Flint (thirteen), are riding steers. And the sixteen-year-old, Tasha, is just starting to ride bareback broncos. Rodeoing has been good for them. It gives children so many challenges that they don't have time to get into trouble or be bored.

By the time I was five years old, I was helping Dad break in horses on our ranch in Garden Valley, Idaho. Dad gave me my first horse, a yearling named Dandy, when I was six. Dad's rule was that if you got bucked off, you got back up.

When I was twelve, Dad produced the first all-girl rodeo in Idaho and entered me in all the events. I won both cow and bareback bronco riding. One time when I was sixteen, a horse bit my toe, and I socked the steel to him, hitting him with my spurs. He came down real hard on me: 1,100 pounds of horse on my 110-pound body. I was raised to get back up, which I did, riding a cow in the next event. That night I ached so much, I soaked in a hot springs for relief.

My mother was gray-headed before she was thirty, and she said every one of them was the fault of Dad and me. Until she died in 1976, she wanted to know when I'd quit rodeoing. The only time I haven't rodeoed was between the births of my first two kids, who arrived eleven months apart. My grandkids say I'll be doing it until I can't get up on the chute anymore and they have to hoist me.

By the time I was thirty-two, I was divorced three times and a single mother of seven. I owned and ran a convenience store, insulated houses, and built fences to support my family and my "rodeo habit." In 1984 when I was thirty-nine, I married Jim Youren, a rancher eleven years my senior. He's my fourth husband, and I ain't turning this one loose.

I hope they all have as good a life as I had. Up until 1997 I felt as if I was the luckiest person in the world. That year I lost my thirty-four-year-old son, Jim, when a tree fell on him. He had five kids. Six weeks later a son-in-law died in a backhoe accident. He had two kids. They were both super dads. There is not much I can do but just go on and try to help raise those grandchildren so their dads would be proud.

Although I've had two hundred stitches, broken my back, had all my teeth knocked out, and been scalped rodeoing, I'm not done setting goals. When I quit bareback bronco riding, I'm going to get me a barrel-racing horse and make the men's national finals—or give it a good shot anyhow. My grandpa Alley won at calf-roping when he was seventy.

I love being a grandma. I can spoil the little ones bad, baking cakes and buying candy, and then give them back to their parents. They kind of like Grandma, so they're around a lot. I ride with them, and I've set up a little playland for them in an airport hangar that was here when we bought the property.

Grandma has lots of love, and she hasn't given it all away yet. Unless I'm a terrible cranky old lady, I'm not going to have a lonely old age because I'll be telling my grandkids stories.

Elissa

EPSTEIN

Elissa Epstein, sixty-four, is a businesswoman with a law degree and is active in philanthropic and political activities. For almost a decade she has been a board member of Leadership America, a women's resource group. A widow, she has three children and five grandchildren, ages three to fourteen, with another on the way. She lives in New York City and Atlantic Beach, New York.

When our first grandchild, Clifford, was born, it was the first time I ever saw my husband, Herbert, cry. I cried, too. It was really a big passage, bringing another life into our family.

Because we were young grandparents it seemed like a novelty. When our first two grandchildren were old enough to swim, I hid out with them on our boat. We even put our hands up and swore never to reveal our whereabouts to their parents.

My husband died sooner than I expected, and I have kept up the family traditions and other holidays we had shared. The biggest one was Thanksgiving, when we'd take our two grandsons to the Macy's parade, the Big Apple Circus, and then dinner at our home. With each new grandchild I continue to do this. I think consistency gives grandchildren an added feeling of security and stability.

Each of my grandchildren is different, but I find they're all special. Clifford (fourteen) is this instinctively perfect child who doesn't try to please—he's just pleasant to be around. He's handsome, a very good athlete and student, and has impeccable manners. He and I both love politics, so the biggest thrill in my life was taking him to the 1996 Inaugural Ball. His brother, Luke (eleven), is a little clunkier but has a great fashion sense. He's a poet and a dreamer. Both boys live near me, so they're like extended family.

Then in Los Angeles there's Hunter (five), who is very intellectual, analytical, and almost Talmudic in his thinking. His brother, Griffin (three), is small, agile, and tumbly. I can still carry him under my arm. I have one granddaughter, Ali (three), in Washington, D.C. Ali and Griffin were born within eight days of

each other, but Ali is a head taller. We go to the zoo often because she loves animals. She is assertive and a bit bossy but makes friends easily. To me she is "Miss Ali," and I always say, "She stands tall."

The key thing is high and focused energy, going the whole mile with my grandchildren. I jog and work out every morning so that I'm prepared for a swim, a trek up a mountain, an afternoon at the circus, or a night at the opera, theater, or movies with them.

The most important things I can give my grandchildren are my feelings about honesty and loyalty. It's not something you can actually teach them; it's just something they experience. They know they can be truthful with me about anything, whether it's being scared at the Natural History Museum because it's dark in there and the exhibits are so big or having a toilet-training mishap, which to them is a little-child disaster. They know nothing can change the love I feel for them.

Grandchildren are like a dividend. All the time and energy you put into your children you get back from your grandchildren. With your children you always want them to be perfect. I never worry if my grandchildren are going to embarrass me or if they're successful. I just love them the way they are.

Doris
DRUCKER

Doris Drucker, eighty-seven, is the inventor of the VISIVOX. It is a feedback device that lets public speakers see whether they are being heard; their voice volume is displayed by light signals that represent continuous changes in loudness. She has been married for sixty-two years to Peter F. Drucker, the business author and lecturer. She has four grown children and six grandkids, ages ten to twenty-nine. She and her husband live in Claremont, California.

I am not the type of grandmother who bakes cookies. I like to do things with the grandkids. For instance, in 1984 I took the three older grandsons—Nova, Marin, and Jeremy—to a shuttle launch in Florida. They were then fifteen, thirteen, and ten. We had a great time, and they will always remember that.

Right now I am closest to my youngest grandchild, Allison, who is ten years old and lives in Chicago. I e-mail riddles to her: "What do you call a cat that has eaten a lemon? A sourpuss." She loves that. It's really a ball.

Eighteen years ago I bought my first computer. My husband is antitechnology. He is not good at using a computer, so I have to read his e-mail. To me a computer is a utility—it lets me do my work more efficiently.

Of course, compared to my grandchildren who are all experts with computers, I am nowhere. My seventeen-year-old grandson is a real computer enthusiast; he designed the logo for the VISIVOX, which I invented three years ago. It consists of a portable metal box, about 8 inches by 12 inches by 2.5 inches, with a built-in microphone that converts voice volume into light signals. The louder you speak, the greater the number of lights of different colors that go on.

I got the idea for the VISIVOX because my husband is hard of hearing and does not hear the resonance of his voice. During his lectures I would be in the audience shouting, "Louder, louder," and then I

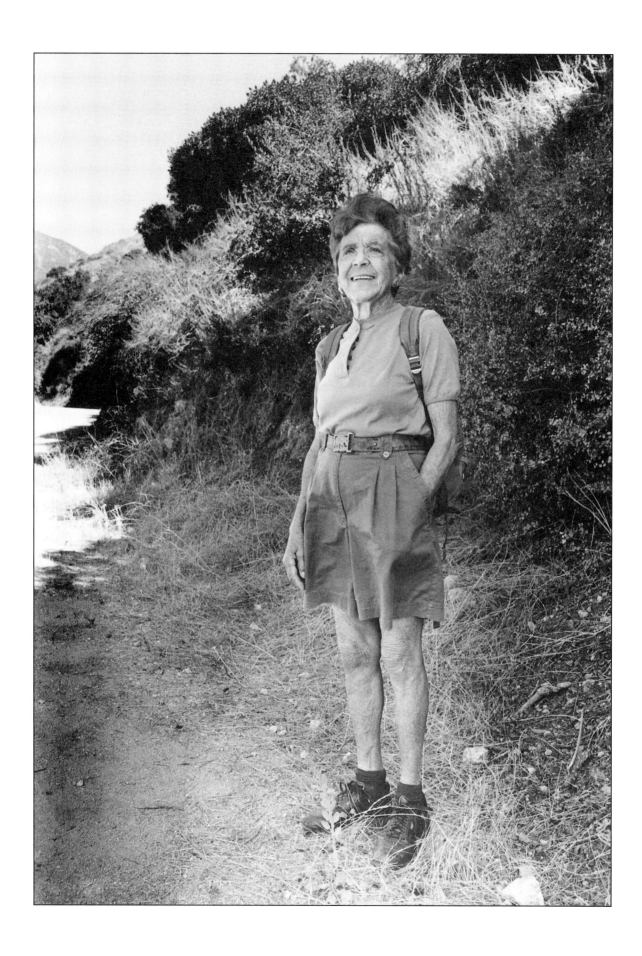

thought there must be a better way. I researched and found an engineer in northern California to help design the VISIVOX. He is my partner.

The device is very useful not only for public speakers, teachers, and preachers but also for people with speech impairments that prevent them from speaking at a consistent and audible level. That includes stroke victims, people with Parkinson's disease, emphysema, laryngectomies, traumatic head or spine injuries, and the deaf. So instead of a speech pathologist sitting next to them and saying, "Louder, louder," they can be told, "Try to speak loud enough that one light goes on, and tomorrow you try for two lights."

It took over a year and a half to get the right product and a patent and a trademark. I started selling it a year ago. It is hard work—I am a one-woman band. There is no public transportation in this part of the country, so I spend a lot of time just driving from one place to another.

I used to play tennis, mostly doubles, four times a week. Now I am lucky if I play twice. If a potential customer wants a demonstration of VISIVOX, I can't very well say, "Sorry, not tomorrow. I have a game."

From childhood on I have always been a sports nut: hiking, skiing, swimming. I grew up in Germany, the oldest of three children, in a small town outside Frankfurt. My father was a businessman and my mother a housewife. After high school I went to England. It was during the Depression, and half of my class went abroad as nannies—it was a job when there was no work to be had at home.

I took courses at the London School of Economics and the Sorbonne in Paris. Although I was fascinated with physics, I studied law because it was the only thing my parents were willing to pay for. Besides, as a woman I would have had to become a high school science teacher, which I did not want to do. So after two years abroad I went back to Germany to finish the required academic courses. I met my husband when he was a teaching assistant at the university.

In 1932 I went to Holland to write my thesis on international law at the World Court. Then Hitler came to power, and what was the point of going back to Germany? I returned to England where I had many friends and got a job. My husband-to-be also went to England, and we got married in 1937, just before we decided to go to the United States.

Here he worked as a correspondent for a number of British newspapers and then became a professor at Sarah Lawrence College. Next he joined the faculty at Bennington College in Vermont where we spent eight happy years and raised our children. Two were born while we lived in New York, and the other two were born in Vermont. In the beginning, when my husband started writing books, I used to edit them, but there was too much friction involved.

We left Vermont when my husband got an appointment as professor of the graduate business school of New York University. We went to live in New Jersey, and I took evening classes in physics and mathematics. After I got my master of science degree, I started on my Ph.D. in physics at N.Y.U. By that time, though, I was in my late forties, and I realized that I wouldn't get an interesting job in physics by the time I was finished. Physics is a young person's field.

Instead I started working as a freelance technical writer and, a little later, took the federal exam to become a registered patent agent. I really liked patent work. I read all kinds of inventors' ideas, from soap bubble toys and fruit pickers to disc brakes on automobiles and helicopter parts and whatnot. The inventors give you a rough description, and from that you have to write up the patent application—a very detailed description of all the parts; how the device operates and why it is better than anything similar that has already been invented; and what the inventor claims is the essence of the invention.

Over the years I came up with some inventions of my own. One was a device that allowed programming of meal preparations. It was clumsy compared with the microwave oven and went nowhere. I also came up with a pulse rate counter to wear on a wristband. I showed it to a cardiologist, who said it was a very good idea,

but where would there be a market for it? Now lots of people who do aerobics use such pulse rate counters. It is easy to invent things; selling them is the hard part.

In 1971 my husband was offered a professorship at the graduate school of Claremont University, and we moved to California. We have a cabin in the Rocky Mountains in Colorado where the family gets together in the summer for a very active outdoor life. When I was about seventy, I went on a trek in the Himalayas with one of my daughters.

What is very important to me is to have people around who are supportive when you really need them. When I had surgery, people said, "What can I do for you? I'm praying for you." One rainy February day when my husband was sick, a neighbor came to our door with a big pot of beef stew.

I am part of the local Meals-on-Wheels group. We see these old people, and we are their only contact with the world outside their door. You have to give back to other people, which is something I have told my grandchildren.

And I also tell them to be considerate and to keep in touch with parents and grandparents. And don't run off without thinking how it affects other people. I hope that all of them will be honorable members of the family of man and that each of them has and keeps forever an awareness of the wonders of this earth.

Itaf

FAWAZ

Born in Lebanon, Itaf Fawaz, fifty-eight, emigrated in 1974 to Dearborn, Michigan, which has the largest Arab population outside of the Middle East. She and her husband, Atallah, a retired autoworker who is also from Lebanon, have five children and five grandchildren, ages one and a half to nine. Fawaz, a homemaker, became a U.S. citizen on July 4, 1979.

Yes, I very much like America, but my English is not very good. My children and grandchildren speak it. But all the time in my house they must talk Arabic with me. I teach them stories from the Koran, and we visit the mosques.

It is very important to keep the culture and tradition of my birth country for the grandchildren. On different days I make the Arabic food—hummus, tabbouli, shish kebab—for my family.

I was born in Beirut, and I had a happy childhood. My parents were very loving with my brothers and sisters and me. My father worked his whole life as a businessman. He died when I was thirty-two.

My husband saw me when I was walking to school in Beirut one day. I was eighteen; he was twenty-six. He wasn't allowed to talk to me, and I couldn't talk to him. His mother and sister came to talk to my family to ask for my hand in marriage. After we got engaged, then we could talk.

After I got married, I stayed ten years in Kuwait. My husband sent me to Beirut to be with my family when I had our first child, a son, at twenty-five. The next two, a daughter and another son, I had in Kuwait. For the fourth child, a girl, I went home again to Beirut. Later, in America, when I was forty years old, I had our fifth child, a son.

I came to America because my husband wanted to be near his sisters and brothers. All of them, except my husband, were born in the United States. My husband's father came here in the beginning of the 1900s when there weren't many Arab people. He returned to Lebanon before World War II for his

daughters to find Arab husbands. Once they married, they came back here.

My husband's family petitioned for us to come to America. In the beginning we lived in southeast Dearborn Heights. There were many immigrants from Eastern Europe, South America, and Asia, and some Arabs. I was very homesick. I didn't drive, and I didn't speak English. My children were my only company until my husband came home from work.

Every Sunday my husband drove the family to the Eastern Market in Detroit to buy food for the whole week. There were no Arab shops near our home. We got our meat from the Jewish shop in the market, and nobody thought a second thing about it. Like the Jewish people, we don't eat pork. I think we have more things in common than differences; we are both Semites.

Where we live now there are more people from the Middle East, so it is easier. The shops and mosques are near us. Many people in the neighborhood speak Arabic. I took some English classes, but it is harder when you are older to learn a new language. I can understand more English than I am able to speak. I read books all the time, but always in Arabic. Being busy at home raising my children, I didn't have the opportunity to practice speaking English as the children did in school and with friends.

Like my own parents, I was very strict with my children. Any movies they wanted to see, my husband and I watched first. A kiss on the cheek, okay; a kiss on the mouth, then the movie was not okay for them to see. We didn't let them watch the television shows. One of them, *Three's Company,* was about a man living with two women. My children were forbidden to look at it. All the time we played Arab music in the home.

I've returned to Beirut twice, in 1993 and 1996, to visit

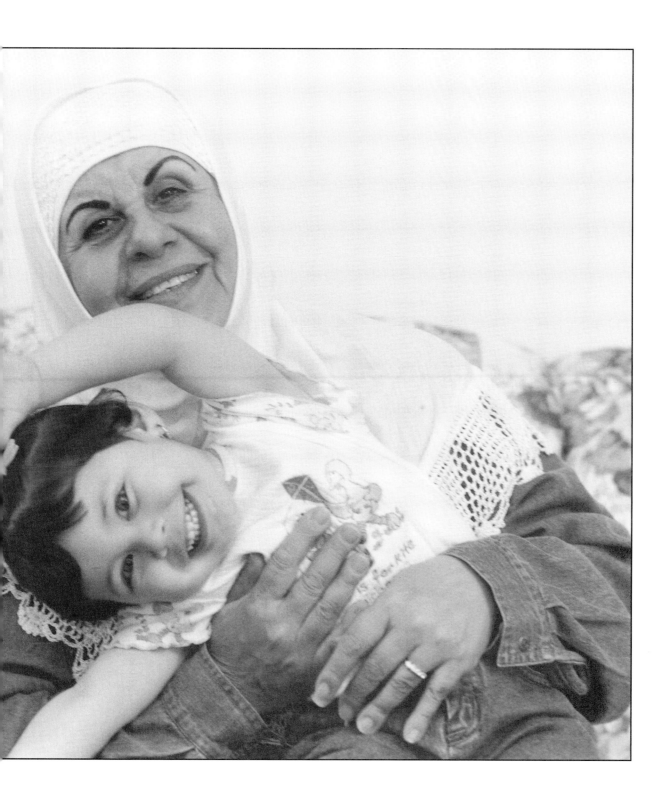

my family. Each time I stayed two months. My country was destroyed by war. It's gone. For me this is very, very sad. It was a beautiful cosmopolitan place.

What I like very much in America is that girls can do many things such as sports and swimming. For a girl in Lebanon, when I was growing up, this was not encouraged. Everywhere it's a man's world. I always encouraged my daughters to become independent financially. You never know because you might not have a nice husband or he could pass away.

Education makes it possible for a woman to be financially independent. One of my daughters has a master's degree in marketing and finance, and a very good job writing contracts for the health care system. The other is the social work supervisor at the Arab center here. They are both married to Arabs.

One of my sons is divorced and married again, both times to wives from Latin America. I have three grandchildren from him. When he married outside the faith, I was very upset that his children wouldn't be full Arabs. But the moment I laid eyes on the first baby, Ali, I loved him like any other grandchild.

As I get older I am becoming closer to Allah. Last year for the first time since I have lived in America, I started wearing the *hijab,* a head covering. I was planning a pilgrimage to Mecca in Saudi Arabia this year, but my husband became ill and I couldn't leave him.

I worry that my grandchildren will get too far away in their lives from their Islamic heritage. Each generation becomes more American. One of them is still a baby. If they start speaking English to me on the phone, I scold them. My children also make them speak Arabic at home. Our whole family spends so much time together that it has become a habit for the grandchildren to live the Arab culture.

I want them to know everything about our history, and I would like for them to also understand that every people has a book, the Koran or the Bible, that God gave them, and everyone came from God and is a good person.

Really, I hope one day that we all get together, and I wish *salaam,* peace, for everybody.

Eleanor R.

MONTANO

Crime prevention specialist Eleanor Montano, the founding member and president of the Los Angeles–based Mothers and Men Against Gangs— Support Services, is past honorary mayor of Wilmington, a largely Hispanic suburb of Los Angeles where she lives. She has earned dozens of honors, including the YWCA Silver Achievement and the Cesar Chavez and Los Angeles Human Relations Commission awards for community service. A widow, Montano, sixty-eight, is a professional wedding cake baker. She has five grown children and nine grandchildren, ages three months to sixteen years.

My grandchildren have been a great comfort to me since my husband Emilio's death from a weak heart a year ago. They are always saying, "Grandpa liked this, Grandpa liked that," as if he were still with us. I had hospice come to the house. It was so much gentler than a hospital—no tubes, no needles, no nothing. His grandchildren were with him when he died. He had a smile on his face.

When my eight-year-old grandson, Matthew, and his five-year-old brother, Marshall, sleep over, they stay in the room where their grandfather died. They push the adjustable mattress buttons on the bed and make sandwiches of each other, and we all crack up. My children didn't see my father-in-law, their grandfather, when he died. We told them he was just asleep, which is the worst thing you can tell a kid. My youngest used to wake up screaming in the middle of the night. He thought that if he fell asleep he would be dead. I didn't want to make the same mistake with my grandkids.

As a member of the LAPD Crisis Response Team, I deal with a lot of grieving people at the scene of fatal accidents, homicides, and rape. I have learned that it doesn't matter who you are, rich or poor, when it comes to death, we're all adolescents. One time a call came into the hot line from a ninety-seven-year-old man who was dying. His little brother had died when he was five years old, and his parents never allowed him to say the brother's name. Even after they died, he still couldn't—he felt too guilty. He just wanted to talk to someone so he could say his brother's name and be okay before he passed on.

It is so important to listen. I make a point of spending time individually with one or two grandchildren.

That way I can really listen and pay attention to what they are thinking and feeling. We all get together for birthdays and holidays. Each grandchild gets to pick what he or she wants me to cook for the birthday, and I bake cakes with themes they choose.

My children are bringing them up the way they were raised, so the cycle of good behavior is not broken. When they drop the grandkids off, my children tease me: "Your grandchildren are going to jump all over your furniture and tear up your house." I say if that's so, I'll just put cages up and check the grandkids in as soon as they arrive. From the minute my grandchildren run up on the porch steps, they're like little angels.

I see too many kids in trouble. Many parents bring gang wannabes to my house for me to talk some sense into them. One time this mother called, and from the way she was talking about her son on the phone, I thought he would be some horrible, horrible kid. When she brought him over, I was shocked. He was ten years old.

At some point my granddaughter, who was then two, came into the room and started digging inside the woman's pocketbook, which was on the floor next to the sofa. I told my granddaughter the purse wasn't her property and to leave it alone. The boy's mother said it was okay for her to play with it. "Excuse me," I said. "Maybe your child can, but not my granddaughter. I'm teaching her, and so is my daughter, to

respect other people's things." Instead of saying no to her ten-year-old, the mother was taking the easy way out. I told her that sometimes you have to make enemies of your children, but later on they'll love and respect you more. My kids used to call me "the warden," but when they were older, they thanked me.

I had a strict Catholic upbringing. One time when I was seven, my grandpa pulled me inside the house after he saw me standing on the sidewalk with this twelve-year-old girl. He told me I had to go to confession, and when I asked why, he said it was because the girl was talking to boys already.

I was born in Long Beach, California. My parents divorced when I was three. After my mother, who was from Mexico, remarried, I got permission from her to move in with my maternal grandparents. Their home was five miles from ours. I lived there from the time I was five until I was eleven when Grandma died of cancer. Then I went back home.

I called my grandma *La Otra Mama* [the other mother], as if it were one word. She was just this wonderful person who helped everyone. She taught me to have a conscience, something you don't hear about too much anymore. She never had a bad word to say about anyone.

When I was little, we went out to a restaurant where they wouldn't serve us. The waiters just kept walking by our table and laughing. I

thought maybe there was something wrong with me. Grandma said they were too busy with other customers. Much later on I realized it was because we were Spanish-speaking. I never heard the word "prejudice" from her mouth. She believed her goodness alone could protect me from cruelty and ignorance.

Until I was six years old I didn't know a word of English, and being the only Latina child in the class, no one wanted to talk to me. The teacher put a yarn over my head, tied both ends, and attached a name tag with E-L-E-A-N-O-R in big red letters on cardboard. I'd never seen that name before because at home I was "Leonor." Until I could say and spell my name in English I was stuck with the name tag. And if I spoke Spanish, the teacher put me in a closet.

For the next five years I sat in silence in school. That's why I'm not so sure bilingual education works. To me it's just another way to sell double books to the schools. The sooner you learn the language of a country, the easier it is, which is why I insisted with my children—and now with my grandkids—that they speak to me in English.

I couldn't go to high school because, as the oldest of seven children born within ten years, I had to help our family. Instead, I went to work in a local hospital helping the dietitians, and when I was older, I worked part-time as an elevator op-

erator. I turned over my whole paycheck to my mother, who was a school custodian, and step-father, who worked in a foundry.

I met Emilio at a ballroom where my mother took me when I was fifteen. He was in the Navy, and he asked her for permission to dance with me. A few years later we starting seeing each other. But we didn't get married until after he was out of the Navy and we had saved for a year. I was twenty-one, and he was twenty-six.

Within the space of twelve years we had five children. My husband drove a ten-ton cement truck. I wanted to stay home with my kids, so to earn extra money I took in laundry from eight priests. Because all my kids were born in September, it was cheaper to bake them cakes than buy presents. I took a course and eventually started a wedding cake business out of my house.

Between the church and my cake business I got to know many people in the community and saw what problems existed. I have been volunteering for over thirty-five years. The most important thing I try to show my grandchildren is that whatever they gain from life, they must always give something back.

When we visit the cemetery, Marshall, the five-year-old, always wants to bring along a big pail of water to wash "Grandpa's lid," which is what he calls the gravestone, and to make the grass around it the greenest lawn.

\mathcal{P}enny
CHENERY

Penny Chenery, seventy-six, was the principal owner of the greatest thoroughbred in modern racing history, Secretariat, the 1973 Triple Crown winner. Back then she was known as Penny Tweedy. She is the mother of four children and six grandchildren, ages two to fourteen. Chenery lives in Lexington, Kentucky—horse country.

\mathcal{M}y grandchildren don't really ask me questions about Secretariat, nor do my children dwell on this because of what it might imply to their friends. They want the kids to fit into middle-class schools in the suburbs. I feel similarly. I wish for my grandchildren an event or achievement in life that is completely satisfying because, above all, it is something they decide to do rather than something that is expected of them.

I was born Helen Chenery, the youngest of three children, into relative comfort. When I was a baby, my parents called me "Henny Penny, the little red hen who thought the sky was falling," and to this day most people know me by my nickname. When they were little, my grandchildren called me "Penny"— until they discovered their friends called their grandmothers something else. Now I am "Grandma Penny."

I grew up in Pelham Manor in Westchester, a suburb of New York City, where most people were from the South and wanted to make something of themselves. And they did. My mother, a Smith College graduate originally from Oregon, was a homemaker. My father was a civil engineer from Virginia. When I was five years old, his business life changed. He discovered he had a feel for finance, and with a partner he started buying utility companies and putting them together in a holding company. And they made a lot of money in one year. It was really very exciting. In 1929, Dad did not even suffer in the Depression because the utilities field was quite stable.

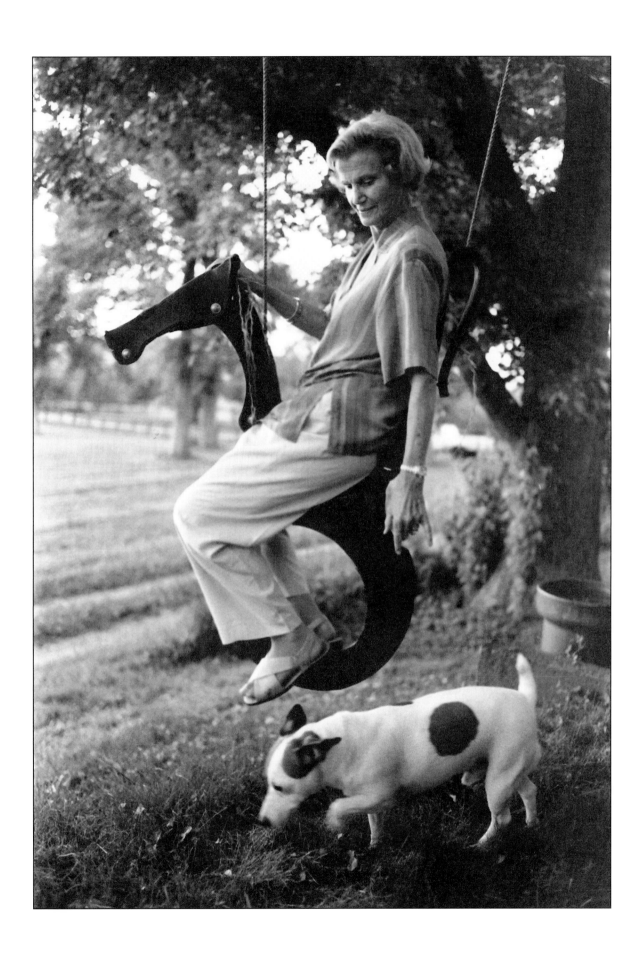

My life, too, was a great piece of stability. The imperatives of my early years were to get an education and to go along with my parents' wishes for me to attend good schools, get good grades, and marry a well-educated man with the proper background. I grew up with twelve best friends (boys and girls), and from the time I went to private school (Madeira) until graduating from college (Smith), we were "our gang." Our parents were also more or less the same. Riding was our family sport at clubs and our farms in Connecticut and Virginia.

Once I graduated from college, I thought, "Okay, I have completed my obligation to my parents, my community, and my friends." World War II was on, and my brother, Hollis, bless his heart, told my parents that I ought to join the American Red Cross and go overseas.

I wanted to do it; I was dying to get out and find adventure. My parents consented, and off I went to France and then Germany. And that was just the most liberating thing because we were able-bodied recreation workers, and our job was to cheer up the soldiers with conversation as well as hand out doughnuts and coffee. For the first time the Chenery name didn't mean anything. Nobody knew my parents, and I didn't know anyone else's parents. I realized I was a very provincial little snob, and I learned to drive a mean truck.

Upon my return to the United States, I en-rolled in graduate school in business administration at Columbia University. There I met my future husband, John "Jack" Tweedy, a law student who was graduating six months before me. We became engaged, and when he went to Denver, Colorado, to look for a job, to my intense disappointment my dad said, "Oh, forget your degree." Like a dummy, I did. But, see, I was still the good girl.

I was twenty-seven by then, "getting on," and Jack was the first man whom I liked that my parents liked. He was a very nice guy. I discovered that although I liked my husband a lot, he essentially wanted a different kind of wife: country club, sports playing, good cook, entertain friends. This was not enough for me. I was always active in the community, on the board of this or that, but I went through a period of being very angry and wanted out of the marriage, and it was hard on my kids.

I really knew before our youngest son, John Jr., was born that I wanted out of the marriage. But then we had two daughters, Sarah and Kate, born two years apart, and five years later Christopher, who was named for my dad. I heard my husband say to somebody, "You know, it all starts when they go to these women's colleges. Their professors listen to them, and they begin to think they have something to say." And I thought, "This is the man I am married to?"

But I was expecting another child, so I said

to myself, All right, you'll have to stay married a few more years. Our marriage was in a state where I think it was acknowledged between us that we were pushing this one through. But I didn't know what I would do. I didn't want to be one more divorcée with four kids.

In a sense I am glad I stayed as long as I did in the marriage, twenty-four years. What I try to say to young women who are in the same kind of distress I was in is "Sweat it out. There is a lot of life left, and kids take twenty years. If you live to be seventy-five, what is twenty years?"

I learned about racing from my dad, who had several thoroughbreds and was quite sure about his breeding program. When Dad incorporated his horse ownership, he put me on the board, and I had this new responsibility of taking care of his horses and business affairs. Dad's health was not good, and Mother had died a few years earlier.

I was fifty when we had our first good horse, Riva Ridge, who won the Kentucky Derby in 1972. Suddenly there was my door to freedom. Yes, I could see there was another life. Basically I had more or less finished up chunks of my life: education, marriage, children. Then came Secretariat and the Triple Crown in 1973.

I discovered that I related well to people and enjoyed being the center of attention, and I had learned to talk on my feet and be interviewed. My experiences so many years before with the Red Cross abroad made me comfortable talking with all kinds of people.

Secretariat had become a cult hero. Nobody else did what he had done: He won the Triple Crown, setting records in all three races. His thirty-one-length victory in the Belmont Stakes marked him as a unique champion. He was a horse with charisma. He would show off for people, and his fame grew as a stud because it was so glamorous to see him. Because my father's death in January 1973 created a huge inheritance tax burden, Secretariat was retired after just two years of racing. It was just the saddest day of my life. I felt as if I had lost a child.

By Christmas 1974 I ended my marriage. After Jack and I were divorced, and I had gotten out of my system all my frustrations of being submerged and feeling that I didn't have a chance to live for me, I fell in love with this attractive guy. We moved in together in New York City and went to Hollywood parties and New York movie screenings, which was really neat. He was in television and was not really from the same world socially, but I was fascinated by his world of showbiz colleagues. We were married five years; I was with him ten: two and a half years before our marriage and two and a half years after our divorce.

My children were very cordial to him, and he was gracious to them. But there was Mother living in sin, and it changed all the ground rules.

I became friends with my children instead of being mother, leader, and judge, and I really loved that.

The best thing for me and Jack had been being by ourselves in Denver in the early years of our marriage. So now I don't want to be sitting on top of my kids. As I get older and less able to live on my own, I'm sure I will move closer to them.

I keep an apartment in Denver, where all my children live. In Kentucky, where I have been living since 1991, I'm beginning to feel as if I am at grown-up camp, playing hooky from my real life because I enjoy it so much. Within the year, I expect, I will move to Denver, get a house, and still have a yard and my dogs.

With my grandchildren I want to be more of a friend than a role model. Now that some of them are in young adulthood, they're so much more interesting. When I go to Denver, I can spend time with them rather than "having the family over."

Each of my grandkids has chosen a different role—deliberately so, I think. For example, Elena, fourteen, is very accomplished and has a scientific bent. She hasn't been seen in a dress for five or six years. She is pretty but has no vanity. Her sister, Alice, twelve, is so dramatic and so el-

egant, with a great sense of fashion. She wants to be a performer of some sort. I'm thrilled she has the talent, but I tell her, "Before that talent scout finds you, stay in the education mode." Both girls are Kate's daughters, and all three love to hike in the mountains.

I was not exposed to all the sports they do in school. Mandy, twelve, my son Christopher's daughter, swims competitively. She and her father and mother are real jocks. Mandy also loves to ride horses, and I like watching her.

I am not the traditional cookie-baking and knitting grandmother, although I did knit one terrible sweater that was passed on from the oldest to the youngest. What I hope for my grandchildren is that they'll have the opportunity to do what they want and have the self-confidence to pursue what interests them. I want them to have the tools of education. Unless they foul up, they will have the advantage of some financial backing, so I hope they will choose well. I want them to have interesting lives, work, and partners.

I have a lot of energy and a lot of friends. I'm basically cheerful. I expect to have a good time and give other people a good time, and I hope things will go well. And if not, I'm not a terrible worrier.

Christine

BUSSEY

Christine Bussey, thirty, is a grandmother of two: Quentina, one, and Requan, two. She lives in Philadelphia public housing with her mother, her two children, and her two grandkids. Bussey is eight months pregnant with another child.

I'm not a good grandma 'cause I don't have a job so we can have a better place to live. And I'm eight months pregnant. When my daughter, Christine Jr., was telling me that my baby is going to be younger than her two kids, my grandkids, I just laughed. You know it's strange.

My two kids, Christine, who's sixteen, and Arsenio Hall, who's nine, are from two different fathers I haven't seen since. I got pregnant the first time when I was thirteen. My mother was real mad. She took me to the hospital to get an abortion. It was too late—I was going on six months.

My mother helps me with my kids and grandkids, though she didn't agree with my having them. Everything bad happened after my father died back in the seventies. He drove a moving truck, and my mom stayed home with us kids. Altogether there were seven of us. There are only four of us left. One of my sisters died from complications from AIDS, another from drinking, and a brother from diabetes.

I didn't want my daughter to follow in my footsteps. I wanted her to be better than me. She wouldn't listen. Christine has two kids by two men. She ain't married, either. She was fourteen when she had her first child. I was a grandma at twenty-eight.

She used to get scared when her baby threw up. I just went in the room, and she said, "Take the baby." Now she says, "No more babies." She's starting school to get her GED. She wants to be a mortician. My mom and I look after her babies. My mother had a stroke last January, but she's okay now. She gets SSI money. I get welfare.

The only thing I'm mad with my mother about is that when I turned a certain age, maybe eleven or twelve, she should have been telling me about sex and guys. But she just talked about wanting me to stay in school. I went to school till fifteen and then Job Corps for a few months. But I never had the ability to go out and get a job. Maybe I was afraid I wouldn't get one.

I'm going to tell my granddaughter, Quentina, when she gets older, "Don't let these guys out there destroy you by messing up your mind with sex." I don't want her to go through what I did.

My grandkids bring joy to my eyes. I dream of them having things, everything, education being number one, and then a house or whatever else they want. I wish these same things for my children, too. I know it's possible because I have a brother who has his own family, a house, and a job doing carpentry.

After my baby is born, I'm not having more kids. I want to go back to school and be a carpenter so maybe I can build a mansion for my family. When times get hard, at least I will be ready, if I have a job, for anything that could happen. I've had a rough life, but I've got to look forward.

Ethel "Billie"

GAMMON

Ethel "Billie" Gammon, eighty-one, is founding director of the Norlands Living History Center in Livermore, Maine. She wrote the grants and designed the study programs that give students a nineteenth-century rural living history experience. In 1997 she was inducted into the Maine Women's Hall of Fame. A widow, Gammon has two grown children and four grandchildren, ages seventeen to twenty-eight.

At eighty-one I'm still blessed with abundant energy and the joy of life. Doctors say I have arthritis and osteoporosis, which all adds up to one four-letter word: L-A-M-E. It is not that I can't get up the stairs, it's that I can't get there fast enough! And I've never been a worrier. My daughter has the worry concession for the family. Even when she was little, she knew how. I just never got the hang of it.

I believe that worry is the sin of unbelief because if you believe and have faith and trust in the Almighty, you don't worry. One of my favorite sayings is "Yesterday is history; tomorrow is a mystery; today is a gift. That's why we call it the present."

And what a gift to me my life at Norlands has been. In addition to four grandchildren of my own, I have bushels of grandkids—those who have interned and studied at Norlands. Not a week goes by that I don't hear from them. Many people like grandchildren best as babies. I prefer them when they are older. It's like making new friends. My four grandchildren are my very special friends.

When my oldest grandchild, Darcy, twenty-eight, was at college, she stayed with me during school breaks. She and I read poetry and did her history assignments together. She wrote her master's thesis about my life.

I was born in rural Augusta, Maine, in July 1916. My father was a dairy farmer from Nova Scotia. My

mother, a very proper English lady, taught me that ladies should drink only from teacups and always with saucers, never from mugs!

I had four wonderful older half-brothers from my father's first wife, who had died. A sister, who was born two years before me, was a sickly baby, and my mother was always admonishing the boys, "Keep quiet—you'll wake her." So when I came along, they refused to call me Ethel. They didn't want another sister. I was "Bill" to them. My mother compromised by calling me "Billie." My brothers taught me ever so many things. Oh, I crossed streams on logs with them and did flying leaps from beams in the barn into the hay below.

I attended one-room schoolhouses in Nova Scotia and Maine that looked much the same as the one at Norlands. The teacher's desk was on a platform; the amenities extended to slate and slate pencils. There was no electricity. A box stove provided the heat. The bathroom was an outhouse in the woods.

In the one-room schoolhouse in Maine, I read everything everyone else had to read in the higher grades, and I'd listen to their lessons. At the end of seventh grade I was allowed to take the eighth grade achievement test. I did better than all the eighth graders, so the school superintendent decided that I should go directly into high school. I was twelve.

Since the nearest high school was four miles away from our farm, I boarded with a family as a mother's helper. It was a very lonely time. All the high school kids were older than I, and their jokes were too advanced for me! But I did well in class, winning an essay contest and writing the class poem. At fifteen I graduated with honors.

Those were the Depression years, and my parents worried all the time about meeting mortgage and interest payments on the farm. It is the reason that I have never had a credit card or loans or owed anybody a cent. I pay every bill the day it comes in. I know most people don't live this way anymore. And I have never bought a television. I gobble up nonfiction books.

Through a partial scholarship and a variety of jobs—waitressing, washing dishes and windows in the dormitory, and doing office work—I was able to afford the $50 annual tuition at a two-year state Normal School. In 1934 I graduated magna cum laude with a certificate in elementary education and was chosen class poet. I was seventeen.

In Livermore, during my second year of teaching, I first learned about Norlands, the 450-acre, nineteenth-century farm of the Washburn family. The seven Washburn sons were a political dynasty unrivaled in American history. They were governors, bankers, millionaire entrepreneurs, presidential advisers, and congressmen. Three of them served at the same time.

But the most important event of that year in Livermore was that I met Alfred Quimby Gammon, who three years later became my husband. After that happy year in Livermore I taught two years in Augusta, where my salary was doubled—from $14 to $28 a week! During the Depression, the government didn't allow two wage earners in one family. So when Alfred and I decided to marry, I really had to think about how much I loved him to give up teaching, which I also loved. I became a homemaker.

Except for three years abroad in the Navy during World War II, Alfred worked for the International Paper Company his whole life. In 1941 we remodeled an old carriage house where I still live. It is three miles from Norlands. Our daughter, Nancy, was born the next year, and our son, Michael, four years later. In 1954 when they were both school age, a Washburn descendant asked me to open the Norlands library every Wednesday in summer.

My job was to study the Washburn family history and tell it to visiting relatives and anyone who happened to drop in. That first summer, only twenty-seven people appeared, so I had plenty of time to study and to dream. I'd look at the church with its fallen steeple, and I could see that lovely spire touching the sky again. I'd look at the little one-room schoolhouse, half-hidden in the bushes, and I'd imagine children lining up to go inside and a teacher standing in the doorway ringing the bell.

When I talked to the trustees of Norlands about turning it into a living history museum, they did not share my enthusiasm for such a project. It took nineteen years and the help of a Maine Museum official to convince them!

During the intervening years I taught church school and

took local high school kids on cultural excursions to Boston and elsewhere. I sailed all over the Maine coast with my husband when he was finally able to find time for vacations. I learned to ski every Maine mountain with a lift, of course by the longest and easiest trails. And I became a grandmother.

In October 1974, twenty years after I first went to Norlands, we opened the little one-room school for visiting classes. That year I completed my bachelor's degree in history because I thought it would give me more credibility in creating the Norlands curriculum. The next year I finished my master's. My thesis was seven hundred typed pages on the Washburn journals. It was forty-one years since I had graduated from Normal School. I was fifty-eight.

We called the Norlands school the "Little Time Machine" because it transports students back to the education of an 1850s one-room schoolhouse. The teacher and people who work at Norlands wear period costumes and play real characters.

We always begin our three-day live-in program for college students with a visit to the nearby cemetery on the hill, a place usually reserved for endings. All the Washburns are buried there. My husband, who died twelve years ago at sixty-nine, is buried there, and my name is on the tombstone next to his so that when I am gone, I can still watch over Norlands.

My husband always shared my enthusiasm for Norlands, although when he'd pick me up there in the evenings, he had to kind of snap me out of the nineteenth century and bring me back to the present. Our children and grandchildren have enjoyed Norlands and have been willing helpers in the programs.

There is still so much to do, and I love what I do! I have four antique clocks in my house. All of them work, but I don't wind them. It's just that I don't wish to be reminded that time is passing.

When I was inducted into the Maine Women's Hall of Fame in 1997, my granddaughter, Darcy, read a poem she had written. The last stanza read:

> *Well, in theory, I want to be you,*
> *you eighty-year-old*
> *poetry-quoting*
> *white-haired*
> *grandmother of four,*
> *museum director,*
> *grant-writer,*
> *baker,*
> *public-speaking,*
> *"I have to be at the Norlands ten*
> *minutes ago"*
> *Woman*
> *But, in reality, even the thought of it*
> *tires me out.*

$\mathscr{R}uby$

TOM

Ruby Tom, sixty-four, was born in China and came to the United States by way of Canada in 1969. A retired seamstress, she has one son, Kenneth, and two grandchildren, William, two, and Jennifer, fifteen. She lives with her husband, Henry, sixty-five, a retired restaurant worker, in New York City's Chinatown. She speaks little English, so her husband helped translate for her.

Our granddaughter speaks only English, but we've been talking to our grandson in Cantonese since he was born. Later on he'll know English. It is for me very important for the grandchildren to learn Chinese to retain our culture. That way I can hear a part of my homeland in their words.

I was born in Canton. We were a very close family, but I didn't know my grandmothers because they both died before I was seven years old. In our culture, grandfathers were the most important family members. The eldest males always made the decisions for the whole family. I went to school only until sixth grade, and then I just stayed home.

When I was fifteen, we moved to Saskatchewan, Canada. It was in the beginning of 1949, only a few months before China fell to the Communists. Within a few years Mao's Cultural Revolution would purge the country of its liberal elements. We went first to Hong Kong for a month to obtain visas for Canada. I met my future husband, Henry, there. He was living across the street from where we were staying, and a family friend introduced us. He was studying to be a classical opera performer. Both of us were born in the same village in Canton, but we didn't know it until then.

For almost ten years, while I lived in Canada, we wrote to each other. My father's first job in Canada was working in a laundry, and when he had saved the money, we opened a Chinese restaurant. I helped in the restaurant and studied English a little. Eventually I received a marriage proposal from Hong Kong, in a letter from Henry. My family approved. I went there to get married in 1959, and then he returned with

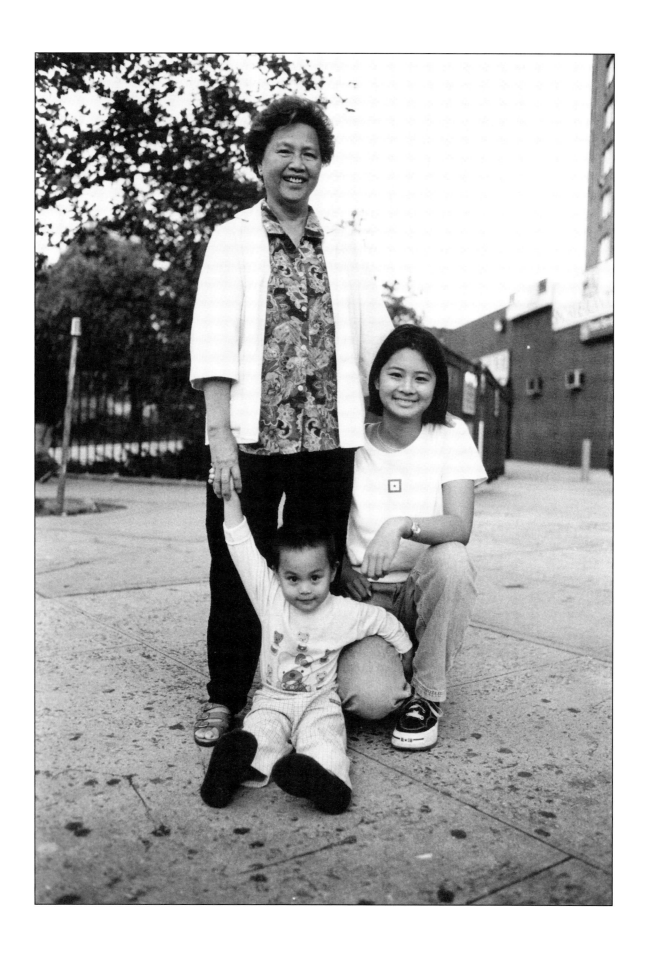

me to Canada. I was twenty-five, and he was twenty-six. He went to work with my family in the restaurant.

We lived with my parents above the restaurant. A year after marrying Henry, I had our son, Kenneth, who was very spoiled by his grandparents. They were older and retired, so when my husband and I went to work, they looked after him. We stayed in Canada until Kenny finished third grade, in 1969. By then my parents had died. My husband's parents, who were living in New York, were getting old and wanted us to come there. We sold the restaurant and moved to Chinatown near them.

We became U.S. citizens in 1970. In New York we had to start all over again. My husband went to work in a restaurant, and I was hired by a factory that taught me to sew. Kenny went to a Catholic school, and his grandparents looked after him while we worked. Afterward, he studied photography, which is his profession today, at the Fashion Institute of Technology.

He made us grandparents fifteen years ago with his first wife. She had come to the United States from Hong Kong when she was three, so she didn't speak much Chinese. English was the chosen language, so that is what my granddaughter, Jennifer, knows. Kenny and his wife were divorced when he was twenty-five. A few years later he married again, a woman who had moved here from China only about twelve years before

and who speaks the same dialect that we do. Two years ago they gave us a grandson, William.

From Monday to Thursday, when his parents are working, William stays with my husband and me. Our granddaughter lives with her mother, Kenny's ex-wife. William and I share a room. It has one bed for him and one for me, and I sing to him in Chinese until he falls asleep.

His grandfather and I have drawings of things, and we tell him their Chinese names. He already knows how to count to ten in our language. You have to start this early with children.

William calls me "Nannan," Chinese for grandmother. When he's older we can go to Chinese-language movies together, which I couldn't do with my granddaughter.

Outside our home we fit in with westernized ways. Inside we like to be more traditional. Every Saturday and for holidays the whole family comes for dinner. We like simple cooking, not too much flavoring, no MSG, just chicken and vegetables, for example, with a very light sauce. In the restaurants they put a lot of spice in the food so that if there is a bar, people will order extra drinks.

I am always so happy to be with my grandchildren. I hope they grow up happy and get a good education so they can have a good job. Then they don't have to work so many hours in a day in a restaurant or sewing factory, as we did.

Rebecca MERRILL

Rebecca Merrill, forty-nine, and her husband, Roger, helped Stephen Covey write his bestselling books, The 7 Habits of Highly Effective People *and* The 7 Habits of Highly Effective Families, *and coauthored with him* First Things First. *Merrill is the mother of seven children and has ten grandchildren, ages two months to six years. She and her husband live in Lehi, Utah, a suburb of Salt Lake City.*

Being grandparents has really changed our lives in ways we never could have anticipated. For example, we used to think that when the children were grown, we'd be looking for a condo with no yard work. Instead we're building a larger house because we want to stay close to our extended family. With twenty-six family members (children, grandchildren, and parents) there simply isn't enough room in our current house for the monthly gatherings that are really important to us.

We're building the new house on the street behind us, close to my parents' home. Our three younger children will live there with us. One of our sons and his family will be moving into our old house, which is wonderful because all the love and memories we shared there over the past twenty years will still be in the family.

I used to think of grandmothers as gray-haired ladies in rocking chairs, but my own mother gave me a very different vision. I remember years ago walking out into the backyard where she was watching over our three oldest boys, who were about two, four, and six at the time. There she was, with her beautiful silver hair, playing leapfrog with them. She was actually leaping over them, and I thought, "This is what it means to be a grandmother?" She must have been close to fifty at the time. She's seventy-one now, and I have deeply appreciated her ongoing enthusiasm and her interest in and love for the children.

A grandmother has a very unique role. Instead of just "surviving" motherhood and getting the children out of the home so she can get involved in other things in life, she can reinvest her most important

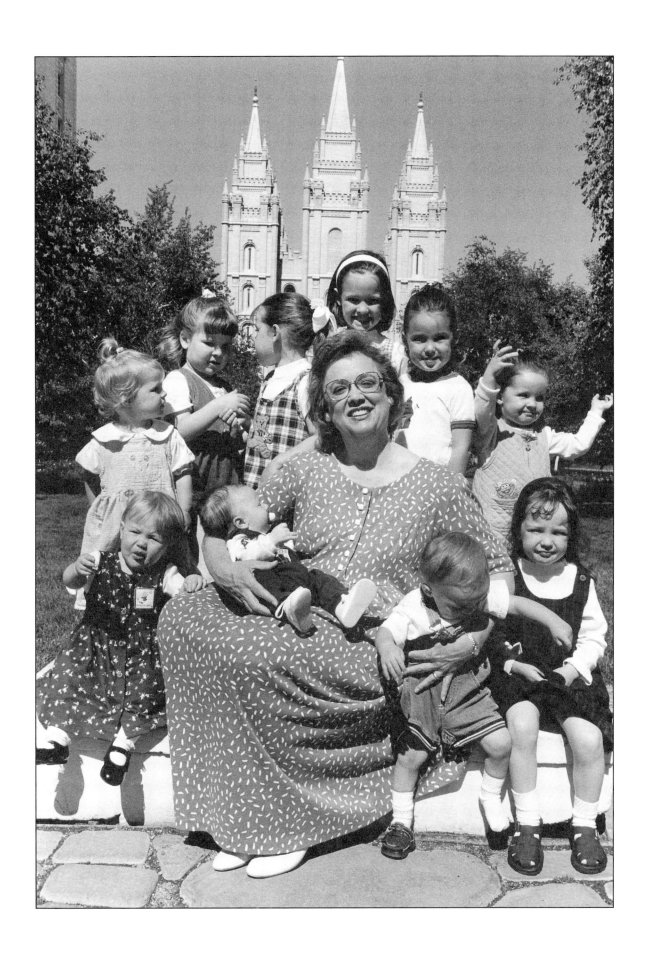

time and her greatest love into the family again. As Mormons we have a deep love of family and a firm belief that families are forever. We look at each other as more than just temporary parents or children but more as forever friends.

I think one of the most important things a grandmother can do is support and express confidence in the way the parents are raising their children. There is a lot that grandparents can do to let grandchildren know their parents are loved and respected.

I would never want our children or grandchildren to think grandkids can "get by" with things at Grandmom's house that aren't allowed at home. When I know our grandchildren will be staying with us, I try to get specific information from their parents about how they normally deal with them and then I support their approach. It works well because while styles of grandparenting may be individual and in flux, we all share fundamental values.

If discipline is necessary, I'll take the grandchild into my room, sit him or her down in a chair, and say, "I love you and I'm sorry you're upset. When you're through crying, just call me and we'll talk about this." There will be some crying for a while, and then I'll hear, "Grandma, Grandma!" I go back in, and we talk about the problem. I remember doing a lot of the same with my own children.

Families that married into ours bring their own strengths and qualities that complement our children's, so there is a wonderful blending of talents that makes every family within the larger extended family unique.

When our children and their spouses go on retreats once or twice a year to review their goals and enjoy a little time together, we often take care of the grandchildren. It gives us a great opportunity to know them on a really close basis. And it's good for married couples to come back into parenting renewed.

In our thirty-one years of marriage, Roger and I have found that such retreats have strengthened our relationship and helped us clarify our direction. In fact, it was on a recent retreat in Carmel, California, where Roger grew up, that we made the decision to build our new home rather than retire to a condo.

Roger and I first met in Texas, where I grew up and where he served a two-year mission for our church. That meeting was enough for us to recognize each other when we later met at Brigham Young University in Provo, Utah. As high school valedictorian, I received a four-year academic scholarship to BYU. Roger was there on a golf scholarship. Within a year we were married. I left school in my sophomore year to give birth to our first son, Adam, and had six more children over the next fifteen years.

It was at BYU, where Roger graduated with a degree in business management, that he met Stephen Covey and attended his lectures on organizational behavior. Later, Roger joined Covey's newly created leadership developmental organization. Since that time he has been heavily involved in leadership development consulting, and I've had the opportunity to help Stephen on his two *7 Habits* books, coauthor *First Things First* with Stephen and Roger, and help them on their latest book, *The Nature of Leadership.*

As a mother and a grandmother, I have learned that many "first things" are often on the spot, in the moment. I remember that while working against a deadline on *First Things First,* I got a telephone call that the wife of one of my sons was in labor. I had barely hung up when the phone rang again. It was another son who was helping me with some writing issues he wanted to discuss. "Forget it!" I said. "My mind's not on writing. This is grandmother time!" Then I went flying out the door to the hospital.

It is such a tender experience, such a precious moment, when new babies come into the world. And it's fun to take the siblings to the hospital where their moms let them sit on the bed and hold the new baby.

About two years ago we decided to build a nine-bedroom log cabin in the mountains about fifty miles away from our home and surrounded by natural forest. We wanted to provide a place where our children and grandchildren can really connect with their roots and the environment. We're just completing it now and decorating it with pictures of their ancestors.

Engraved on a granite slab above the fireplace is our family mission statement: "*To love each other . . . To help each other . . . To believe in each other . . . To wisely use our time, talents, and resources to bless others . . . To worship together . . . Forever.*"

Oddly enough, we see Legacy Lodge as a way of simplifying our lives. Among other things, it saves us the challenge of looking all over the place to find accommodations for twenty-six people for our annual family retreat!

I have always believed that life is more like a moving picture than a snapshot—we're always growing and changing. But while circumstances change, principles remain the same. Grandmothers can help preserve those principles. We can build bridges between generations. We can nurture faith in God. We can pass on time-honored values. We can tell family stories.

What is missing in families today is the time to gather around the fireside and just talk and share. I hope our grandchildren will always consider our home a place where they want to come, where they feel safe, and where they find love and happiness and a listening ear.

$\mathcal{S}arah$

B R A V E

Sarah Brave, eighty-eight, is an Oglala Lakota and a Grey Eagle, one of the elders of the tribe who give wisdom to the young people. At eighty-one she played a grandmother in the movie Thunder Heart. *Widowed for almost forty years, she has four daughters and nineteen grandchildren, ages sixteen to thirty-six. She lives on a reservation outside of Pine Ridge, South Dakota.*

\mathcal{O}n my eighty-second birthday my grandkids had a party for me, and I told all of them together, "Don't go along with friends who drink and do creepy things. Save your money in the bank so you have a future, can eat and dress up good, and never have to go begging around."

A lot of kids today don't mind their elders. My grandkids listen to me. I live alone, but I am not a helpless person. When I am calling around for them, they come. If I say, "Grandson, could you get me logs for the fire," he does. I make quilts and crochet pillows for them. I try to teach them how to have a good life.

I always listened to my parents, and I never answered them back. I was born to Frank Belt and Elizabeth Walks Out-Belt in Cedar Butte, South Dakota, on April 15, 1910. My sisters and brothers were all born in a bed. I was born in the grass by the White River. My mother went to get water there, and just as she lifted the bucket, her water broke and she fell. My mother told my brother, Jonas, who was only two and a half years old, to get Grandpa. It was a mile walk.

When they came, Grandpa put a mattress on a big wooden barrel and carried me on it back to his home. When Grandma asked Jonas what his little sister's name was, he said, "Sarah," a name he had heard in church.

We lived with Grandma and Grandpa Belt when Mom was having me so they could help her with my older brothers while Dad worked for the railroad. Grandma and Grandpa Walks Out and our great-

grandpa also lived near us. We all shared our food. Dad always helped everyone. He taught us that the Lakota way was "If you have plenty, always help the poor people."

We did not get rations like others on the reservation because Dad had his own cattle and horses. He taught us to hunt and fish. We ate rabbit, deer, and beaver. I remember when my grandparents ate, they always sat on the ground. They were accustomed to the old ways, which meant living in a tepee.

Dad also taught us to trap and trade fur. There was always a garden, and we raised a lot of squash, celery, turnips, and carrots. We also made *papa* [dried meat] and *pick cheyaka* [mint tea] and soap from the yucca plant. The young people today don't care to learn this. Dad had a cellar where we hung up chickens and other food to get us through the winter.

In school I was punished for talking Lakota. I only went to eighth grade, but I always wanted to learn more, so I would send for books. Mom died when I was sixteen, and I had to help my dad raise my two baby brothers. When I was seventeen, Dad had a job at a dude ranch breaking in horses and making holes in the ice for them to have water in the winter. He let me work there. It was a man's job, but I worked just as hard as the men.

On payday all my brothers and sisters and I would go with Dad, Grandma, and Grandpa by buckboard to another town where we would camp. From there we would board the train to shop for boxes of cracklings, and I'd help my younger sisters and brothers pick out their school clothes and shoes.

The summer of my sixteenth year, when I passed into womanhood, my grandma took me alone to a camp out on the prairie to show me how to do woman's work. We each pitched and stayed alone in our own tents. She brought moccasins for me to make and bead, and clothes and quilts to sew. Another grandma, designated by other elders, came the last day for *wahokunkiye* [giving words of wisdom] about what I must do as a woman. She bathed and dried me off and gave me a whole new set of clothes, and I disposed of what I had been wearing. The rite of passage was complete.

In 1931 I married Milton Brave. He saw me at a social gathering when I was nineteen years old. It is not our custom for a man to just walk up and start talking to a woman. A friend of his talked to a friend of mine who asked if I would agree to talk to him. I did, and he asked if he could talk to me at the next gathering. We talked several more times. Later on, after my father scrutinized him, as the males do with prospective husbands, we got married. I was twenty-one, and he was thirty-three.

He had been married before, and his wife and four children had died from pneumonia and

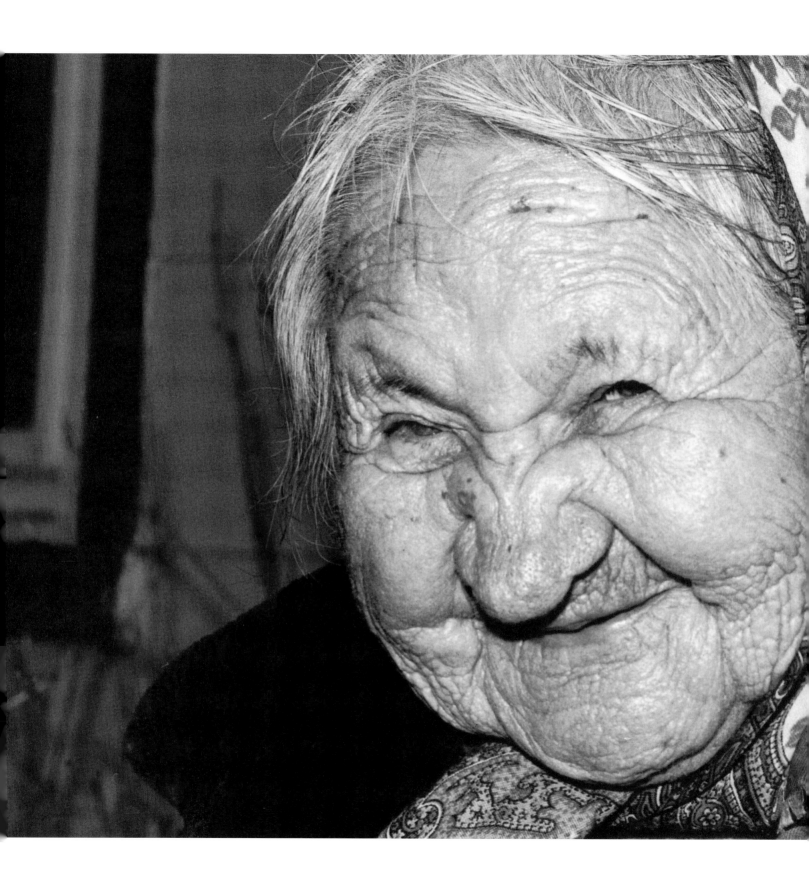

diphtheria. Between us we had cattle and horses, so we could earn our way. Three years before, I had received $500 in benefits as part of a treaty agreement, and I had invested it in cattle and horses.

We started at the house of his father's brother, Grandpa Moccasin Top, and then moved into a log house my father-in-law gave us. We had eight children but lost four. Three died young; two from pneumonia, one from polio. There was no hospital nearby to save them. The fourth died in 1955, in a car accident after serving in the Korean War.

Eventually we moved our log house forty miles away over very rugged roads to my land in Oglala below Cedar Butte. It took two days to haul the cedar logs, a few at a time. We camped all summer and fall at Cedar Butte on my father's land while we rebuilt our house. The day we finished, on November 19, 1945, I had a baby, Dora Ann. Two years later I had Susan, who died from pneumonia.

Milton was a member of the tribal council, the government of the Oglala Lakota tribe. In 1960, when he died, I still had my youngest daughter, Dora, at home. It was hard because there was no welfare. We had only cattle to trade, not money. With my gun I'd hunt for rabbits, prairie dogs, and deer. One time when me and Dora went for water to the dam, about a mile away, a duck was flying south all by itself. I shot it, but it fell into the middle of the water, and we had a hard time getting it out. I roasted it, and when I opened the roaster, we sure laughed. The duck was all skin and bones, but it sure tasted good.

After Dora went to the Holy Rosary Mission in Pine Ridge, I lived by myself. One time some coyote puppies came to the house, and I fed them and they stayed. I made moccasins for them to play in the snow. While I was there, I heard about this movie that was being made, *Thunder Heart,* with Val Kilmer. I studied the lines and tried out for the part of Maize Blue Legs, the grandma, and got it. I was eighty-one. I couldn't believe it.

Until I was eighty-six I worked with the Foster Grandparents Program on the reservation. We went to the Head Start programs and through oral histories taught the children old Lakota ways—the language, history, songs, and dances—and we made clothes and quilts from donated materials for people who needed them.

I had twenty-six grandchildren. Seven died from pneumonia, diarrhea, drowning, and things like that. I helped raise one of my grandsons, Walter, so his mother could go to a trade school in California.

I like to see places. Every year I go to the

Tekawitha Conference, which is held in different places, including Tennessee, Arizona, Washington, and Maine. I even saw the ocean that my dad told me about. He said it was a river where you couldn't see the other side.

My dad told us that nobody can ever "own" the land because the river and the water were our *towin* (aunts), the moon was our *unci* (grandmother), and the sun was our *tunkasila* (grandfather). This is how we are all related because we depend on all of them for life, the most sacred thing in the universe. When we use the water, the air, and the sage, we offer tobacco and prayers. It seems that the younger ones don't want to learn about the land anymore. The river runs dirty and the beavers are gone.

The government gave us land for our own, and I want my daughters to keep and never sell that so my *takojas* [grandchildren] will always have a place when there is no place else to go. And I don't want them to be fighting or arguing with one another. There is an old Indian saying, "Don't fight, you're not animals."

I always tell them to have respect and really, really listen to their elders. Just as my grandfather told me, I remind my grandchildren, who have seen the cowboys-and-Indians movies, that "not all the good guys wear white hats."

Virginia Lee

MORRISON

Virginia Lee Morrison, seventy-one, was born, grew up, married, and raised a family in her home, Green Leaves. Her father and her paternal grandmother were born there, too. Morrison is a member of the Pilgrimage Garden Club, which shows about 150,000 visitors around the historic homes of Natchez, Mississippi, including Green Leaves. Widowed, she lives with the oldest of her five children, George, his wife, and her eight-year-old grandson, Langdon, and his older brother, Wheeler, twenty-one, now in college. In all, Morrison has six grandchildren, ages one to twenty-four, and a one-year-old great-granddaughter.

A grandmother is the nicest thing to be. Every morning I drive my grandson, Langdon, to school. I love doing that. It's a great reason to get up in the morning. It's our special time, and we have these little talks if something is bothering him. I pick him up after school, too. Langdon is the sixth generation of our family to live at Green Leaves.

When I was growing up, I heard a lot about my great-grandmother from my father's cousin, Dacy. She adored and always talked about her granny, so from the time I was little, I knew that if I ever became a grandmother, I wanted to be called "Granny." I was named after my paternal grandmother, Virginia Lee, who died before I was born.

Born in April 1862, she was named in honor of Confederate Army General Robert E. Lee and the State of Virginia. My twenty-year-old granddaughter is also named Virginia Lee and is real proud of the name being in the family for five generations. She wants to be married at Green Leaves.

Tradition and historic preservation are very important to Natchez. Two times a year there are what we call Pilgrimages through the homes. Green Leaves has been on the tour since 1932 when the Pilgrimages began. My mother helped start it. In the spring we have our annual Confederate Ball, which depicts Natchez before 1860 and features a king and queen every year.

The families of my mother (Britton) and my father (Koontz) jointly owned the Britton and Koontz bank, which still exists. My father was a financier. My mother was a real beauty. We called her "Babe,"

except my brother, who used "Mother." But she was "Babe" to my children and all their friends, who were very fortunate to have known her.

She always wore beautiful clothes. She would get up and put on her girdle, her stockings, and her dress, and she would be all ready if someone said, "Let's have lunch" or "We're going to a ball." She wouldn't even get out of bed without putting on her little high-heel mules. Her shoes were dyed to match her chiffon dresses.

She never wore pants, which I do all the time except during Pilgrimage. Then I put on one of her hoopskirts—usually with my sneakers. I always thought I would grow up and be like her. But by the time I reached fifty, I realized I wouldn't, and I might as well not think about it.

I was young, about ten, when my father became too ill to work, and he began spending most of his time in our garden. I still have this wooden box filled with index cards where he listed the date and price of purchase of all the camellias he planted there—ninety-five different varieties, some of them six-inch cuttings.

My mother then went to work, running the Famous and Price department store. It was a property the bank owned. It had a hat department, which was a big thing then, bolts of material for clothes, and the only Elizabeth Arden cosmetics in Natchez.

I used to hate it when my mother went on buying trips, but at least I had my nurse, Crissie, who paid special attention to me as the baby, the youngest of three children in the family. Crissie had worked for my mother's family before my mother was born, and when my mother married in 1917, she came to Green Leaves with her. I adored Crissie, and I can still remember how it felt to go to sleep in her lap against her bosom.

I went to grade school across the street from Green Leaves, Natchez High School, and later Finch College in New York City. My mother wanted me there when she went up on buying trips. That was a whole lot of fun. I went to the wholesale markets with her and picked out the evening dress I wanted to wear to the Finch Ball.

I felt that my mother and Crissie, who did everything for me, really loved me. I don't think you can ever spoil anyone by loving them too much. So if I want to buy my grandson Langdon things he likes because I love him, I just don't worry about that. I've spoiled them all, the children and grandchildren.

When I was nineteen, my father died, and after two years at Finch, I didn't want to go to school anymore and decided to stay home and help my mother run the house. It was a pretty lonely time because all my friends had gone off to college at Ole Miss.

That year I met George Morrison, whose family was from New Orleans. He came to stay with his aunt at another historic house, Gloucester, and to help her run her farm outside of town

following her husband's death. In March 1947 his aunt brought him to Green Leaves during Pilgrimage, and he took a picture of me on the back gallery in my costume. We got to be very good friends. Later that year, on my twenty-first birthday, he brought me a dozen red roses. Two years later, in the fall of 1949, we got engaged, and in January 1950 we were married.

My brother and sister were both married and living in other places, so my mother insisted that we stay with her. Our five children grew up in Green Leaves. George raised soybeans and cattle on the farm his aunt left him and worked for the International Paper Company for thirty years. He died in 1993.

My mother died two years before, in 1991, within a year of Langdon's birth. A few years before, we formed this family corporation at Green Leaves. I am the one who has always lived here, and I take care of it now with the help of my brother and his grown son, who lives here and helps look after the grounds. My sister died, but her six children visit often and come to help at Pilgrimage. Both my sister's and her husband's funerals were held here, so Green Leaves is family headquarters.

My grandson and I love to do things together. He likes to go to the grocery store with me because he can always find something he wants, like a comic book, and I usually give in and get it for him. At Christmas when all the grandchildren are here, I get out the teddy bear tree I started when my youngest son, William, was one year old. I even have my mother's and her sister's teddy bears from 1905.

I save everything. I have a terrible time throwing things away. I've been working real hard to get everything documented and organized for the grandchildren. In every room there are family treasures. In the bookcases and cabinets are mementos of 150 years in this house: jewelry made of hair, pictures, guns, a collection of teacups and fans, hand-painted bird china, children's toys, and invitations to weddings at Green Leaves. There are two letters from Jefferson Davis, the president of the Confederacy.

I keep my father's 1892 christening dress in a cardboard box with the names and dates of every relative, including me, who has worn it since.

My grandson has quite a collection of his own—Batman comics and Teenie Beanie Bears. At night we play in my bedroom with this kitten we named Teenie Beanie. We throw little lightweight spongy balls into this basket for Teenie Beanie to chase and catch. There has always been a child at Green Leaves, which I guess is what has kept me a child at heart.

Jean
FROST

Jean Frost, seventy, is an environmentalist, adventurer, sportswoman, and world traveler. Retired as a history teacher and college counselor for high school students, she volunteers at an AIDS hospice, at the Portland Art Museum, and at one of her grandchildren's classes. Widowed, she has four children and six grandkids, ages one to seventeen. She lives on a houseboat in Portland, Oregon.

This past summer my grandson Mark and I were talking about his college choices, and he said he didn't know anything about colleges. So we spent two days visiting colleges in our area, talking to admissions reps, and touring the campuses. It seems like yesterday that Mark, who is seventeen and a senior in high school, was born. I still can't believe I'm a grandmother or I'll soon be seventy-one years old. I feel the same as I did as a kid when a grade school report card said, "Jean is a very intelligent girl, but she's got to stop whistling and slamming doors."

My older sister was the quiet one—the artist, the reader, the scholar. Today she is retired from an acclaimed career as an oncologist. I was the tomboy, the tree climber, the baseball player. That was and is me. I'm independent. I'm self-confident. I do what I want. And I still whistle.

One of the many things I share with my grandson Mark is an avid interest in sports. When he wanted to learn golf, I took him out to play his first nine holes. It was the last time I ever won a match with him!

I grew up as a preacher's kid in one of the poorer sections of Spokane, Washington. My father was a Lutheran minister, and we lived beside the church in a big Craftsman-style parsonage. We really only "lived" in the kitchen and playroom because the rest of the house had to be kept neat and ready for unexpected visits by church members. Since it was the Depression, we couldn't afford to heat the whole house anyway.

My parents were ultraconservative Republicans. Everyone I knew loved Franklin Roosevelt—except

them. My mother was clear about her distrust for anyone who wasn't white, Protestant, and Republican, meaning Catholics, Jews, and, as we called them then, "colored people." I wonder how she would cope with the fact that three of my grandchildren are racial minorities—two are Japanese, and one is half Native American.

I was in high school during World War II. My mother, a homemaker, went to work; coffee and gas were rationed; we saved tinfoil and hair for bombs, and learned to make soap. The war ended the year I graduated from high school, 1945.

I went to Mills College in California and later on to Syracuse University in upstate New York for my master's degree in history. My older sister was at Johns Hopkins Medical School in Baltimore. At Syracuse I became the house-mother to twenty-five freshmen in return for room, board, tuition, and a small stipend.

That year I met my future husband, Richard, who was working on a Ph.D. in political science at Syracuse's Maxwell School, and I married him twice. The Korean War was under way, and he was called up, so he left for an Air Force base in Idaho while I finished my master's degree. En route to Spokane to prepare for our wedding, I stopped off in Idaho to visit Richard. Not until I got off the train in Idaho did it hit me that I was to be with my future husband for three days in a

motel—unmarried! I was appalled and said, "We have to get married now!" So we were married, and I went home to plan my wedding. My parents never knew, and when I finally told my adult children about this lifelong secret, they only shrugged and laughed.

Instead of being sent to Korea, Richard was assigned to a NATO air base in France, and I joined him later. So we rented a large old run-down chateau in the tiny town of Jeu les Bois, where we were the only English-speaking people for miles around.

After three years in the service and the birth of our first child, a boy, in France, we returned to the States. Richard completed his Ph.D. and got his first teaching job at the Woodrow Wilson School at Princeton University. During our years there, our family grew to two sons and a daughter.

In 1961, Richard had the opportunity to become vice president of Reed College in Portland, Oregon. I settled into the life of a home-maker, becoming active in the PTA, the Scouts, the Little League, entertaining friends and Reed colleagues. Our fourth and last child, a girl, was born in Portland.

I have always been a hiker and lover of the outdoors, and I often went backpacking with friends in the Cascades and Olympics, some-times with all our children. Some of my fondest

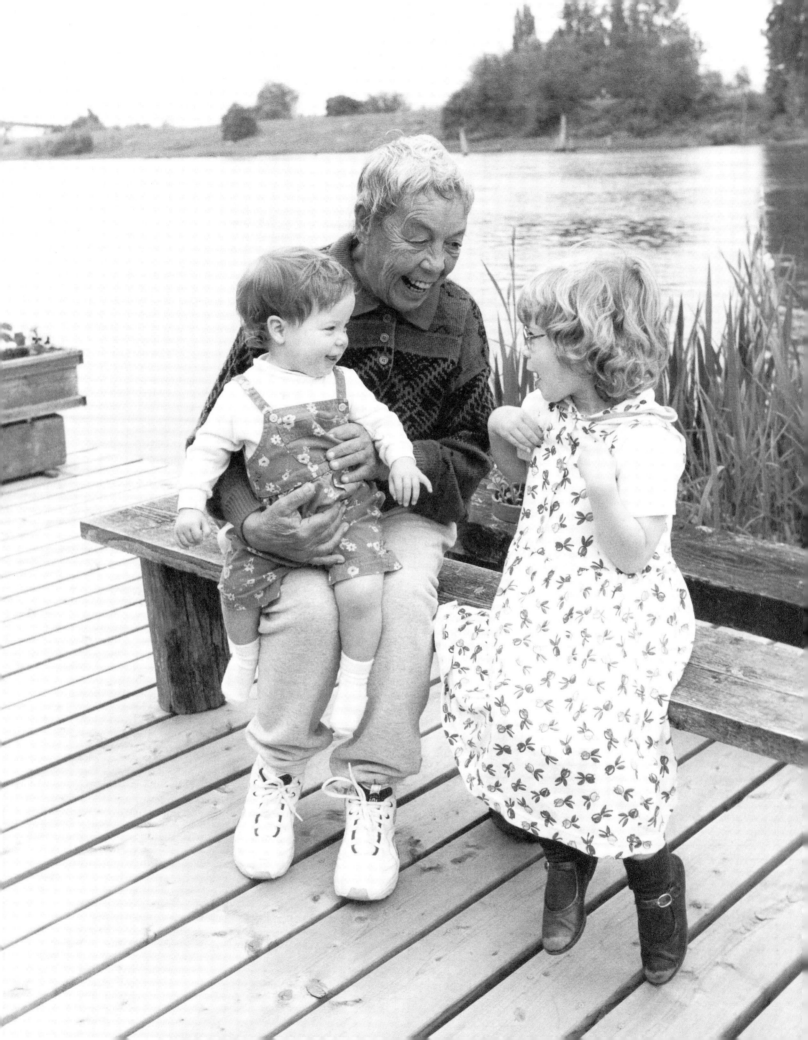

memories are of putting the kids to bed in tents while looking at Mount Hood and Mount St. Helens with their snow shining in the moonlight.

Over the years I have been active in environmental issues, including Beaches Forever, a ballot initiative to keep all the beaches along the Oregon coast open to the public and closed to developers. Last year we celebrated the thirtieth anniversary of the victorious Beaches Forever campaign. In the mid-seventies I was appointed to the State Water Policy Review Board by the governor. We traveled to all thirteen water drainage basins in the state to update their water programs and to try to protect the fishery resource and recreational uses.

My love of the outdoors endures to this day, and it is something I share with my grandchildren. I have taken my youngest granddaughters, Hallie, four, and Gwen, one, to pick strawberries in the spring and select Halloween pumpkins in a farm field in the fall. My granddaughter Delaney, who's half Native American—her father is a Zia tribal officer—loved to go boating with me when she was a toddler, and she has become a very competent rower.

In 1965, Sargent Shriver, then head of both the Peace Corps and Lyndon Johnson's War on Poverty, asked Richard to become the first national director of Upward Bound, a program to help bright but unmotivated and poor high schoolers to go to college. This program still exists on countless college campuses today. After three years we returned to Reed.

Richard died suddenly at the age of forty-five. Two of our children were in high school and the other two in grade school, and my role as a homemaker was radically altered. I had to be the provider. That meant going back to college to obtain an Oregon teaching credential, twenty years after I had earned one in New York. Until the estate could be settled, I had no cash flow. So I earned money by delivering telephone books and Sears Roebuck catalogs while attending college and getting home each afternoon to be with my children after school.

It was a traumatic time, but we got through it, and at age forty-five I started my professional career as a high school history teacher and counselor. I also found that I had some real savvy in financial matters. As I look back, I think I should have been an investment analyst or financial planner. When my grandson Mark had saved a lot of money from a job at a local supermarket, I helped him acquire a custodial account so he could buy some stock.

In 1983 I sold my "empty nest," a four-bedroom, two-bath house, and moved into my dream house, a modest seven-hundred-square-foot houseboat on the Willamette River. I gave all my china, silver, crystal, and furniture to my

children. It's such a relief not to be encumbered with possessions.

A family of beavers lives underneath my houseboat. Geese and ducks come by for bread. My deck is filled with flowers I planted. When the errant logs float down the river, I capture them with a line from a rowboat; the logs are winched up from the water, chainsawed into woodstove lengths, and chopped for winter fuel. My grandson Mark learned to run a small motor on the rowboat and was thrilled to get an old log from the river for firewood. His sister, Delaney, often stays with me at the houseboat when her mother has other things to do.

Delaney is good company because she is so open and friendly. She was a big hit in Japan, where my oldest son, Dan, teaches English to adults in his own school. I took Delaney and Mark and their mother with me to attend Dan's wedding last spring. He married a Japanese woman with two children, Makuyo, nine, and Chiharu, six. It was so refreshing to watch these four grandchildren learn to understand one another's cultures. I can't wait to share the rowboat with my two newly acquired grandchildren from Japan when they visit next summer.

I am happy in my houseboat, which fits into one of my little theories—that we ought to tax people on the square footage they occupy on this earth. The Native American philosophy is very persuasive. They have a reverence for nature and animals, for taking what is needed to survive. I'm a believer as well in their feeling of being one with the earth, that you can't really own the earth because it belongs to all of us.

I live very modestly, and if there ever were another Depression, I would survive with equanimity. I don't spend much money on anything except travel. I didn't start until my children finished undergraduate and graduate school, and I was in my late fifties. And I *do* travel! Just this year, for example, I trekked for three weeks in New Zealand and caught a twenty-four-inch trout in Lake Hawea and then spent ten days in Rarotonga in the Cook Islands. My most memorable adventure was a volunteer working trip to Belize through the Oceanic Society and Elderhostel. I spent ten days with twelve other participants doing research on bottle-nosed dolphins. I also snorkeled for the first time in my life. I have admired the temples and statues in Thailand and the ruins in Ephesus, Turkey.

Back home in my houseboat, I have a good bed, a reading chair, and a Vermont stove. I want my grandchildren to care for the earth and to live as gently as possible. I'm not concerned about their having a reverence for me. I'd like them to emulate me by living as fully as they can, which is what I'm trying to do. I just don't ever want them to be sucked up by the mundane.

Margaret

VARGAS

Puerto Rican–born Margaret Vargas, sixty-eight, a clothing designer and maker, created two costumes for Paul Simon's Broadway musical, The Capeman. *She has also made all the blouses for and did a voice-over in one of her filmmaker daughter Karen's movies. Twice divorced, Vargas is the mother of two grown daughters. She has three granddaughters, ages nine, eleven, and fourteen.*

I remember as a child in Puerto Rico that a woman my age was already in a rocking chair and usually a widow in a black dress for a whole year. Life just stopped for her once she was no longer creating babies. But life hasn't stopped for grandmothers today. We continue our lives through our children. We watch them have children and ask ourselves, "How can we contribute? What can we do to help our daughters bring up their children? In what ways can we help these children grow up and flourish?"

Really, there is no time to get old anymore; the grandchildren keep us young. My God, I kill myself dancing with my fourteen-year-old granddaughter, Alexandra, in her room. She likes rock, merengue, and salsa. "Grandma, you can't go home yet," she always says. "We gotta dance more." Chelsea (eleven) and I work on paintings. She will sketch a flowerpot, and I will paint it. We sign our work "Chelsea and Grandma." Ashley (nine) loves to play cards, and we show each other new games.

I find that I have to be more flexible, open-minded, and friendlier with my grandchildren so they can feel free to talk to me and ask all kinds of questions that I didn't dare ask my grandmother. They like to know about my childhood and their mothers', especially if my daughters had boyfriends when they were teenagers. Ashley has a crush on Hanson, the three brothers who sing, and Chelsea adores Leonardo DiCaprio from *Titanic*.

It would have been unthinkable for me to tell my grandmother about crushes on boys or, let's say, Frank Sinatra. When I was little, my grandmother only wanted to teach me how to be domestic, to sew,

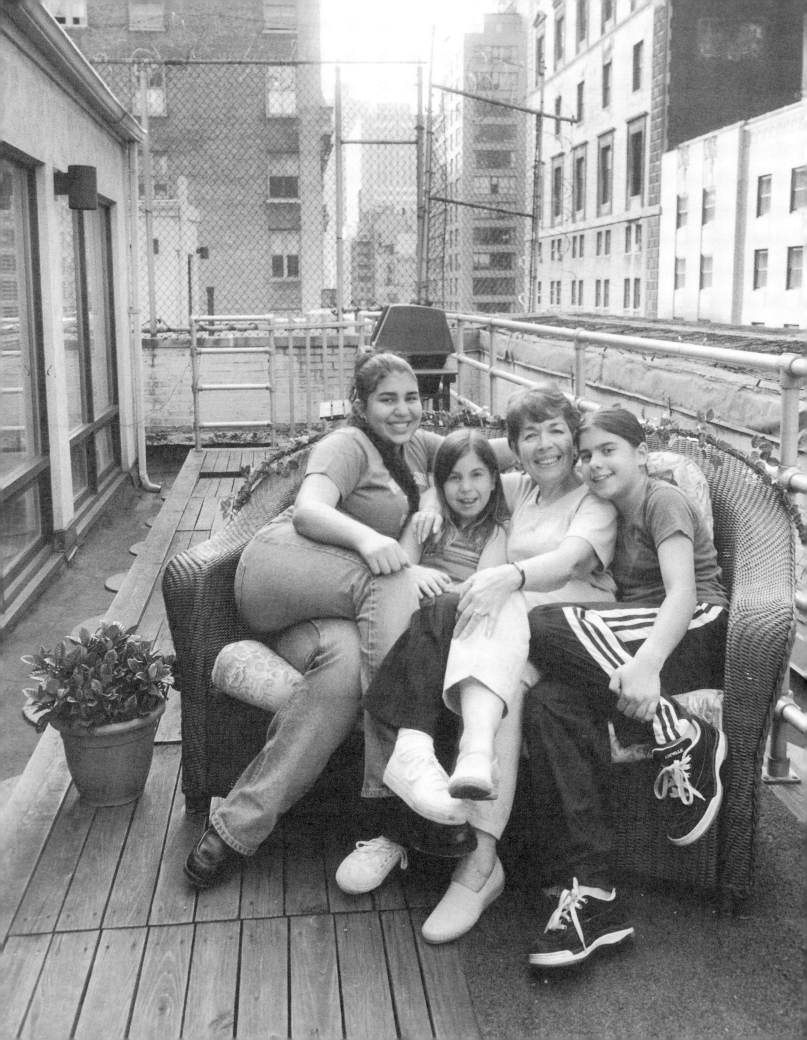

cook, and clean, so when I grew up I would fall in love and get married.

I don't want my grandchildren to ever think that's the only answer to life. Grandmas today—we're talking about education, which is the primary thing. I'm always telling my granddaughters they have so many professional choices and to make the most of them.

I stay over with my grandchildren one night a week. They all go to private Catholic schools, and the work is advanced. If I can, I help them with their homework, especially grammar and spelling.

I am the oldest of four children, born in Santurce, Puerto Rico. My mother was a homemaker, and my father was an electrician. My mother separated from my father, and at sixteen I moved with her and my sister to New York City. My brothers, who were younger, stayed with our father in Puerto Rico.

My mother worked in New York's garment district as a sewing machine operator, making lingerie and underwear. During high school I helped her after school because she didn't want me working on my own at that age. My maternal grandmother had taught both of us to sew, crochet, and make frilly edges on underwear.

After graduating from high school, I got a job with the accounting division of the American Express Company. In those days there were no computers, only a little adding machine. I was lucky that in Puerto Rico our teachers made us add everything mentally. We weren't even allowed to count with our fingers. I'm amazed they let my grandchildren bring calculators to math class.

It is really great watching my daughters be mothers. Discipline, I leave to them. When I give my grandchildren more leeway, my daughters make fun and say, "We don't understand. When we used to say or do the same thing, you'd scold us: 'Don't do this' or 'It's not nice.' Now you just laugh." Well, I'm looking from afar, and I can laugh.

I was married and divorced twice—the first time for nine years when I was twenty-one, the second time at thirty-four for thirteen years. Because I had to raise my two daughters I started my own clothing business, making dresses for larger-sized women, bridal gowns, money bags, and pink ring cushions for weddings, and evening bags. I can't work full-time anymore because I am on call for my mother, who is ninety. She is in ill health in a nursing home.

One of my proudest work achievements was making two dresses for a folkloric number in Paul Simon's Puerto Rican–based musical *The Capeman;* they had gigantic layers, with ruffles and ribbons that matched the cummerbunds. The actresses had to hold the dresses while they danced and shaked. When they came onstage, my daughter Karen said, "Look, Mommy, your dresses are on Broadway!" It felt so good.

I was planning to take my grandchildren to the show later on, but it closed. When they were younger, I taught them to make dresses for their dolls. I love and enjoy my grandchildren immensely. They're so bright and so intelligent and so much fun. I learn so much from them because they're not afraid to speak up, say who they are and what they feel.

I love to cook Spanish food for them—*arroz con pollo* and *tostónes*—all the things they like for me to make. They always say, "We're having a feast because Grandma's coming over tonight." My daughter Karen is married to an Irishman, so we celebrate Irish as well as Puerto Rican traditions. On Saint Patrick's Day I go with them to the parade, and all day we listen to Irish music. Christmas, I make Puerto Rican *pernil* [ham seasoned with garlic], and we dance and listen to Spanish music.

I have taken my oldest grandchild to Puerto Rico several times in the summer. She knows a lot of Spanish. My other two are studying French and Latin because there aren't enough kids in their schools who want to learn Spanish. I'd like all my grandchildren to speak Spanish. But whatever languages they master, I always tell them it can only be an advantage in their future careers.

I became a grandmother for the first time when I was fifty-four. This is the best thing that has ever happened to me. There is a continuity of life. My grandchildren have a certain look on their faces, a gesture, or a way of talking that brings back memories of my children when they were growing up.

My main objective in life is to show my grandchildren that I was somebody. I've made up a portfolio of my paintings and clothing designs for them. When I pass away, I want them to remember and say, "We learned this from Grandma" or "Grandma and I made this painting."

And I want them to always stay close to family because life has so many surprises, good and bad, and with the support of relatives, a person can overcome anything.

I worked for several years at a community center in a disadvantaged area, and I saw grandmothers caring for grandkids whose parents were drug addicts. These grandmothers were doing a great, great service. The proof is that the laws have been changed to reflect their contribution. Before, if a grandmother had sole custody of a grandchild, she couldn't get public assistance. Now she can.

I am very blessed. My daughters are doing a tremendous job with their children. But a working woman, even with a husband, cannot bring up children by herself today. She needs family support. She has to teach her children that there are other people to love and respect—like Grandma. Everyone should have one.

\mathcal{J} e a n
S C H U L Z

Jean Schulz, fifty-nine, is the board president of Canine Companions for Independence, a nonprofit organization that trains assistance dogs and matches them with individuals with disabilities—other than blindness— to give them more freedom and companionship in their lives. A hands-on philanthropist, Schulz has wide-ranging humanistic concerns. She founded Volunteer Wheels to transport elderly and disabled shut-ins and started youth endowment funds within the Community Foundation. Divorced from her first husband, she has been married for over twenty-five years to Charles "Sparky" Schulz, seventy-six, the creator of the "Peanuts" comic strip. She has two children from her first marriage and five grandchildren, ages five to thirteen. Jean and Sparky have eighteen grandchildren between them. The couple lives in Santa Rosa, California.

When you're a grandmother, you're at a point in life when, if you're ever going to take a larger view, now is the time, and that's what makes grandparenting different and more fun than parenting. Looking back, I feel as if I had a heavy, instructive way with my children, and I hovered over them. If they were feeding the dog, I'd explain how to mix the food. I feel so silly now that I didn't know better.

My father, who took a spiritual path when he was older, was always telling me when I'd worry about this or that with my kids, "It doesn't matter." I had a feeling I understood, but I'd rationalize to myself, "Yes, but you don't have to worry about whether they get into college or clean their rooms or do their homework" or whatever the current crisis involved.

What did matter was trust and love, and by imbuing your children with those feelings, they will get where they need to be in their lives. So now, instead of dwelling on some minor infraction or household upset with my grandchildren, such as a messy bedroom, I ignore it and find something positive to say to them: "Oh, I liked it when you said that" or "That must have made you feel good."

Some people may argue that because I don't have to live with my grandkids and their demands all day long, I can overlook their not cleaning up their room or other annoyances. In part, this is true. But I think it has more to do with being able to look at things within the scope of my life and know inside myself—

as opposed to just intellectually—that most things don't deserve the furor we tend to create over them.

I want to be a credible person, someone my grandchildren can safely come to when they can't talk to their parents, which happens a lot in families.

My parents were divorced when I was seven years old, but I never doubted that their initial love and respect for each other continued. I look back on this and feel it has been important to my sense of security. My parents were English. My father was divorced and twenty years older than my mother when they met in Paris, where she was studying at the Sorbonne.

I was the youngest of three children and the only girl. I was born in 1939 in Mannheim, Germany, where my parents ran the Berlitz School. When I was six months old, they were advised to leave and decided to go to the United States, settling in northern California. For a short while they ran the Berlitz School in San Francisco, and then they moved across the bridge to Mill Valley and bought a real estate business.

I had a wonderful childhood there, running around with my older brothers and friends and playing hide-and-seek in old burned-out redwood trees and sliding down the hillside in cardboard boxes. On Saturdays in the summer, when my parents worked, I'd just walk across town, probably a mile, to the valley and play all day at the homes of one friend or another. It was an innocent time in a small town. My parents didn't hover over my brothers and me. They had to work to earn a living and build a business. But we knew they loved and cared about us deeply.

I lived from the age of eight to sixteen, after my parents' divorce, in southern California with my mother and stepfather, who had decided to raise avocados. They knew nothing about

this. They were pioneers, learning as they went along. My stepfather, a Dutchman, farmed while my mother continued to work in real estate.

My parents tried many crops while they waited for the avocado trees to yield a profit. They raised turkeys, black-eyed peas, tomatoes, chickens—anything to make the farm pay for itself until the avocado trees matured. We had our own cow, which I begged to be allowed to milk, and raised calves, pigs, and sheep for our use and for sale. I had to help with everything, so to me going to school was fun.

I now realize that what I hated about that period of my life, having to work on the ranch and not being able to hang around the way my friends did, gave me many of the qualities I like about myself now. I learned so much the natural way, by experience. In that period I had my horse, and the many hours I spent riding all over the open hillsides provided a wonderful way to experience life.

During those years on the ranch I saw my father for two weeks a year in the summer, but we became much closer when I married after two years at Pomona College and moved to San Francisco, just fifteen miles from him.

My first husband was a newspaperman, first in San Francisco and later in Hawaii where we lived for three years. Our son, Brooke, was born in 1958, a year after we were married, and our daughter, Lisa, in Honolulu in 1960. I took uni-versity courses in Hawaii and California, and finished my B.A. in English in 1965.

In 1962 we moved to Santa Rosa, where my husband went into the real estate business with one of my brothers. I began seeing a great deal of my father and listening to his philosophy. After my parents divorced, he had become much more spiritually attuned, and when he retired, he devoted his life to thinking. In many ways my father was like a grandparent to me. I never remember him disciplining me, and his suggestions for my improvement were always delivered so gently.

I knew my maternal grandmother, who came over from England to live with us for a year and a half when I was about nine years old. Every afternoon I'd have tea and talk with her. The women in my family have always been strong and strong-minded. I remember once when my brother was mad at me and I ran into the bathroom and locked the door, my brother, a big fifteen-year-old, was charging at the door. My grandmother came to my defense with her riding crop.

When I was sixteen, I visited my grandmother in England. Pedal pushers were the rage then, and I had on a pair with yellow, black, and white zebra stripes. When I walked into the bedroom, she greeted me with "What are you wearing? Don't ever wear those pants in front of me or in England!" It just wasn't appropriate in her world. She was being her genuine self. Even

though she was stern, I remember that it was fun to be around her, and I loved the stories of her life before the war.

My mother was quite an adventurous woman. When she was fifty, she learned to fly, and my brothers and I followed her lead. She flew in more than twenty cross-country air races, and I sometimes was her copilot.

She was a very serious person, not the kind to pick up the children and hug them, but she cared very much. As her real estate business succeeded, she bought property in my children's names, so every time they get a check, I say, "Remember your grandmother. She cared a lot about you."

I try to be affectionate with my grandchildren. When Morgan, my first grandchild, was a little boy, he'd jump into my arms as soon as he saw me. It was so much fun. But I have to remember that they may not want the same hugs as they become more self-conscious—so now I often ask.

I love one-child experiences, or one of my grandkids with a friend of his or hers. It's so much fun to listen to two peers in the backseat of the car. When Morgan was eleven, I took him to Boston to show him some history. A friend of his and the boy's mother came along. It was a first for me, being alone for a week with one of my grandkids. My hope would be to do this with each one of them.

I go to a class in swinging trapeze with Morgan, and I ride a dirt bike with his eight-year-old brother, Nick. Both boys live in town, so sometimes they spend the night with me. But I'm afraid to tell them to go to bed. I'm not very good at discipline, and I hate doing it. It startles me to realize that under pressure I revert to behaving like a parent because I fool myself into thinking I've come so far from that. When I am with my grandkids, I don't like worrying about parental approval, but I guess it's part of the package.

I feel as though I have a good relationship with my husband Sparky's grandchildren. His fifteen-year-old grandson, Bryan, is a star volunteer at the Canine Companions for Independence headquarters in Santa Rosa. My grandson Nicky has also come down to help socialize the puppies. It is nice to have them be a part of the philanthropic activity closest to my heart.

A lot of being a grandparent is looking back and both thinking and feeling things from the past. My daughter's children are so like her— open and chatty and wanting to share everything that is on their minds. My ten-year-old granddaughter, Chelsea, often surprises me with a look that reminds me of myself at that age—it's uncanny. My older grandson looks so much like my son that I have to remind myself I'm Grandma.

I'm hoping that my grandchildren will learn to trust in themselves and also be able to look into themselves with some honesty. I think the two go hand in hand.

Jannie
COVERDALE

Jannie Coverdale, sixty, lost two of her two grandsons—Elijah, two, and Aaron, five, who lived with her—in the Oklahoma City bombing on April 19, 1995.

I never thought something so bad would happen to me that I would cry every day. I go to therapy once a week, and I have to take antidepressants and tranquilizers. For two and a half years I spent time in my mind at the bomb site. There was always April 19, 1995, and I was looking at the building that didn't exist anymore.

The last time I saw my grandsons was that Wednesday morning when I dropped them off at the day care center in the Federal Building on my way to work. About an hour and a half later I heard an explosion. At first I thought the computers in my office had blown up. Then someone said it was the Federal Building. From a window I could see smoke, the tower moving, and debris falling from it.

I ran outside to find my babies. I saw this woman running down the street with a little black boy who I thought was Aaron. I started running behind them, and when I got up close, I realized I had never seen that little boy before. It rained hard and cold all that week. I couldn't get into my apartment because the building, a half-block from the bomb site, was damaged. The Red Cross gave me vouchers for warm clothing.

My son Jeff's mother-in-law found me on Wednesday night at the church that had become a safe haven for families and took me home with her. Jeff arrived from out of town and searched all the hospitals for Aaron and Elijah. I thought I was dreaming the whole time. This couldn't be happening. Everyone I'd seen or asked said their babies were dead.

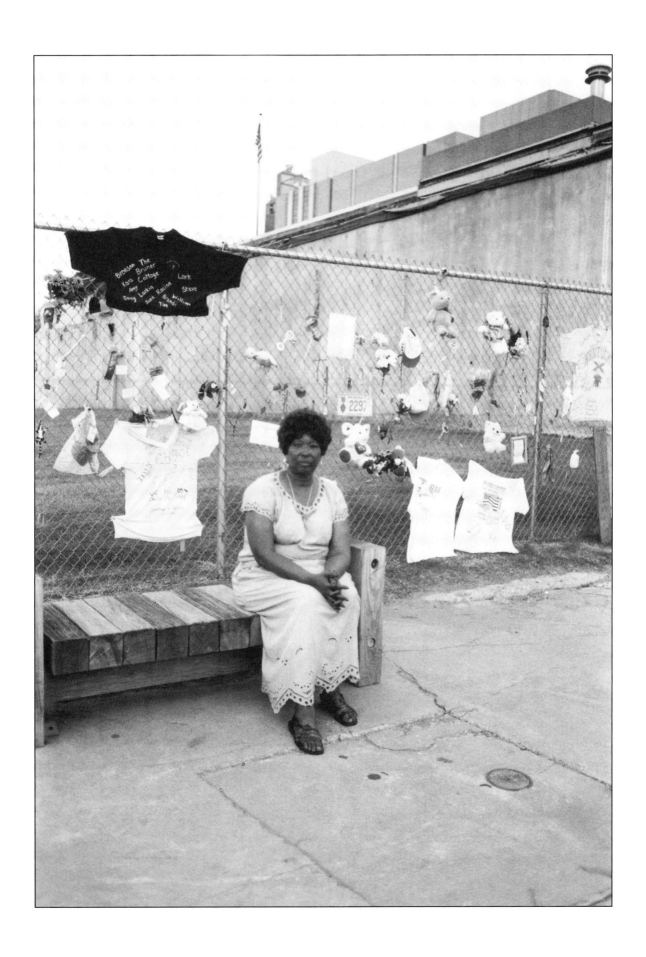

Late Saturday afternoon, as I sat with my four sons in the church, a woman asked us to come with her. I wouldn't go because I knew what she was going to tell us. My sons went to the funeral home that night. They wouldn't let me see my babies. Sometimes I think I should have gone in there. Maybe their condition wasn't as bad as my imagination tells me.

Some people say I have too much anger in me, but I feel that I have a right to be angry. I gave up a lot that day—I gave up my life because those two little boys *were* my life. Aaron and Elijah were everything I ever wanted.

Elijah was three months old when he came to live with me on December 25, 1992. He was the most beautiful baby I had ever seen. Aaron followed in March 1993. My son Keith had asked child welfare to give me custody of the boys because he and his wife were not good parents.

I was fifty-five at the time, and I thought, "Lord, what am I going to do with those two little boys?" But I never got too tired to play with them. I have four sons, and I don't think I ever loved them as much as I did my grandsons. Maybe it was because, as a grandmother, I was older and more settled.

At eighteen, right out of high school, I married a soldier who spoiled me pretty rotten. We lived overseas, saw half of this country, and met all types of people. After we were divorced, when I was thirty-four, I ended up raising my kids in the projects, which was damaging to them. But my second oldest son, Jeff, got straight A's in school and won an appointment to West Point.

I felt bonded to my grandsons. Although they had their own bedroom in my apartment, Elijah still crawled into my bed to sleep with me every night. As he got older, he became my shadow, following me everywhere I went in the apartment. One time when I had a headache, Elijah led me by the hand to the living room couch, climbed up on my lap, and kissed me all over my forehead. "Is it better, Granny?" he asked.

Aaron was my protector, always making sure I didn't forget to take my eyeglasses and keys with me in the morning. Every day he'd get up and make his bed. Of course, the sheet would be hanging on the floor. Afterward he'd try to make my king-sized bed, sitting in the middle of it and pulling up the sheets and smoothing them.

I taught both grandsons their prayers, and Aaron said them for everyone we knew. He sang in the church choir. I really believe those two little boys were angels. I feel as though God played a trick on me, giving them to me for such a short time, knowing I would fall in love with them.

I have nine living grandchildren, but it is painful for me to be with them because I am always reminded of the two who are missing. I would like to lecture on hate crimes, but I would fear for my grandchildren that some group might

try to hurt them. I am not worried about myself being threatened, but I would never put my grandchildren in harm's way.

All my life my mother told me that everybody had some good in them. But there I was, fifty-seven years of age, and looking at a man, Timothy McVeigh, who had nothing good, nothing at all, just pure evil. I attended both McVeigh's and Terry Nichols's trials.

There were others, I believe, who were involved in the bombing. For me there is no closure. Although I don't think the government did anything wrong intentionally, I will always wonder if it was negligent in preventing the bombing.

Americans have a short memory, and that's why I'm going to keep talking about Aaron and Elijah. There is a fence at the bomb site where I put up their pictures and some poems. A memorial is being built. I think there should be an eternal flame on a hill so that anyone entering or leaving Oklahoma City will see it and remember what happened here.

After the bombing I lived in a motel for six months. The first time I went back to my apartment, I heard the bomb in my mind and saw Elijah's head roll across the hallway. When I stood on the balcony, I faced the building that wasn't there. I couldn't bear to live there anymore, and I've moved in with my oldest son and his wife a few miles away.

Aaron and Elijah's father, Keith, thirty-six, divorced his wife and moved to Florida after the bombing. He is having a very hard time. I haven't worked since the bombing because I have a lot of memory loss from the trauma, so I would have to be retrained to return to my county government job or other work. I am thinking about becoming a child advocate.

I just try to get through one day at a time. I dream about Aaron and Elijah, and I wish I could reach into heaven and bring them back. Although I'm still having a hard time with God, I talk to my babies in my prayers. Some days I think about going and being with them, but I have to stay to find out what really happened that day.

Grandparents just don't bury their grandkids. It's supposed to be the other way around. Something went terribly wrong.

Sarah KNAUSS

At 117, Sarah Knauss is the oldest living person in the world. She lives in the Phoebe Ministries Nursing Home in Allentown, Pennsylvania. The mother of a ninety-four-year-old daughter, she has one grandson, Robert Butz, a seventy-two-year-old retired insurance company owner; three great-grandchildren; five great-great-grandchildren; and one great-great-great-grandson. Because Knauss has difficulty speaking, her grandson told what he remembers about her.

She was born on September 24, 1880, in the coal regions of Pennsylvania, in a little town called Hollywood, and later moved sixty miles to Bethlehem. Her father was a master stonemason of a zinc company.

Grandmother was a great storyteller. She told me that when she carried pails of beer to her father in the mines, she saw the fighting between the murderous, protesting Molly Maguires and the Pinkertons, hired as strikebreakers by the coal companies.

She married my grandfather when she was twenty-one, and they moved to Allentown. A tanner by trade, he became the circulation director of the local newspaper and then went into politics as the recorder of deeds for the county.

Grandma lived right across the street from the school I attended from first to ninth grade, so I spent a lot of time at her house. I used to go often for lunch, and she took care of my

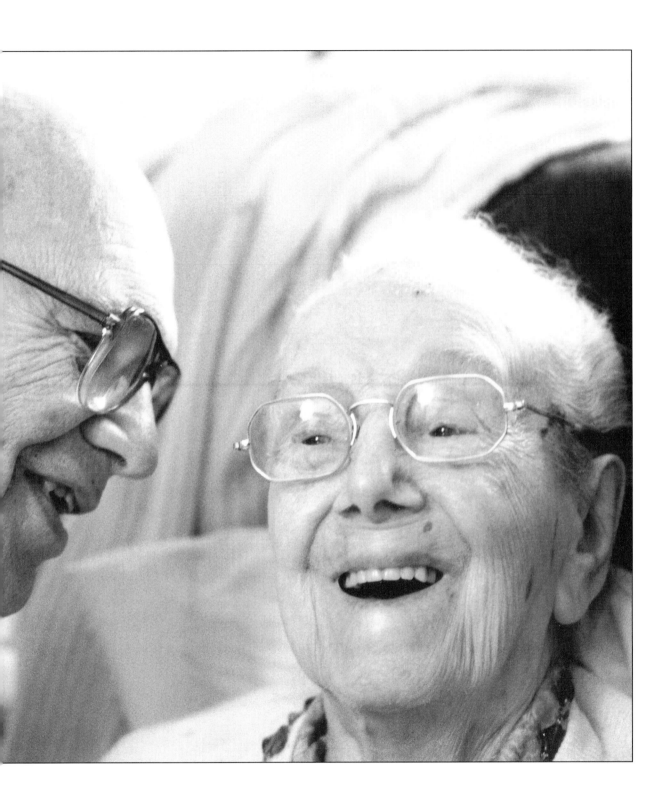

dog. She had a real working icebox, and on hot days I'd get myself a piece of ice and suck on it to stay cool. When I had supper at Grandma's house, I was allowed to eat while listening to the radio—which my parents didn't allow at home. This was one of the privileges of being with my grandmother.

Grandmother was always hospitable. She didn't do too badly at cooking. Her best recipe was Moravian cakes, the old-fashioned sugar cakes, and big German doughnuts with sprinkles. At holidays, Christmas and the like, we'd feast ourselves full and then fall asleep on the floor in her living room.

Her great joy in life was to make people in our family happy. Until about ten years ago she made all of my mother's clothes and some doll clothes for her great-granddaughters. She loved to make quilts and crochet tablecloths.

Grandmother liked beer, and up until ten years ago she had a shot of whiskey every afternoon at four o'clock. I think in her case it probably helped a lot as far as keeping her circulation going. Grandmother also loves chocolate. Recently, Nestlé sent her forty-eight pounds of chocolate to be given out to everyone in the nursing home.

She always did things in moderation, which I learned from her. She never smoked a cigarette. She had a mania for horses, but she never bet.

She just loved to watch how their legs moved. I took Grandmother to visit the racetrack and see the trotters and pacers once a year.

Grandmother never drove a car or traveled by airplane. She just never wanted to fly. She didn't get excited by all the new inventions of the century. She saw them as part of an evolutionary process. It was more like: So be it, we now have a telephone.

I can't say I remember her ever saying she had a doctor's appointment or annual checkup. She has never been hospitalized. Somehow she could handle any viruses; her body quickly built up immunity.

When my grandfather died at the age of eighty-six, she moved in with one of her great-grandchildren and baby-sat for her great-great-grandchildren. She was still baby-sitting for them when she was 100 and living with my mother. When Grandmother turned 109, she went into the nursing home. My mother, who is going to be 95 this year, lives on her own and still drives. She visits Grandmother about three times a week.

I think part of Grandmother's longevity is her strong genes, but I also believe the biggest factor has been her remarkable disposition—letting things be, not getting excited, being tranquil. The only complaint I've ever heard from her is that there are too many old people in the nursing home.

Beatrice "Bebe"

SHOPP WARING

Four months after she graduated from high school, eighteen-year-old Beatrice Bella "BeBe" Shopp from Hopkins, Minnesota, became the 1948 Miss America. Today, at sixty-eight, she lives in Rockport, Massachusetts, with her husband of forty-four years, Bayard Waring. She is a spokesperson in television commercials and print ads for Rascal electric scooters for the elderly and disabled. An avid cook and gardener, she has four daughters and nine grandchildren, ages one to fourteen. Under "Interests" on her résumé she states: "Whenever needed, caring for nine grandchildren."

My oldest granddaughter, fourteen-year-old Lindsey, always has a party the night of the Miss America pageant. The kids hang up banners, sing and dance, and do whatever else they see on television. They even wear crowns.

I have always believed that the idea of becoming Miss America gives young girls something to look up to. Boys could dream about basketball and baseball careers, so the pageant has always been a wonderful opportunity for a girl to set goals, accomplish them, and win scholarships.

I spent a great deal of my year as Miss America defending the concept of it. Over the years I have judged local and state pageants in twenty states. It is an awesome thing because you're changing someone's life. I always tell the girls that it isn't going to be the most important thing in their life, that it will be important if it leads to other opportunities.

Becoming Miss America changed my life and pointed me in another direction. Otherwise I might not have had the wonderful family, my children and grandchildren, who have given me such immense pleasure. Winning the pageant made this possible because it brought me to New York City where I met my husband.

Being chosen Miss America was a big shock to me, as well as the kids I grew up with. I was always talented in music, but I never thought I was pretty. I was the only child of the health education director of

a cereal company and a homemaker in Chicago. In my sophomore year of high school, we moved to the small suburban farming community of Hopkins, Minnesota, where the company transferred Daddy.

I was head of the band in my junior year, and in my senior year I won two state music awards as a classical vibraharp soloist. I never made basketball queen or cheerleader, nor did I have any acting training. In our senior class play, *Riding the Rails,* I sat on the stage in an old-fashioned hat and dress and accompanied the actors on piano. That was me.

The local photographer, who took our yearbook pictures and was a family friend, thought otherwise. On the Tuesday before I turned eighteen, the photographer and his wife and my parents sat me down to talk about my entering the pageant.

I felt that I was too young, and I told them that I wanted to find out who I was first and to go directly to college. But they pressured me into entering the pageant. Five days later I was chosen Miss Minnesota. Three weeks later I was headed for Atlantic City. My father, who had taught me to play the classical vibraharp, coached me, telling me to hold my head high and smile during pretty passages of the music. I chose Debussy's "Claire de Lune," which I had been playing on the piano since I was fifteen, and adapted it to the vibraharp.

Arriving in Atlantic City that September 1948, my only ambition was to place in the top ten to qualify for a college music scholarship. I was very discouraged after tying for second place in the preliminary talent contest. I had put all my cards into my talent, and I thought I was finished. Mommy came to my hotel room and gave me a pep talk. To my amazement I won the swimsuit and evening gown competitions the following evenings. On the last night, which included the talent finals, I got enough points to become Miss America.

I have no memory of the moment I was crowned. All I remember is walking onstage, hearing the applause, and calling out, "Oh, Daddy." I won a $5,000 scholarship to college and a $3,000 car, a Nash, that looked like an overturned tub.

I enrolled in the Manhattan School of Music in New York City, where I received a degree in percussion in 1952. During my third year in New York, some friends invited me out one evening, and we agreed to meet under the clock at the Biltmore Hotel. There I met my future husband, Bayard Waring. We started dating but didn't get married until three years later when I was twenty-four. A year later I gave birth to the first of our four daughters. I became a full-time wife and mother, just as I said I would when I answered a question at the Miss America pageant.

I love to cook, and I've catered all my daughters' weddings and large dinner parties. I also spend a lot of time gardening, growing herbs and flowers, and weeding in my sun hat and knee pads.

Our children and grandchildren spend their summers at our family compound in Rockport. The house my husband and I live in was built by his father, and the one next door, where my ninety-five-year-old mother lives, was our vacation spot for many years.

At fifty-four I became a grandmother for the first time, and I was thrilled. But I don't feel like one in the traditional way that people think of "grandmother." She's sort of like "Mama Santa Claus," kind of pudgy and in the kitchen with an apron on and her white hair pulled back in a bun. My mother, to me, is a more typical grandmother, very cuddly.

I insist on certain things. When the grandchildren come for Christmas and Easter dinners, I set a formal table, and they have to use good table manners. In the summer when we eat outside on the patio, I don't care. We have pool and shuffleboard tables in our basement for them. When they go downstairs and play, they have to show respect for the equipment and put everything back the way they found it.

If they think Grandma is too strict, it's okay because I feel they have to learn. And if they get it from me, fine. I also give them love, lots of hugs and kisses.

I think the changing times have affected the Miss America pageant, too. When I was in it, unless you had to work or were in a professional job, the ultimate goal was marriage and children. Today it's completely different. A career comes first, and women are marrying and having children later. So I like to think grandmothers are changing, too. I'm not sure a typical grandmother exists anymore.

One of the things I want my grandchildren to understand is that life is not perfect. If you have a disappointment or heartache or make a mistake, you pull yourself up by your bootstraps and go on. Some people use their failings and mistakes to self-destruct. I really believe that God wants us to go on and become better people.

There have been bumps along the way for me. Ten years ago I had melanoma, from which I have fully recovered. For seven years my husband, who was previously in the food services business, and I co-owned a restaurant. I was the hostess and played vibraharp and sang cabaret tunes during the cocktail hour. Then came the Arab oil crisis; the economy took a nosedive, and we had to learn fast what the bottom line means when you run a business. Finally making it successful, we sold it in 1979.

I had always wanted to be a missionary, and I decided to become a VISTA volunteer in 1989. I worked with kids who had drug problems and helped develop a puppet show, with white and black children talking to each other through songs.

I am also an Episcopal lay minister, which I trained for twenty-five years ago. On Sunday mornings I sing and play hymns on the piano at a nursing home. Every six weeks, when our minister can't do a service there, I distribute communion to the old and infirm.

I remain very active as a judge and supporter of the Miss America program. I never pushed any of my children to get involved with the pageant although it would have pleased me if they had entered. I am completely against child pageants, however, and I would never participate as a judge at any contest with girls under eighteen.

The greatest thrill for me every year is preliminary night, always a Thursday, at the Miss America pageant. They invite all of us to go onstage and walk the runway. I love it! When those lights from way up in the rafters hit you for those three minutes, you're it. I can still remember that feeling. It was just glowing. Next year I hope my oldest granddaughter, Lindsey, will be in the audience with me.

A couple of years ago I started giving away things because if something happens to me, I don't want my children and grandchildren having to go through everything and deciding what they want. I read over all the Miss America clippings that my mother so lovingly put together in an album fifty years ago. As I reviewed my life, I couldn't believe it was I who became Miss America. It was a strange sensation, seeing my life there and my life here and all that has happened. It is both storybook and period piece, and *here I still am*—just Bea—loving every minute of being a grandmother.

Sylvia
WOODS

Sylvia Woods, seventy-two, is the owner of Sylvia's restaurant, the home of soul food, in New York City's Harlem. With her husband of fifty-four years, Herbert, she started the business thirty-five years ago as a one-room luncheonette. Today her face is recognizable on cans of collard greens and barbecue sauce sold nationwide under the Sylvia's line of food products. She has four grown children; fifteen grandchildren, ages one to twenty-four; and two great-grandchildren. Most of the family work in the business, both in New York and Atlanta, Georgia, where another Sylvia's opened recently.

The restaurant has always been home to my children and grandchildren, a place where they visit and eat and watch me work, which I am always doing. Ten grandchildren, the older ones, now work here.

When they were little, I or someone else would fix their food, bring it to the table, and clean up afterward. However, once they were older, they had to help themselves. I'd tell them, "You don't see me sitting here and asking a waitress or any service person to bring me anything, not even coffee. So get up and get your own. The maid is off!"

I talk with my grandchildren a lot about my life because I want them to know my story. Sometimes I think that even with generations of hard workers in my family, a higher power had to have a hand in guiding us. I was born Sylvia Pressley on February 2, 1926, on a farm in Hemingway, South Carolina. Two weeks later my father died of complications from being gassed in World War I. His veterans benefits were not enough to live on, so my mother went to New York City to work in a laundry.

My grandmother cared for me. I was named Sylvia after her. My mother sent us money as often as she could. Grandma—I called her "Ma"—was a midwife. We lived in a four-room house with no electricity. As a child I walked three miles a day back and forth to an unpainted wooden schoolhouse. It went up to the eighth grade, with two grades in each room.

Working at the laundry, my mother saved enough money to build our first house. My mother and

grandmother taught me to cook on a woodstove. Everything I know about home economics I learned from them.

While I was growing up, my mother went back and forth to New York for periods of time to work in the laundry. When I was fourteen, she took me along and put me in a cosmetology school. Since there were no beauty salons back home, she figured I could open my own business, which I did at sixteen, out of our house. She was a very smart businesswoman, ahead of her time. Later on my mother became a midwife like my grandmother. They were said to be the best around.

I married my childhood sweetheart, Herbert Woods, in January 1944 when I was eighteen. Two years before, he had enlisted in the Navy, then segregated, and was sent to baking school. After our marriage he received shore duty. The next year we had the first of our four children.

In 1954 we arrived in New York City. Herbert worked as a cabdriver and I got factory jobs, first making hats and then cigarette lighters. I didn't enjoy these jobs. I wanted work where I could "reach out and touch" people. We lived in Harlem, and every day I'd pass this luncheonette four blocks away where they served pig's feet, lima beans, and pork chops.

One day I got up the nerve to walk in and ask for a job. The owner was black, from South Carolina, and had grown up on a farm, so when I told him I'd worked in a restaurant back home, he didn't believe me. Being familiar with the area, he knew there was no such establishment. I said I needed the job very badly. He told me to report to work at 7 A.M.

I arrived at 6 A.M., very nervous, because I didn't even know where to put a knife or fork. We always just put it all on one napkin. I had never eaten out in a restaurant. I watched the other waitresses and I learned. I ended up being the best waitress.

Seven years later, when the owner wanted to sell, he suggested I buy it.

Reluctantly, I asked my mother to mortgage the farm to lend me the money for a down payment. She did. My husband and I didn't take a salary for a whole year. It went toward our monthly payments. We depended solely on tips, both from the restaurant and my husband's driving a taxicab, which he continued to do. We opened for business in August 1962. Although we still owed $1,800 to the owner, he turned over the keys to us, saying, "You'll make it."

My husband and I did all the shopping, cooking, and serving. The restaurant had only a counter, eight stools, and four booths. Today, Sylvia's occupies an entire city block in Harlem.

Now that I'm seventy-two, I've reduced my hours, getting in at around noon, instead of eight in the morning, and leaving around ten at night. For years my husband and I started at 5 A.M., buying the food, and finished at midnight. I've always worn a white doctor's coat and nurse's shoes to the restaurant, which I think comes from my mother and grandmother having been midwives. Every year before my birthday I tell my grandchildren, "I need your help because I'm going to hang up my coat, put on street shoes, sit down, and mingle more with my customers."

They love working in a restaurant that is a family business. I remember that my son Kenneth, who is forty-five, was resistant years ago to come in with us because he said he was a manager in a shoe store in South Carolina. So one day I asked him, "How much are they paying you?" and when he told me, I said, "That's not managing pay. All you have is some dumb title." He left the shoe store and has been at Sylvia's since then. That was over twenty years ago.

In a family business I do think it is important that the children and grandchildren work at outside jobs because if they don't, they'll always be thinking the grass is greener. It usually takes them about a month before they realize it isn't.

Although I have not yet hung up my white coat, I am glad that I have the time to give my grandchildren, especially the younger ones, the attention my own children might have missed. We laugh and talk and hug and kiss. When my kids were small, their father and I were so busy just trying to make a living.

I wish for my grandchildren that they think like me, pray like me, love like me, do not take anything for granted, and always be the best they can be.

Every Christmas and again in the summer we all go to the family farm in South Carolina. We can still feel the spirit of my mother and grandmother and God piloting us in this amazing life we share. I tell my grandchildren the same thing my grandmother and mother always said: "Give *out* but don't give up because God is the wind beneath your wings."

Barbara

MARTELL

Barbara Martell, fifty-five, has two grown children and two grandchildren, Brianna, ten, and Trevor, six. She and her husband of thirty-one years, Fred, who is retired, live in Aspen, Colorado.

My granddaughter, Brianna, wrote a composition about me for Grandparents' Day at her school: "I love her so much. My grandma is a grandma on the outside and just a kid at heart. She is so much fun to be around."

Why not? Is there anything better than just enjoying my grandchildren and having fun with them? Grandparents today don't get old. Our grandparents were born old. When I was a child, visiting my grandmother was more like an obligation.

At forty-five, my husband, Fred, and I became grandparents for the first time. When he said he didn't know how to be one, I told him, "What's there to be? Just do what you would want done for you."

We ski, play tennis, golf, and horseback ride with our grandchildren when they visit us in Aspen. And I like to try new things with them such as snowboarding—even if we end up on our tushies half the time. In New York City, where we take them to the circus and the theater, they stay with us in our hotel suite.

When we met and married in 1967, Fred was an independent animation photographer who helped design the NBC-TV peacock logo for their first show in color. He was thirty-one, and I was twenty-four. A few years later, at my father's urging, he joined my family's real estate development company in New York and Florida.

Marrying Fred was a great gift because I couldn't have children and he had a four-year-old, Piper,

from a previous marriage. His ex-wife later died in an auto accident. When Piper was six, I formally adopted her. Two years later Fred and I adopted a baby son, Kevin.

Whenever I tell my grandchildren that Piper had another mother, they look at me as if I'm crazy. Piper has always refused to think of me as her adoptive mother. I think you're either born with a mother's instinct, with the love and tenderness for a child, or you're not. Because my daughter loves me so much, whatever I do with her children, my grandchildren, is perfect in her eyes.

I give my grandchildren a lot of love, and I tell them, "Your mommy and daddy aren't allowed to spoil you like I do because they have to live with you and I can go home."

Piper is divorced. My grandchildren feel that they can talk to me, but I tell them, "Grandma can't pick sides. Daddy's your daddy." I hope that, just like their grandparents, they will be lucky enough to marry a friend they can love the rest of their life.

I try to give my grandchildren a little tradition and instruction: Eat with a fork behind your knife; don't curse; be polite and respect others.

They call me "Gram" or "Grandma," and if those don't work, we get to "Barbara."

Really, they're just so much fun to be around.

Barbara and Fred Martell's daughter, Piper, died in an automobile accident on August 4, 1998, in Maine. She was thirty-six years old. Piper was on her way to visit her daughter, Brianna, at summer camp there.

This photograph of my grandchildren and me was taken the last time Piper brought them out to Aspen. Piper felt it was a lovely thing for the grandchildren and me to be in the book. She went out of her way to show up for the scheduled photo shoot. It meant taking the children out of school for a day to travel from New York for an extended weekend. Piper herself missed a few classes—she was in her first year of law school. It wasn't even her weekend with the children; it was her ex-husband's. She figured a way. That was the kind of daughter she was, loving and considerate, glad for me to be "immortalized" as a grandmother. So the photograph is especially meaningful to me due to the tragedy of losing my beloved Piper.

Sa thi

NGUYEN

Sa thi Nguyen, eighty-seven, came to America with her family in 1975, after the Communists overran South Vietnam. A widow, she has six children, thirty-six grandchildren (ages ten to forty-five), and thirty great-grandchildren. Nguyen lives in the Texas gulf coast city of Rockport with one of her sons. Because she speaks only Vietnamese, her twenty-four-year-old grandson, Hung "Tommy" Nguyen, translated her words.

I have been blind since I was thirty-four from an accident. I have never seen my grandchildren. I've just touched them, carrying them when they were babies and feeling their arms when they were older to see how strong they are. I have thirty-six grandchildren. One of my grandsons, Dat, plays football at college. He is an all-American linebacker. I am happy for this because he is representing the Vietnamese people in the United States.

When the Communists invaded South Vietnam, we fled in a wooden boat that carried about thirty people. A U.S. Navy ship eventually took us to America and to freedom. None of my immediate family fought in the Vietnam War, but some distant relatives were executed by the Vietcong. I never think about going back to Vietnam. Why would I? I can't even walk to my door. And there are no more relatives left there.

We first stayed in Guam for a few months until sponsors could be found for my family. We all lived in a big tent on a U.S. Army base. They treated us very nicely. Our first move was to Michigan. I was sixty-five, and my husband, a former shrimper, was seventy-three, so there was no opportunity for work. We applied for and got SSI. Our sons did factory work there, in New Orleans and Fort Worth, Texas, before settling in Rockport.

The place where we had lived in Vietnam, on the outskirts of Saigon, was called "Rock of the Port," so we felt at home here. With money saved from factory work, one of my sons bought a shrimp boat, and

he worked very hard. Today our family owns a Vietnamese restaurant, crab plant, and marine supplies store.

I always tell my family, "You have worked very hard to make a success. Don't stop now. Keep going." They still get up at 4 A.M. three times a week to go to the crab plant.

My husband died eight years ago, and I am living with one of my sons. I am Catholic, and every day my daughter-in-law takes me to church. The mass is said in Vietnamese. I have never learned English, but all my grandchildren speak Vietnamese in addition to English. If you lose the language, you lose the culture. The whole family goes to Sunday mass, and afterward we have lunch at the church.

Being blind, I have never seen America, but I am glad for the freedom my grandchildren have to get an education, work, and have their rights. I talk to them about morals and values and how they should discipline their children. I tell them not to yell but to speak sweetly and softly. I wish for them good health and that they finish school and are successful in whatever they try to do. When I touch my grandchildren, I feel their goodness and strength, and I am proud.

\mathcal{B} r e n d a

L E E

Brenda Lee, fifty-three, dominated the record charts in the sixties, surviving the British Invasion, and has had more hits in more categories—pop, rock, easy listening, country, and R&B—than any other female in the history of the business. Recently she wrote her first published song, "The Kind of Fool Love Makes," with Michael McDonald from the Doobie Brothers. She is the mother of two daughters and has two granddaughters, Taylor, nine, and Jordan, one, born on the same day eight years apart. Lee and her husband, Ronnie Shacklett, live in Nashville, Tennessee, where she is active in many charitable causes and is always available to sing at Taylor's school.

\mathcal{M}y granddaughter Taylor and I sing a lot of gospel and hum other stuff together. She's a fine pianist, and she's been studying classical music for the last four years. And my grandbaby, Jordan, is already starting to move with the music. It's really kind of fun, doing what I do, to see them enjoy music. Taylor has perfect pitch, but I don't know that she will ever become a singer. But she can really do it if she wants.

I wouldn't be unhappy if she did. Of course, the music business has been an emotional roller coaster ride. But I don't care what business it is, nothing is easy. You have to work hard. And nothing's ever for sure or forever. You're the darling one day, and nobody knows you the next. You have to be able to handle it mentally, and you can if you really love what you do.

I do. Singing has always been my best friend. I never stopped and thought, "Why am I doing this?" I've just always been singing, even humming as a baby. I grew up the middle of three children in Lithonia, Georgia, about twenty miles outside Atlanta. My father was a carpenter and my mother a homemaker. He died in a construction accident when I was eight years old, and she went to work in a cotton mill before remarrying a few years after. The first song I ever learned was "My Daddy Is Only a Picture." My grandparents died when I was very young.

By the time I was five, I was singing in the church choir, and that year I won first prize in a grade school singing competition in the county. It led to my singing on a local Atlanta radio station, for which I

was rewarded with all the ice cream I could eat from the show's sponsor. I sang "Too Young." Next I got a spot on a local television show, which in turn landed me my first professional booking. I sang at a Shriner's Club luncheon and was paid $20.

My first break came when country legend Red Foley heard about me while performing in the area and invited me on his popular ABC-TV show *Ozark Jubilee,* where I sang "Jambalaya." I was twelve. I became a regular from 1956 to 1959 and appeared later on *The Perry Como Show,* a Bob Hope special, and other national programs.

In May 1956 I recorded my first song, "Jambalaya," on Decca Records in Nashville where we moved that year. It was followed by "Sweet Nothin's" in 1959, which reached number four on the Billboard chart within a year. Then came my number one hit, "I'm Sorry," in 1960. I think it was the first pop hit out of here.

I was fifteen, and I bought my mom a car and her first house. Before she saw it, I had it decorated top to bottom. It was such a grand feeling to be able to do this for her. She went everywhere with me. Until then money was always scarce, so I never had music lessons and don't know how to read notes. I was so immersed in my singing that I never thought of playing a musical instrument, although now I wish I had learned to play the piano. I have really small hands, and I could never reach an octave anyhow. But I'm a real quick study—I can hear a song once or twice and know it.

I feel that I had a great childhood. I was very loved, and my mom taught me morals, integrity, and honesty—a lot of really wonderful traits that are missing today—and how to get discipline, to be strong, and to survive. Taylor wears little eyeglasses and had braces on her teeth up until a year ago. She said some of the boys in her school made fun of her, and I told her, "Well, you're a unique little girl, your own little self, which you need to treat special."

I met my husband, Ronnie Shacklett, at a Jackie Wilson show in Nashville when I was seventeen; he was six months older. I saw him across the room and thought he was a nice-looking guy and that I'd like to meet him. So I had a girlfriend give him a note saying "Would you call me?" and my telephone number. He wasn't keen on music, but he said he knew who I was. His family was in the building business and politics; his brother was a state senator and his dad a city father.

We went out in October 1962, and we were married in April 1963. When I was nineteen, I had our first child, Julie, and at twenty-five our second, Jolie. While they were growing up, I was performing all over the world, but they had roots and knew I wasn't gone because I wanted to be but because of my job. My manager's

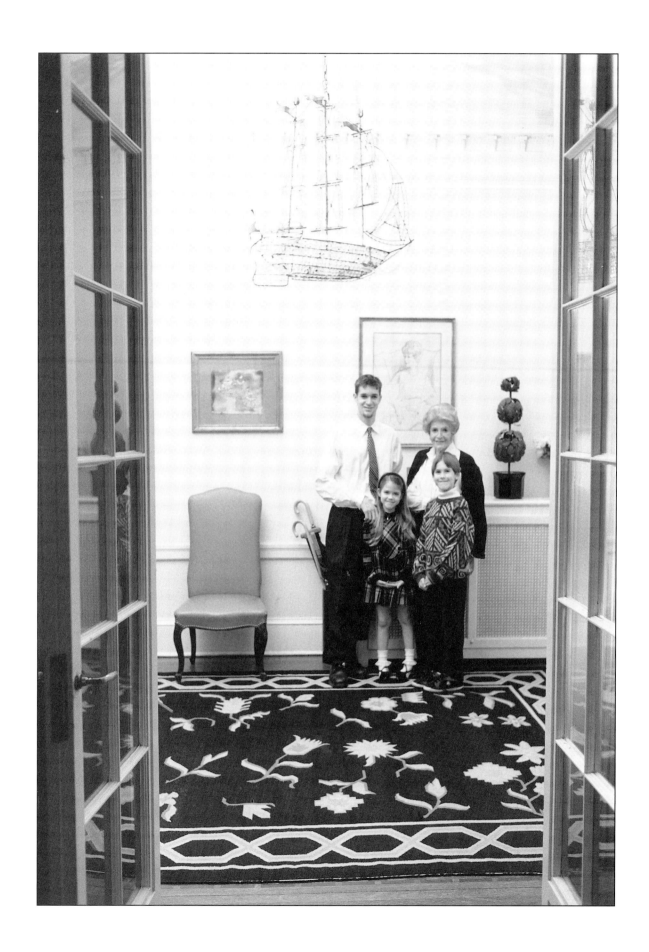

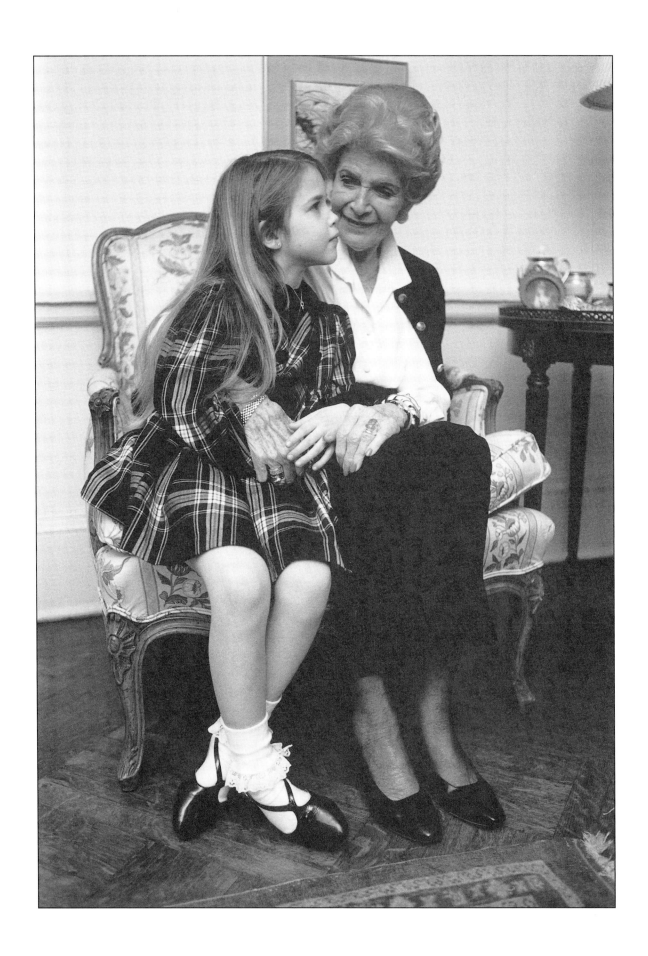

good care of my three young children. Eventually, my husband and I drifted apart.

After four years I decided to try something new. With a very small sum of money, I opened "The Golden Egg," a gift art and collectibles shop in Georgetown, which became quite a success. I did this for four years before deciding to go back into real estate, which turned out to be the right thing for me. I opened my own firm and worked pretty hard, but with enthusiasm, and all the while trying not to neglect my children or my social life, which was also necessary for business.

In my free time I would be with the children or read. I do read a great deal, and my taste is very eclectic. I prefer to read books in the original language, whether it is French, English, or German. I read extensively about children's upbringing. For me, the new way of "laissez aller," meaning, loosely, "don't break their spirit," is flawed.

I still believe in directing children's behavior, imposing order in their daily life, studies, and appearance. I don't think that the schools are doing a particularly good job of guiding children today. Character, which is something different, will form more or less naturally on its own. However, behavior, as we know, can be learned.

I raised one of my grandboys from the age of two until he was twelve. That was a great plea-sure. His father, my oldest son, had remarried and had two more children. It was just a difficult situation for my grandboy. But at twelve he went back to live with his father for four years and then went away to college. I wish he had stayed longer with me, but he is doing very well now, working and getting his master's degree. The youngest of my seven grandchildren is my grand-girl—at last a girl!—and she is adorable.

I retired in 1991, and it has been wonderful since then. I returned my realtor's license, thinking, "Forty years is quite enough!" Now I can go to the country and see friends and family without having a bad conscience about neglecting my duty. But alas, I have to do my own desk work, which is very tiresome for me. I always had a secretary; I just am not a desk person. I travel a great deal and am going to a wedding in Peru, in Machu Picchu, this winter, and I always go to Europe in the summer.

I enjoy very much the company of my grandboys and grandgirl. I like to help them by giving them whatever I can from my own experience and from what one finds in life. The most important things in life: honesty, goodness, and intelligence. That's it. The rest will follow automatically. These are the things I want, above all, for my grandboys and grandgirl to have in their lives.

Christine
BRADFORD

Homemaker and farmer Christine Bradford, eighty-eight, is the matriarch of a tobacco farming family in Cynthiana, Kentucky, the heart of bluegrass country. She still raises her own cattle, rakes her hay, mows her own one-acre lawn, and helps her family raise their tobacco crop. In 1997, Bradford was awarded the Top Farm Hand prize by the University of Kentucky Agricultural Extension Service and the Harrison County Beef Cattle Association. She was the only woman to ever win—or even to be nominated for—this honor. Widowed after a fifty-eight-year marriage to L. T. Bradford, she has five grown children; sixteen grandchildren, ages twenty to forty-nine; thirty-two great-grandchildren; and three great-great-grandchildren.

I was raised on the farm, and it just came natural. Whatever was to be done, I just did it. My great-granddaddy, granddaddy, and daddy all raised tobacco. It was the only way to make your living. My two sons and two of my daughters are tobacco farmers; nine of the grandchildren work in tobacco. Several of the great-grandchildren want to farm: Jacob, who is seventeen now, has had his own crop for several years, and next season, Nick, nineteen, will raise his first twelve acres.

Tobacco has always been the mainstay for farmers at this end of the county. To us folks it is not just a way to make a living, it's a way of life. It takes lots of hands to put in a crop. Up until recent years the hands were nearly always family. Working tobacco keeps a family close.

I grew up about forty-five miles from here. I learned about tobacco farming because my parents would take me and

my older brother, Emmett, when we were still small, to the stripping room in the barn. We'd play on the bench, and then we'd decide to pull some leaves off the stalk. Of course, we'd mix the leaves up and have it all messy-like, but Daddy would say we stripped real good and we'd feel proud. And eventually we did get it right.

I drove a buggy horse to grade school. Her name was Daisy, and she was real pretty, auburn and with a white face. The menfolks built us a barn at the school, and each one of us had a stall for our horse.

I married L.T., my husband, when I was sixteen and he was twenty-one. He came from here; his family was tobacco farmers. We started with forty acres of land up near Sunrise, thirteen miles away, and then in 1944 we bought this land where I live.

You start with a little land, and when you get enough money, you get a little bigger farm that is more level. We sheared sheep for lambs' wool to earn money to pay taxes back then. Today I have 457 acres. Between my children and grandchildren the Bradfords have about 3,000 acres. All live within thirty miles of me except my granddaughter, Pattie, who is a court stenographer in Connecticut. Her children come back home every summer so they can learn to drive tractors and do other chores.

I'm very proud of my family, and it's handy because everybody is so close. You can share machinery and help each other out quite a bit.

I was a farm wife. I had six children. My first child, Betty, was born when I was seventeen; her sister Georgia was born when L.T. was in the barn milking. We lost our fourth child when he was fourteen months old from diphtheria because they didn't know about penicillin that could have saved him.

I canned beets, peas, corn, apples—anything that came out of the garden. I still do. I cooked and baked for the family and the hands and did the washing and sewed their clothes. For sixty years I raised chickens, about 125, in the brooder house at the start of each year. I always liked caring for the baby animals. If a cow has two calves, she'll likely ignore one of them, so I'd feed that one for her. I reckon I've bottle-fed orphaned cows for eighty-three years now.

I never did milk the cows, but I did carry the milk to the house, strain it, and put it in the tub with ice water to get it cooled down because we didn't have a refrigerator. I made cream and butter. It was somewhere around '44 when we first got electric and running water in the house.

L.T. died in 1984. I was seventy-four then. My children and grandchildren asked what I wanted to do. I didn't think I could sit in the house and look at the four walls all day, so I decided I'd just help run the farm myself. So I told my family, "I want to live right here by myself

and work, and you can all help me out when I need you. I'll give you a ring if I do." If I get blue or something now, I can go out and talk to the cattle, and they come to me and let me know they're happy. I don't even have to get out of my truck. They just come running to me.

The year L.T. died brought many changes. I took my first vacation in my life after I broke my arm from falling off a lawn mower. I went to Myrtle Beach, South Carolina, with one of my daughters. Since then I visit Florida for two weeks every winter. There is a lot of ocean—it's real pretty and all, but I only need enough water to fill the bathtub. I gave up teaching Sunday school because, with the broken arm, I couldn't carry the little ones.

There is always something to tend to on the farm. The great-grandchildren look forward to my "rodeo" twice a year when we inoculate and spray and give the cattle their annual checkups. The little ones started calling this work the "rodeo" because they love to play cowboys, and they get their outfits on because they see that on television.

Last spring we ran 123 cows through the chutes. My grandson, Troy, and I usually get the first herd up, twenty to twenty-five head of cattle, by ourselves. Once the first herd is in, the others know something is going on and they just follow. I don't do that much running anymore, mostly because I don't have to. I take my bucket

of feed, and they'll come to me. I sort the cows myself to decide which ones I keep and which ones I need to sell.

Raising tobacco has changed quite a bit since L.T. and I started. Back then everything had to be done in coordination with a workhorse. That was before tractors and all the machinery was invented. Today most plants are started hydroponically, and some farmers buy seedlings from greenhouses in Florida and Georgia. In a twelve-acre crop, there may be 85 thousand little plants to take care of. When tobacco blooms in July, we "top" the crop, which means breaking the sticky pink flower off each plant. It takes a good while and gets your hands all black and gummy. After that we put a chemical on to kill the suckers [side shoots that deplete the plants' nutrients], and then by August or September we house the crop, cutting and hanging it in the barn.

I haven't helped house for the last several years because each stick of tobacco has six plants on it and weighs about sixty pounds. In September and on through the fall, we strip the tobacco, removing each leaf from the stalk. I've always liked stripping tobacco. The whole family pitches in. Children play under the bench. We keep a big fire going in the stove on cold days.

The tobacco market opens the Monday before Thanksgiving every year. When the crop is sold, we get the money we'll need to raise the next year's crop and to send the children to

college. The winter is the time for repairing fences and barns and machinery. Some of my grandchildren are more mechanical minded than I am. They're awfully handy.

Some folks around here have switched to factory jobs and just farm on weekends now. But, of course, tobacco is an every-day job. With land and machinery being so expensive and with just the one paycheck each year after you sell your crop, you have to be extra economical and make the day's work count as much as possible. I never did smoke, and I don't know many tobacco farmers who do because we need both hands free to work.

Around here we tried to grow tomatoes, cucumbers, and cabbage, but after you take the first bunch to market, it seems they don't need the next truckload. Some people are selling hay, corn, and soybeans, but we haven't found anything that can take tobacco's place.

One of my grandsons, Kent, who has a college degree and got very good grades, became a grain telemarketer, but he'd rather be farming and is now in the process of looking for land, which today is scarce and expensive. His wife is a nurse. I reckon they'll do fine.

Of course, not everybody is cut out to be a farmer, and that's fine. Some of them want to be teachers, realtors, dancers, writers, and so forth. What I really want is for them to be happy.

It is tough being a tobacco farmer today, but I like the farm life. There is privacy and quiet, no one hollering across, "What are you doing?" Now I can have a lazy day every once in a while. I can sleep until seven or so before I check the cattle or bottle-feed the babies. I can just put a pot pie in the oven for my grandkids, Pam and Troy, and sit on the porch if I want to. I tell them, "You all go ahead. I'll be along directly." I'm eighty-eight now, and I can't do all the things I used to.

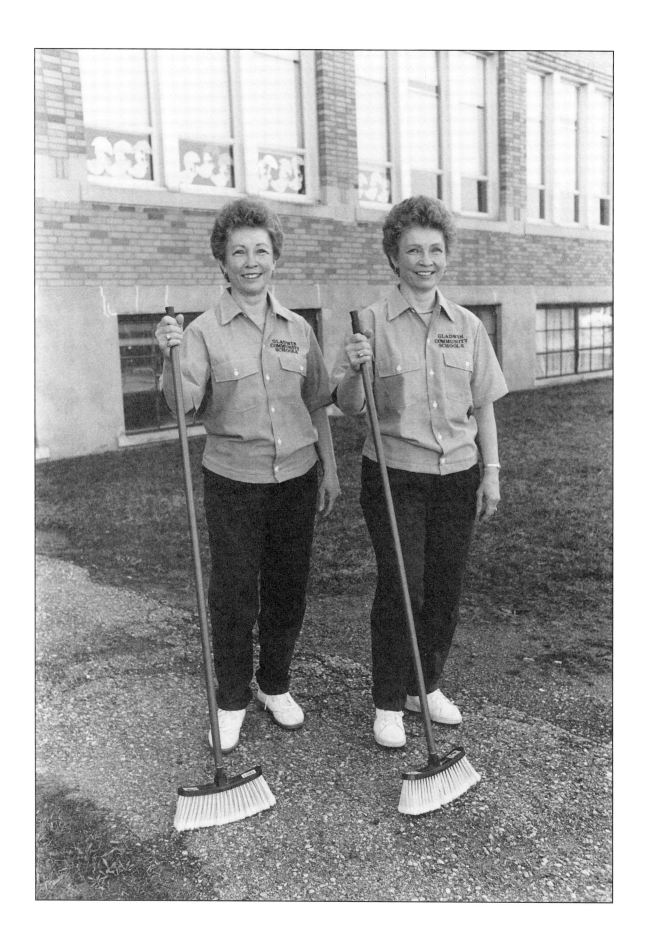

Sharon

KILBOURNE &

Sharleen

DOW

Identical twins Sharon Kilbourne and Sharleen Dow see or speak to each other every day. These fifty-eight-year-olds were born in Flint, Michigan. For many years they worked on automobile assembly lines for the same company. Now retired, they volunteer as custodians at high school. The twins live with their respective spouses in houses facing each other across a lake in Gladwin, Michigan. Sharon has three grown children; Sharleen has four. There are eleven grandchildren between them, including a set of eight-year-old fraternal twins.

Sharon:　　We dressed alike all the way through school. The teachers put different colored ribbons in our hair to tell us apart. We switched the ribbons, so that didn't work. We have always enjoyed confusing people—we still do!

Sharleen:　We have the same clothes, but we only dress alike when we work as substitute custodians or for special occasions such as birthdays, anniversaries, or twin conventions.

Sharon:　　But we no longer dress alike for someone else's party because we wouldn't want to take the attention away from the host or hostess.

Sharleen:　If one of us goes shopping alone, she just buys two of the same outfit. We always get haircuts, highlights, and perms together. We do this to keep up with the International Twins Association meetings. In 1995 we won the Most Alike Females competition in our age group.

Sharon:　　Sharleen was a grandmother five years before me, and she has a set of eight-year-old twins, Eric and Erica. When Erica was little, she called me "Aunt Grandma."

Sharleen:　It was a surprise and very exciting to have twins. If I could have chosen, I suppose I would have wanted identical twins because Sharon and I enjoyed it so much. But I feel blessed by having twins, even fraternals. A lot of people today feel you have to separate twins in school.

Sharon:　　You don't separate best friends, so why would they separate twins? Just to be mean? We tell the twins how lucky they are to have a lifelong companion to do things with. We think of ourselves as role models. We were together in the womb, and then all through life.

$\mathcal{A}nn$
TURNER COOK

Seven decades ago when Ann Turner Cook was four months old, her cherubic dimpled face became destined for immortality. She is the original Gerber baby; a portrait of her face is on the company's baby food jars worldwide. Now seventy-one, she is a retired high school English teacher and department head in Tampa, Florida, and is writing the last murder mystery of a trilogy. Married to Jim Cook for fifty-one years, she is the mother of five children and the grandmother of ten, ages eight to twenty-seven.

\mathcal{M}y career peaked at four months old. It is kind of sad when you think of it because I had a long career as an educator and did many things in my adult years. Of course, if you're going to be a symbol for something, there's nothing nicer than to be one for a baby.

When I was four months old, Dorothy Hope Smith, a family friend, commercial artist, and infant portraitist, used me as a model for what would come to be known as the Gerber baby. She and her husband, the *New Yorker* cartoonist Percy Barlow, were close friends of my parents.

In 1928, Gerber baby food had just been introduced, and they asked artists to submit drawings for an ad campaign. They were a vegetable canning company until the owner's wife had the idea of making baby food. The agency Dorothy Smith worked for asked her to do an illustration. She sent in the charcoal sketch that she had already done of me with the idea that if they liked it, she would do a more refined version.

They unanimously selected her sketch out of all kinds of finished drawings, and they said they wanted it just the way it was. Three years later, in 1931, as a result of the popularity of the sketch, it became the official Gerber trademark. I think my portrait is now on jars in eighty countries.

The first time I realized I was the baby on the tin cans—which preceded the jars—was when I was about three years old. I have a vague recollection of my mother passing a store shelf with Gerber baby food when she mentioned it.

My mother later told me that Dorothy Smith had taken pictures of me with a movie camera, and she would stop the film at the pose she wanted and sketch it. Apparently she did a lot of sketches, but the only one that survives is the famous drawing. Because it was so lightly and delicately done, the sketch has always been kept under glass in the Gerber company's vault.

I met Dorothy Smith only once, when Daddy and Mother took me on a trip to New England. By then I was in college. She died in 1955. No one knows what happened to the film.

I didn't go to school until I reached second grade because my mother, a homemaker, taught me at home. We were living on a sheep ranch in Colorado that my paternal grandfather owned. It was during the Depression, and Daddy's assignments as a magazine illustrator had dried up. My grandfather had my parents come out to oversee the ranch.

Daddy still went on with whatever artistic work he could get, but eventually, fed up with life on the ranch, my parents returned to New York City so Daddy could try to reestablish himself in his field. He later became an artist and writer of the comic strip "Wash Tubbs and Captain Easy." It ran for some thirty years in over five hundred newspapers.

Reluctantly, they left my sister, Joy, and me with our grandparents, and we moved between Colorado and Texas, where my grandfather also owned a lot of property. Once Daddy was doing well, we moved first to New York City and then Orlando, Florida, where I attended junior high and high school. In 1947 I received my bachelor's degree in English with a minor in journalism from Southern Methodist College in Dallas, Texas.

My plan was to go to New York to get a newspaper job, but that summer, while I was back home, I met Jim Cook, a Navy veteran who had served during and after World War II. He was visiting from Chicago, and a mutual friend had told him to call me. He proposed on the second date, and six weeks later we were married. This year is our fifty-first wedding anniversary.

We moved to Illinois, where he went to college on the G.I. bill. In 1951 when Jim was graduating from the University of Illinois, the Gerber Company clarified their ownership of rights to the trademark by paying me $7,500. I don't usually like to quote the figure because it sounds so small, but the truth is, that was quite a good sum of money in those days. And it made it possible for us to make a down payment on a modest little house and buy a new car, and it gave us a start in the world.

So I never felt put upon or anything. There had never even been a signed release because Daddy was an artist who drew from models. He didn't think anything of his friend using me as one.

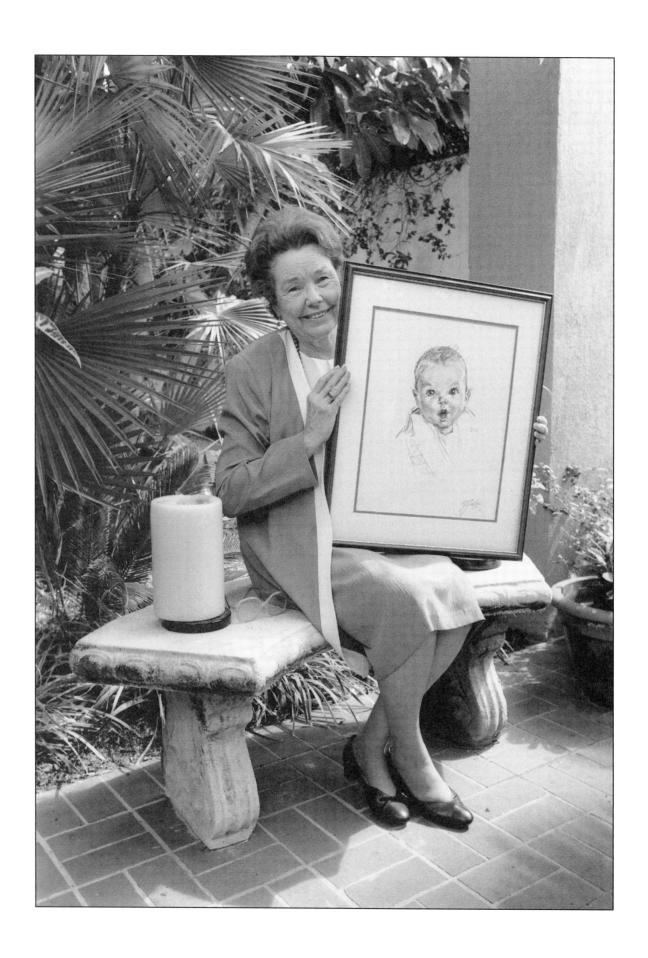

Jim, who had a degree in criminology and sociology, got a job observing and working with gangs. We stayed in Illinois for ten years, in the space of which I gave birth to our five children. We lost our first son, James Robert, to sudden infant death syndrome at the age of three months.

I didn't start working until I was thirty-seven so I could be home with my children until the youngest was in second grade. I was fortunate because I think today very few women can afford to do that. By then we had moved back to Florida. I taught first in Jacksonville and then Tampa, where in 1968 I earned a master's degree in English education from the University of South Florida.

I wanted to be a writer from the time before I learned to read, and I think a lot of English teachers do. But I was practical in choosing a career that would give me the same hours as my children, and I've enjoyed it for twenty-six years. But no English teacher, if you're conscientious, has time to write. You're grading papers, making lesson plans and tests—it's just every night. For fifteen years I was chairman of the high school English department, supervising twenty teachers, so that was extra work, of course.

In 1978, Gerber invited me to its headquarters in Fremont, Michigan, to be honored at their fiftieth anniversary celebration. They re-

moved the original charcoal sketch from the vault that evening and put it on an easel. It was very fragile. They gave me a copy of it. I told the executives that they were lucky I didn't turn out to be a go-go dancer or something.

Until then, except for the payment for their trademark ownership, there was almost no communication. The philosophy for years, until the company changed hands, was to discourage publicity because they didn't want the customer to think of the baby as a boy or a girl or any one thing. Being a teacher of literature and knowing about symbols, I could understand their point of view.

However, that never stopped my children and later on my grandchildren from pointing to my picture on the jars in the supermarket and announcing, "That's my mother" or "That's my grandmother." Then I'd have to decide whether to tell perfect strangers or just let them think my kids or grandkids were crazy, which is kind of what I did.

I became a grandmother when I was fifty, and I loved those babies. I was really sorry when my four kids went out of production. There is nobody who loves babies more than I do, and the tinier the better. When they were younger, I always read the children's classics to them. When they were a little older, we went to museums together. Every New Year's Eve all the grandchildren would spend the night with us. My husband

and I also enjoy taking them for rides in the pontoon boat we keep at our country place on the river in Homosassa, seventy miles from Tampa.

We have eight grandchildren and two step-grandchildren. Only four of them live in Florida. Now that they're older and involved with friends and school activities, we don't see as much of them as we would like. But we don't like to impose. We get a rare sighting of our fifteen-year-old granddaughter, Ashley, who is just completing her freshman year.

I retired in January 1989, and since then I have written two murder mysteries of a trilogy I hope to complete this year, and I've had short stories published in a fiction quarterly.

I have a great resource in my husband, who ran the largest county jail in the area for many years. He was in law enforcement, but because of his background in sociology and criminology, he is very interested in the reasons for the crime, not just catching criminals. A year after I retired,

my husband decided it looked pretty good, and he followed suit in 1990.

I do most of my writing at our place on the river which has a rich Seminole Indian history that I have woven into a few of my short stories. There are great oak trees, Spanish moss, and a network of rivers; these service my writing because I like my mysteries to have a lot of setting.

Each of the three novels has a baby who is very important to the plot. Looking at a newborn's eyes, you're looking at the oldest thing in the human race because you're looking at all the generations of evolution that culminated in this individual. At the same moment you're looking at the newest thing, too, because here is this newborn who has no experience in the world and opens his little eyes and looks at the world for the first time.

It is a mystical experience, and I am so looking forward to the time when my grandchildren can experience this both for themselves and, again, for me.

Enid
ZUCKERMAN

Enid Zuckerman, sixty-six, and her husband, Mel, seventy, are the founders of Canyon Ranch health resorts in Tucson, Arizona, and Lenox, Massachusetts, in the Berkshire Mountains. The mother of two grown children, Enid has one granddaughter, Nicole, eighteen. She and her husband divide their time between the ranches in Tucson and the Berkshires.

When my daughter-in-law, Jill, was pregnant, I dreamed of a little blond baby girl wearing a blue and white gingham dress. The day my granddaughter, Nicole, was born I was so excited I bought tons of flowers to fill Jill's room. When it came time to take the baby home, the nurse handed us the baby and said, "You can dress her now." There was nothing for her to wear since we had never even thought to have clothes for the new baby! We wrapped Nicole in a little hospital blanket and took her home in a Mercedes.

Since that day I have more than made up for this oversight. Over the years we've enjoyed many shopping sprees together. She is nineteen now and has tremendous fashion savvy. She is tall and has great legs and likes to wear her skirts as short as is legally allowed. When she was two or three years old, she would sit at my feet learning how to put on makeup, and I would give her things to take home. There were times she would put on blush and mascara, and look as if she had a fever of 105!

From the moment she was born, she was "my girl." Her dad and mom separated when Nicole was four years old. She went back and forth between her parents' homes, and ours in between. I was forty-seven when she was born, so I had lots of energy to give her. In high school she played the flute, and I never missed one of her band performances. As Nicole was growing up, our grannie-grandchild relationship grew into a friendship. When she has somewhere important to go, she calls me for advice about what to wear.

My husband, Mel, and I moved to Arizona from New Jersey five years after we were married. Our son, Jay, was three years old, and I was pregnant with our daughter, Amy. Mel was an accountant at the time—something he never enjoyed. He went into the building business and did that very successfully for the next twenty years.

Life goes on, and building houses was becoming a bit boring. I had this wild and crazy idea that we should go on to something different. Someplace in my mind I thought that doing a "fat farm" would be great! We knew nothing about hospitality, food, or fitness. It just felt like the time was right, and we could learn as we went along. And learn we did!

After making the decision to pursue my wild idea, the money market sort of dried up as we were midstream in our project. We didn't get the loans we were promised, but we were at the point of no return and had to continue on. We put ourselves and all we owned on the line to do so. We never doubted for a moment that it would be a success.

We opened Canyon Ranch in December 1979, eighteen months after we bought the land. How naive we were. We just thought we would open the doors and "they" would come. We had no budget for advertising. The first day we had eighty-four employees and seven guests, of which one was paying; the rest were comped. The first stroke of luck came when a reporter from a national weekly news magazine visited the ranch and did a story on us. By then it was April 1982. She put us on the map. Over the years we have added hiking, biking, healing, and behavioral programs. In 1989 we opened our sister property in the Berkshires.

At this point in my life I work at the areas that still interest and excite me. For example, I attend the marketing meetings, oversee food development, and work with interior designers on an ongoing basis. My husband is the main cog, the business brains, the creative one. Canyon Ranch has become a wonderful merger of a personal mission—health and wellness—and a great business.

I personally do all my exercising indoors. I am fair-skinned, and the Arizona sunshine plays havoc on me. I do weights three times a week and Pilates, a stretching exercise, twice a week.

Nicole was six weeks old when we opened Canyon Ranch, and it is a part of her life, too. She teases me about not being the cookie-baking type of grandmother: "You don't cook, and you don't hand me down any recipes." But I have given her other values: eating healthy and exercising.

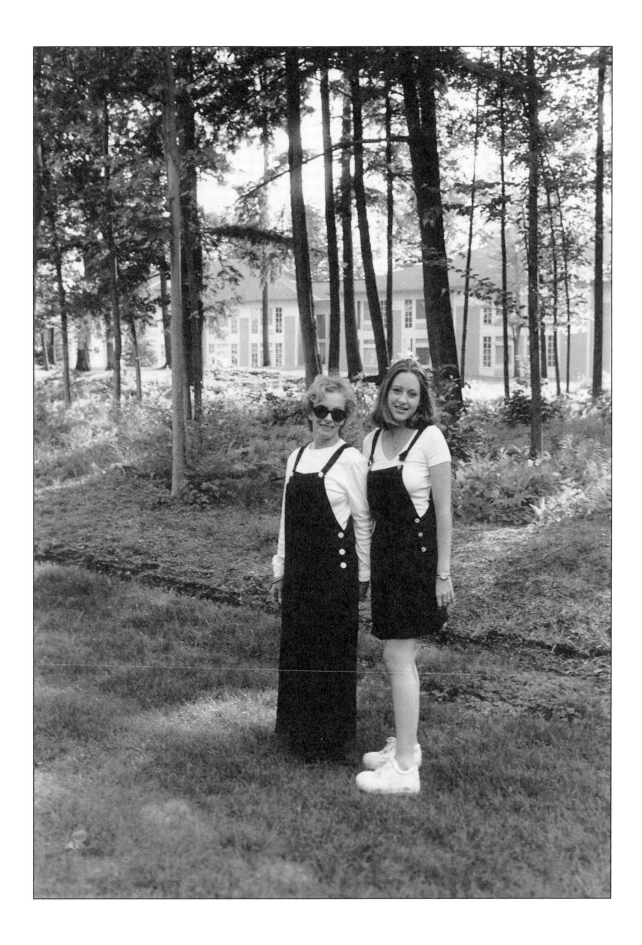

\mathcal{B} r o n i s l a v a

ISRAEL CHERNINA

*Bronislava Israel Chernina, eighty-five, emigrated with her family to the
United States from the Soviet Union in 1980. She became a United States
citizen five years later. After a repressive and difficult life as a Jew in the
Soviet Union, she cherishes her liberties in America. Chernina has two grown
daughters and two grandchildren, Elina, twenty-one, and Alex, twenty-five.
A genuine* babushka, *she lives in Brooklyn, New York. Although she
studied English in America, a fall two years ago affected her speech, so her
daughter, Raisa, translated her words.*

\mathcal{I} am an American and a Jew. Both things are equal. I like America very much. Here you are free to be
a Jew. Since I came, my grandson was bar mitzvahed and my granddaughter bat mitzvahed. My grand-
daughter went to a kibbutz twice in Israel and to volunteer in the Israeli army. At her college in Pennsyl-
vania, she put together a group of Jewish students to go to a synagogue and to stand up for Israel. I am
very proud of my grandchildren.

It was impossible to be a Jew and survive in the Soviet Union. My youngest daughter had to change
her internal passport from "Jewish" to "Byelorussian." Otherwise there was no chance for her to go places
or get jobs. I kept "Jewish" on my passport because it was always there. But when I told people my middle
name, which in Russia is your father's name, I gave it as "Iosif" [Joseph], not "Israel," his name. It was Jew-
ish and not Jewish, in between—even though it was also Stalin's name.

I was born in Minsk in 1913. I talked Yiddish with my mother at home, and she kept the Sabbath. I
went to a Yiddish school for two years, but after the Russian revolution, the Bolsheviks shut it down.
From then on I went to regular school and a trade college, and I became manager of a clothing store.
Both my husbands were Jewish, but they were more Communist than Jewish. They didn't care for reli-
gion. And there was only one very small synagogue, with no prayer books, and it was dangerous to go in
case someone reported us.

I met my first husband, Boris, in a street in Minsk where all the people went to talk. He was a fire

180

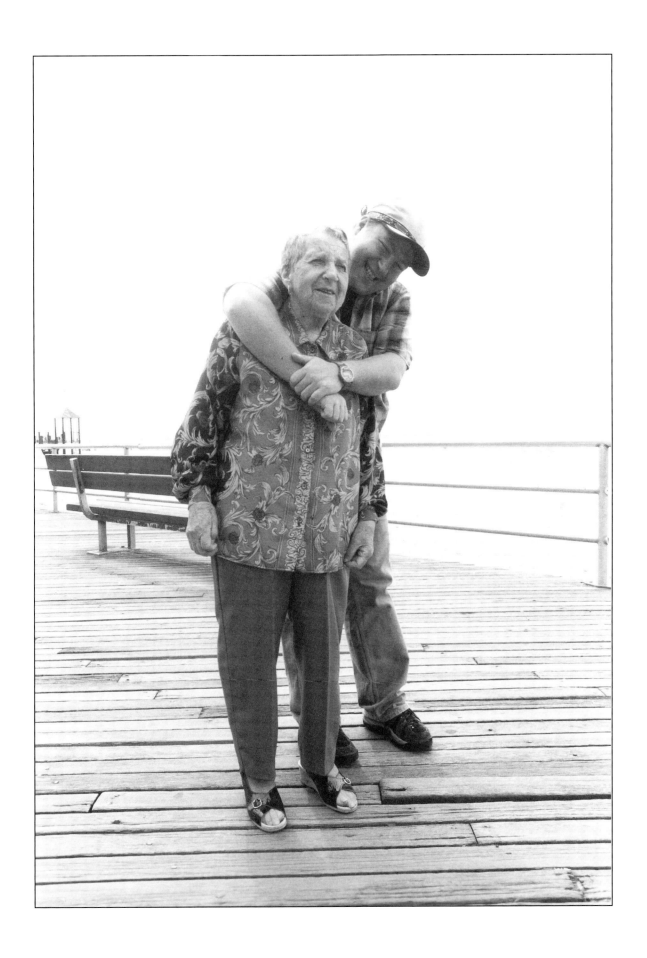

commissioner and high up in the Communist Party. I married him in 1935 when I was twenty-two. We had a daughter, Lilya, in 1938, and a son a year later.

In 1939, after the occupation of eastern Poland by the Soviet army, my husband was sent there to help set up the Communist Party. The occupied land became known as Western Byelorussia. I followed him there with our two young children.

Two years later, on June 22, 1941, Nazi forces suddenly attacked the U.S.S.R. in the middle of the night. No one knew it was actually the war, because there was no prior declaration. My husband said he was going to find out what was happening and asked me to wait for him.

I didn't wait there because I was afraid for my two children and the child I was pregnant with. I walked for four days back to Minsk. My son was killed by a bomb, but I kept going with my daughter. Later on I lost my baby. My husband disappeared, and I never knew what happened until the army sent papers saying he was killed in the war.

During World War II my mother moved to the center of the country near the Volga River, and my daughter and I went there. I worked in a hospital, cleaning, helping nurses, everything. The Nazis didn't reach there. Many of my family who stayed behind in Minsk were sent to the ghetto, where they were rounded up and executed by both Nazis and anti-Semitic Byelorussian militia; they were sent to slave labor camps or just withered away.

My older sister and her two daughters and son were sent to the camp after her Byelorussian husband, who was not a Jew, reported to the Gestapo that she was Jewish. They survived. After the war, when her older daughter was married, he showed up at the wedding. My sister closed the door in his face. A few days later he killed himself.

After the war, in 1946, I married again. His name was Iosif Chernin, and he had served as an intelligence officer with the Russian army. Afterward he managed a big glove and bag factory. He died five years before I came to America.

In 1980 when Leonid Brezhnev was the Soviet leader, things became very hard-line and bad for us. My older daughter, her husband and two children, and my younger daughter wanted to leave. I was sixty-five and thought it would be too much of a change to start over in America. But then either everyone or no one left, so I went. I also wanted to see my grandchildren, who were then three and seven years old, grow up in America and be free.

Because my older daughter didn't want to live in New York City, we went first to Akron, Ohio. The Jewish Family Service of Akron arranged everything, a three-bedroom apartment with a refrigerator. It even had orange juice, meat, chicken, and other foods inside. I felt

rich—I would never need for anything. I thought, "Now I'm starting to live!"

At the end of our first year, my older daughter, Lilya, got a job as a computer programmer with IBM and moved to upstate New York. Every summer I went to stay with them and baby-sit my grandchildren when they were little. After we moved to New York, for two weeks I would also go to a summer camp for Russian Jews in the Catskills.

I love to play dominoes, but Russian men don't like women to be in the games. One time when my granddaughter was with me at the camp, I just sat at a dominoes table, watched the men play, and wouldn't leave until they let me in the game. Then I beat them in it.

My granddaughter learned Russian at home and speaks it with an American accent. My grandson had already been in school one year in Minsk before we came, so he knew Russian. But my culture is Jewish, not Russian, even though we couldn't practice our religion all those years. Every year when we sit down to the Passover Seder and other Jewish holiday meals, I remind my grandchildren of how lucky we are to be in America and to be proud of who we are, Jews, and always stand up for this.

I became an American citizen in 1985 and registered as a Republican because I liked President Reagan. Later I switched to Democrat for Clinton. The first thing I watch on the television is the news about politics. It is very important to vote.

In 1988 my younger daughter, Raisa, and I moved from Ohio to New York because I wanted to be closer to my other daughter, and I thought it would be better for Raisa to meet friends. She married a Russian Jewish journalist. They live a few blocks away from me in Brooklyn, near Brighton Beach. Raisa is a very, very good daughter. She is my wall; she protects me. She took me in a car to see America, and we've visited Israel together.

My grandson, Alex, has his degree from Cornell and is taking graduate courses in child psychology at the University of Chicago. My granddaughter, Elina, is studying to be an accountant.

Elina wants to live in Israel and marry an Israeli. Better my grandchildren marry Jews, but if not, as long as they choose a good person, it's okay. I don't see my grandchildren as much as I want since they are very busy in school and jobs. Besides the Jewish holidays, I see them when I go upstate to their home in the summer or they visit me in Brooklyn, where we talk and play cards and go on the boardwalk. I always want to cook for them, but they don't want so much food.

I don't worry for my grandchildren's future. In America they can have a good life, a good education, and a good job, and be proud of who they are—American and Jew.

$\mathcal{D}iane$
R E Y N O L D S

After twenty-eight years as an elementary school teacher, Diane Reynolds, fifty-six, looks forward to a retirement that will be the opposite of sedentary. She and her husband, Paul, fifty-eight, live in Hampden, Maine. They are accomplished at just about every outdoor activity, from fly-fishing to swamping and righting canoes. She is also a nature photographer. Their three grown children are all former state gold medalists—two sons in downhill skiing and a daughter in gymnastics. The Reynoldses have four grandchildren, ages four months to eight years.

On Saturdays I take my eight-year-old grandson, Zeb, for skiing lessons that I bought him for Christmas. His father, a state gold medalist in downhill, feels he should be doing that. He's very busy between his work as a sales engineer and as a National Guard pilot many weekends, so I told him, "Let me do it. It will be wonderful for Zeb and me."

I'm not traditional like Zeb's other grandmother. She has been the caregiver; she is always in the kitchen baking cookies for Zeb and his sister, Laura. I'm selfish about my time with my husband. If it's convenient and it fits in with what we're doing, that is when I want to be with my grandkids. I love spending time with them, but I prefer not to baby-sit. The two older ones live nearby, and I see and talk to them all the time.

My husband, Paul, and I are both very outdoorsy. We ice-fish, fly-fish, snowmobile, ski, hunt, and go camping. For the past five years he has been the director of public information and education at the Maine Department of Island Fisheries and Wildlife. Before

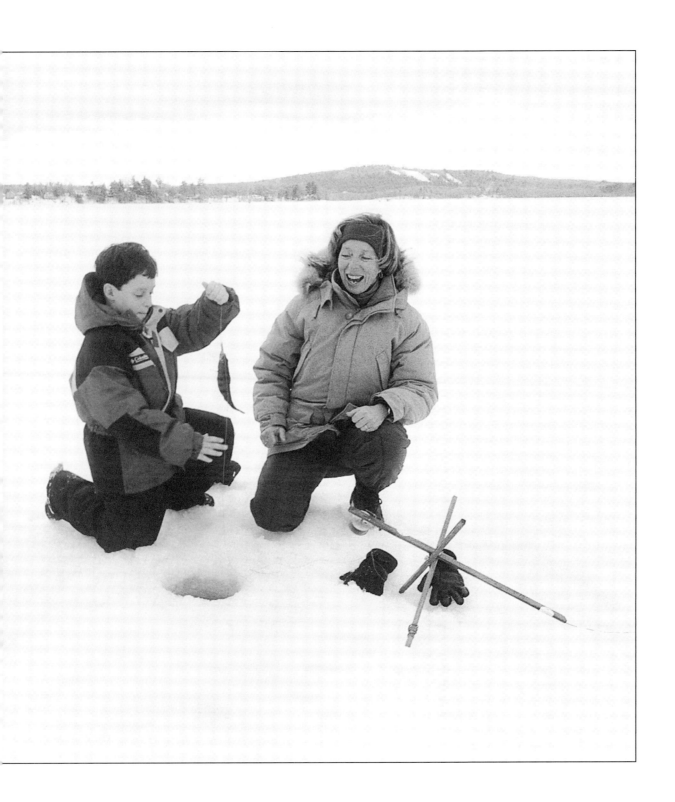

that he was a newspaperman with the *Bangor Daily News* for twenty years, the last ten as managing editor.

We met as seniors at the University of Maine. I completed a double degree in sociology and elementary education in the customary four years. It took him six because he'd leave and do other things in between. That whole last year was one big party. We decided if we could have so much fun together for a year, then we could probably survive marriage. We married when I was twenty-two and he was twenty-four. We have been together now for thirty-three years. He is my best friend.

We lived for four years in Virginia Beach, Virginia, while Paul was communications officer at the Naval Air Station there. Our first two children, Scott and Suzanne, were born ten and a half months apart. I was miserable taking care of two little babies, thinking I had to make sure they and my husband were happy every second and the house was perfect. It was the stupidest thing. I couldn't eat or sleep. I was full of anxiety. I guess all the pressure just caught up with me after I had my two children. I was a nervous wreck and trying to hide it from everyone. Finally, one day I went to the Navy chaplain, who suggested that I learn to take care of myself while caring for others. He suggested I teach Sunday school, which I did, along with joining a bowling league. That was all it took to feel better. From that point on I

have made sure to take care of myself and lead a balanced, active life.

The outdoors has always been my therapy. Paul and I missed Maine, where we could have this kind of life, and moved back after his Navy stint. If I sat at home, I'd start worrying about little things—a pain here, a pain there—so I stay active. I'm better with the environment than being with groups of people. I can't stand sedentary things like meetings. We watch very little television—nature programs and public broadcasting. At our son's house there is only one small black-and-white television, and none in the children's bedrooms. So our grandchildren have wonderful imaginations.

I love my solitude. We live on thirty acres, which is ideal because I don't like to be able to see my neighbors. The last thing I'd ever want to do is join a country club. We have a cross-country ski trail that winds around the property and into the woods. Out back is a stream, where we fish for trout in the spring, and a garden. We pick fiddlehead greens by our stream.

Both my paternal grandmother, who hunted and fished, and my dad opened up the outdoors for me. She lived until she was ninety-one. Dad was an artist, a watercolorist, educated at the Museum of Fine Arts in Boston, and a wonderful trumpet player. In order to support the family, he opened a garage and did bodywork, painting cars. My mother was a homemaker.

Dad taught me and my younger sister, Jannifer (Jannie), to ski when we were just little things. He built a ski rope tow out of an old car engine to pull us up a little hill. By the time I was sixteen, I started skiing seriously. Around that time my father began having trouble walking, dragging his leg, and he felt extremely fatigued all the time. Diagnosed with multiple sclerosis, he declined rapidly. He was in a nursing home for sixteen years until his death in 1989.

My mother was frantic when she had to go out to work. And I just made up my mind that was never going to happen to me. I didn't know if I wanted to teach; I just knew when I went to college that I had to do some work to take care of myself because I wasn't going to get married just to have somebody take care of me. Also, having paid for most of my own education, I figured that I should do something with it.

I decided to go the teaching route because of a favorite aunt who was a teacher and my mentor when I was growing up. She told me wonderful, crazy stories about her experiences in the classroom. It sounded like all kinds of fun. It was exactly that.

I didn't work until my first two kids were school age and my husband, Paul, with his foot in my back, said, "Get out there—we need the money." After my third child, Josh, was born six years later, I stayed home for only three years.

I am glad Paul encouraged me because I have loved almost every day of teaching for the past twenty-eight years. I work at a small country school five minutes away. There are only 105 pupils, kindergarten to fifth grade. I teach a combined kindergarten and first grade class.

This is the first season I started hunting because I am semi-retired. I get out early, while it is still light. After lunch I put on my blaze orange hat and jacket, and go out into the woods in back of our house. My husband always wanted me to hunt with him, which is flattering because he has this group of men he goes all over with—elk hunting in Colorado, turkey-shooting in upstate New York.

Granted, deers come running across our lawn, and I couldn't stand the thought of shooting them, but out in the woods on a cold day, things look different. The first time I had my chance, with a beautiful doe thirty paces in front of me, I missed. I choked up; it's called "buck fever." I felt both relief and disappointment.

I am happy just sitting on a log for two hours, with little birds and other creatures coming up to me. I know that, as Paul says, the hunt, the killing, is second to being out there and seeing everything. It's like that with fly-fishing, my favorite activity besides skiing. Sometimes I just paddle my canoe, take out my binoculars or camera, and watch the moose, beavers, birds, and ducks. Again, it's the beauty of the scenery and the wildlife you see, as well as the serenity.

Paul and I were fly-fishing long before it became trendy. When we were first married and didn't have two nickels to rub together, we'd hire a lady we knew for the children and head up north, pitch a tent, and fly-fish for a week. One week we didn't see anyone else the whole time. That week sustained us through some very hard times. Sometimes we'd fly-fish for two or three hours without saying a word to each other, or we'd read and talk. It deepened our relationship.

I always liked to do boy stuff. As a little girl I wanted to wear blue jeans to school before it was allowed. My daughter, poor thing, hardly ever had a dress on, and she preferred to play with miniature trucks and cars. In college she majored in art, and today she's a stay-at-home mom in Florida with four-month-old Mary and two-year-old Paul. I stayed with her a week this winter when she gave birth.

My two grandchildren in Florida are still babies, so for now I do sporting activities with Zeb and Laura, who is seven. I play soccer on the lawn with Laura, who wants to learn to ski next year. I'm determined that Zeb ski with me at Sugarloaf, our favorite ski area in Maine. I've been skiing there since I was sixteen. I'm just tickled to downhill ski with my grandson.

This summer my husband and I will be retiring. He'll write and give speeches, and we hope to collaborate on projects, books, and the like, on the outdoors. I'm very content here. I see myself living in this house the rest of my life, braiding rugs and gardening. I can't stand doing dainty little things like needlepoint. Exercise is the first thing I try to do every day, and I think it's because my father got sick so young. In the winter months I lift weights and use the treadmill at the gym. In the summer I'm up by five in the morning for a three-mile walk before breakfast.

I am active in Becoming an Outdoors Woman in Maine. Begun in 1990 in Wisconsin, BOW is a national program where women learn to throw axes, swamp and right canoes, shoot firearms and bows and arrows, kayak, sail, fly-cast, hunt with dogs, survive in the woods alone, and more.

Picture postcard–ish as it may sound, I want to see every sunrise and every sunset. That, along with sharing the pleasures of an active outdoor life with my husband and grandkids, is really my hope.

I don't want my grandkids to be like I was as a child, full of fears and phobias. It took me until I was in my thirties to gain confidence and not feel as if I had to please everybody all the time. I would give anything for them to find that peace and confidence while they are still young.

And, of course, I wish them to have happy, enduring relationships with someone who can be their best friend, just like their grandma and grandpa.

Dr. Carolyn
GOODMAN

Dr. Carolyn Goodman, eighty-three, is the mother of civil rights activist Andrew Goodman, who along with James Chaney and Michael Schwerner was murdered by the Ku Klux Klan in Philadelphia, Mississippi, during Freedom Summer 1964. Andrew Goodman was twenty years old. In 1966 she and her husband, Robert Goodman, founded the Andrew Goodman Foundation to carry on their son's dreams and goals. For many years a clinical psychologist, she created a much heralded program for mothers and children from deprived backgrounds. Twice widowed, she has nine grandchildren, ages six to seventeen, from her two living sons, Andy's brothers. She lives in New York City.

A couple of years ago I gave a speech at a summer camp for politically active kids, and I took along my grandson Jacob, who was then twelve years old. He was very proud that there was a bunk named after Andy. Being a quiet and philosophical boy he didn't talk about it at the time but said later, "Grandma, we had a wonderful day." His feelings about the uncle he never knew were implied.

His brother Ivan loves to talk and is very open. One time as we were chatting away at lunch, a woman at the next table in the restaurant turned to him and said, "You know, you're very lucky to have such a young grandmother." He answered, "What do you mean? She's eighty-one!"

I was born in New York City but raised in a Long Island suburb. My father was a lawyer and an Al Smith Democrat, meaning middle of the road politically. My mother, a homemaker, was a brilliant Barnard College graduate who read everything and was something of a "rebel without a cause."

At college I met Bobby Goodman, and we fell madly in love. His family was more progressive than mine—his mother was a Socialist. His degrees from Cornell University were in liberal arts and civil engineering; mine was in family life from the New York State College at Cornell. We were married in 1938.

Within the space of six years, I gave birth to our three sons, Jonathan, Andrew, and David. Although the boys have very different personalities, there is a common thread among them—they are caring, responsive people. Andy, in particular, had a strong sense of commitment to social justice even as a young boy.

During the summer of Andy's junior year in college, he asked us for permission to go to Mississippi.

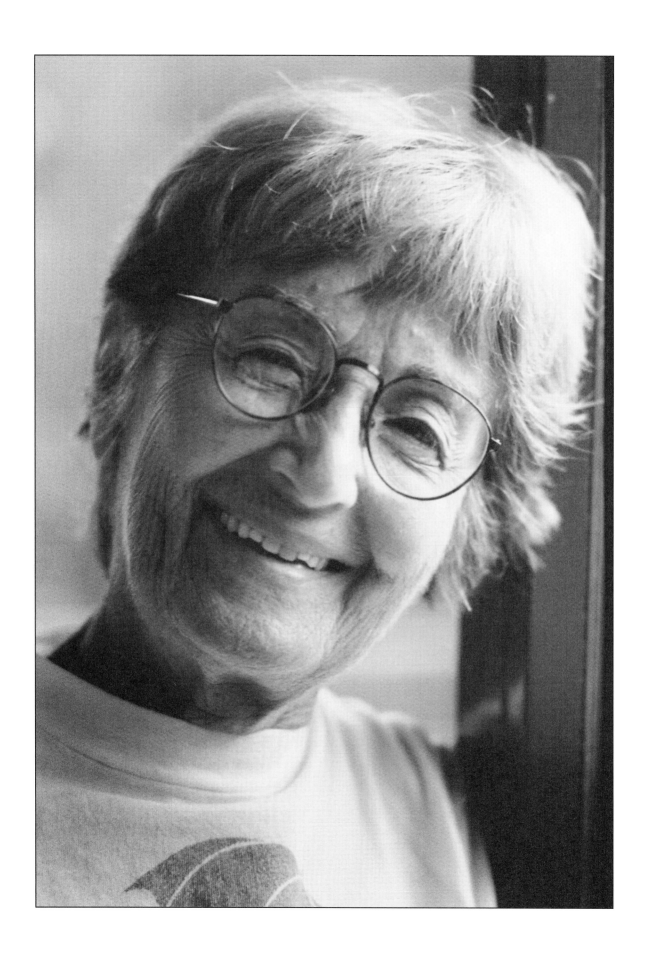

He was to register black voters. Because Andy was not twenty-one, the Student Nonviolent Coordinating Committee required parental approval. It was not surprising that my heart sank, because it was incredibly dangerous there. But there was no way that Bobby and I would have stopped him. It would have meant that our whole lives in the forefront of progressive movements, be it antifascism or labor, would have been a sham. In our family we were open about our values, interests, and political views. I am very much the same with my grandchildren.

I have seven grandchildren in Israel, six boys and one girl, and two grandsons in New Jersey. The ones in Israel live in an Orthodox Jewish town just outside Tel Aviv. Their father is my oldest son, Johnny, a Juilliard graduate and a brilliant musician who became very religious about eighteen years ago. The path he has chosen is very different from his earlier life and not at all like mine. He has every right to follow his own path. His father would have totally agreed with me. When I am visiting Johnny and my lovely grandchildren, I am respectful of their way of life.

Because of the distance to Israel, I do not see my grandchildren as often as I would like. When I am there, I tell them stories about my life and my work, their grandfather, and how we lived when their father was growing up. They look forward to my visits because like most grandparents I tend to spoil them.

My son David's two children, Jacob (sixteen) and Ivan (thirteen), live in a New Jersey suburb. They do not have television at home. David took it out in a moment of anger when he thought they were spending too much time at the set. They do watch television when they stay with me. Do I say anything? No. Being a grandmother is different. It's up to their parents to discipline them.

The two boys are excellent musicians and athletes. At Jacob's eighth grade graduation, he was asked to play a clarinet solo, which he did so beautifully and with such wonderful musicianship that I was taken back to the days when I would listen to Andy practice the same instrument. Tears began to flow.

For weeks after Andy's disappearance we had not wanted to leave the city, hoping we would get a call informing us that Andy was safe. When my husband and I finally got to our country home, I remember how forcibly the loss struck me. Walking in the garden and seeing the corn I planted before Andy had left for Mississippi, I thought, Here were these corn seeds, so dead and dry-looking, that I put in the ground. Now they have grown strong and tall; and here was my boy, strong and beautiful, cut down long before his time.

Without Bobby Goodman, so supportive and steadfast, I could not have survived Andy's death. Five years later, Bobby died suddenly at fifty-five of a massive cerebral hemorrhage. On

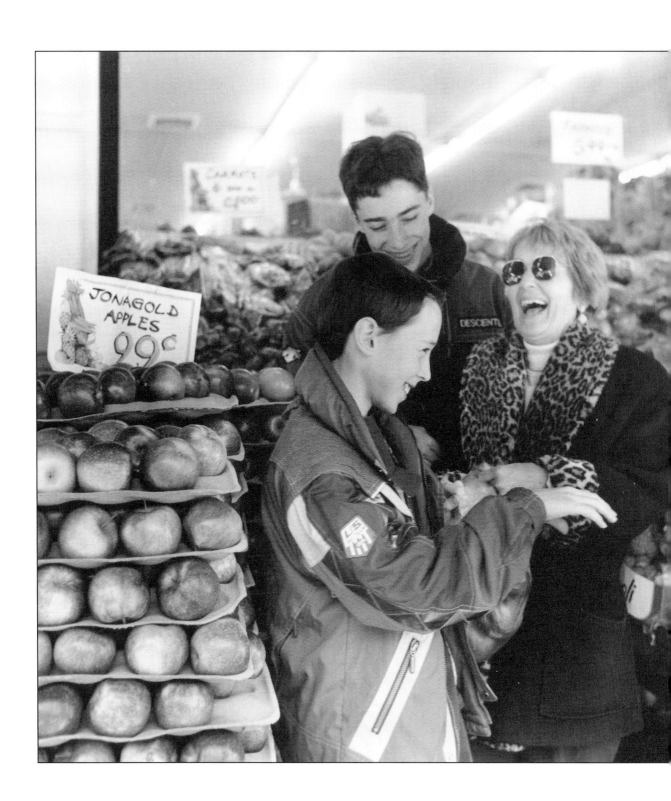

his gravestone I had three words engraved: poet, humanist, engineer. Later on I met a wonderful man, remarried, and lived a happy, harmonious life for twenty years until his sudden death—another grievous loss.

After the deaths of Andy and Bobby, I returned to school, at fifty, to get my Ed.D. in clinical psychology from Columbia University. I chose to work in a deprived community, setting up a program in a psychiatric hospital for disturbed mothers and their very young children.

I remember one of the women in the program was very difficult to reach in any way, no matter how I tried. In my office one day she suddenly saw and pointed to a copy of Andy's memorial book I kept on my bookshelf and asked, "That little book there says 'Andrew Goodman.' Did you know him?" I said, "Yes, he was my son." She burst into uncontrollable tears. That was the turning point in our relationship. She learned that I, too, knew what pain was, and we became good friends.

I am now eighty-three, and I am proud of the fact that I am able to be active with projects that are meaningful to me. I have just completed a documentary film called *Hidden Heroes* about youth activism in the nineties. The Andrew Goodman Foundation helped train many of these young people in earlier projects.

There are always many challenges and so much to look forward to. A new project has begun—I've started my memoirs, a big undertaking—and who knows what else will present itself that says, "Carolyn, here is another challenge that will interest you!"

I wish for my grandchildren a peaceful world and, most important, inner harmony. I hope they meet and love someone with whom they find happiness and share common interests. They will choose their own paths in life as their parents and grandparents did. And that is as it should and will be.

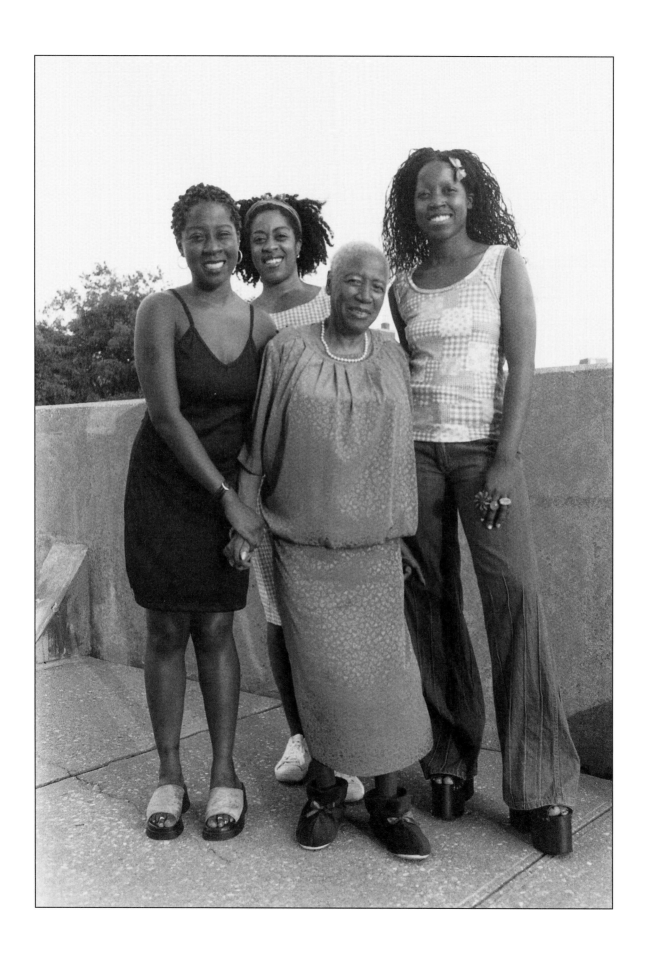

Minnie
YOUNG JOHNSON

Minnie Young Johnson, eighty-one, is a retired nurse. A widow, she raised one daughter, Joyce. She has four grandchildren, ages twenty to thirty-three, and lives in Brooklyn, New York.

I always tell my grandchildren if you put something in the bank, you'll get something out, and if you don't, you won't get anything. Don't expect to get something for nothing. They all work very hard and have great jobs in the arts, advertising, and communications. I told them never to settle for anything but the best and to always keep their pride.

I started working when I was fifteen years old, after graduating from junior high school in Brooklyn. In the beginning I did day work, cleaning and cooking, but I was always taking care of people's children, and I loved it. Deep within me I always had this love for children. I decided to become a baby nurse. This doctor whose child I was caring for wrote a reference for me: "Minnie is better with the babies than the mothers are, and the babies are taken with Minnie."

I was born in Georgetown, South Carolina, and when I was maybe seven years old, my cousin, who was much older and a grown woman, took me with her to live in Norfolk, Virginia. The children who stayed with my mother had a father who was different from mine—not that I knew anything about this. Maybe I had a child's intuition, because I was glad to get away. But I always kept in touch with my mother, and my cousin would take me to visit her.

When I was ten or eleven, we came to New York. There were problems and deep segregation in Virginia. My cousin had a grown daughter who was already living and working in New York, and she decided to bring us up to live here. It took a while to get used to New York because all of a sudden you're getting

more with the white people.

I remember when I started school here, I'd go to the back of the classroom, and the teacher would say, "Oh, no, Minnie. You come up front." We lived by a church in Brooklyn that we used to call "the mission next door," and I went to Sunday school, sang in the choir, and met very good people there.

When I was about twenty-six, I gave birth to my daughter, Joyce. Although I was a single working mother, we lived as part of a family. We shared a home with a friend from church who had a daughter Joyce's age. When we went out to work, my friend's mother, Bahma, as everyone called her, looked after the children. She was an elderly, beautiful lady and very strong. So that's how Joyce was brought up. It was very, very positive. You make sure that your child is set and everything is right so you can have a free mind to do your job.

My daughter has blessed me with four wonderful grandchildren, who are all kind, honorable, and productive. Joyce, who works for the state, and her late husband, Josiah, an electrical engineer from Nigeria, worked very hard to give their children the best private school and college educations. On the graduation cards I bought them, I always wrote, "It's only the beginning. Keep aiming for the top."

I taught them to rely on God and that if they always worked hard, they could reach the highest goals. For example, my middle granddaughter, Omoronke, who is a very accomplished journalist for magazines and television, tends to get impatient when things don't go her way as quickly as she wants. I tell her, "Just have faith. Don't rush it. It will happen when it's supposed to happen."

I did weekly baby cases until I was in my thirties, and afterward I worked in a hospital and got my practical nurse license. When my eldest granddaughter Derin was old enough, I took her with me to the baby ward so that she could see what I did. They all know how hard I studied for my nursing exams so I could ensure my future.

When I was in my late forties, I married William Johnson, a widower and former soldier who worked in manufacturing. I really had no interest in meeting anybody, but this friend who introduced us said, "At least talk to him, meet him." It lasted thirty-two years, until he passed on February 6, 1993.

I took care of all my grandchildren, more so after I retired. We have always lived in the same building. I used to walk Derin to day school after I got off working nights at the hospital. I was younger then, so we'd dance together and play games. When they were babies, I bounced them on my lap and sang gospel spirituals to them.

My grandchildren are a miracle of God. As I tell them, if you build a foundation, solid and right and with love, that's how they bloom. They have.

Jean
CUTLER NICHOLS

Artist Jean Cutler Nichols, also known as "Oxyjean," was one of the workers at the 1969 Woodstock Festival and lived on the famous Hog Farm commune. Now fifty-three, Nichols runs the Art for the Heart studio, a creative project for adults and kids in Penasco, near Taos, New Mexico. She lives with her common-law husband, Alan, fifty-seven, and their sixteen-year-old son, Martin. Nichols has two other grown children and a twelve-year-old grandson, Abraham.

I am very proud of my grandson, Abe. At age twelve he plays the piano very well and loves jazz. I am also proud of my daughter, Djuna, who made sure that he got lessons and practiced. Djuna went through some rough years but has come out with flying colors. She questions her upbringing—life in the Hog Farm commune, raised by a village. What we in the sixties saw as freedom and adventure, she experienced as insecurity.

We were mostly on the move, traveling around the country or the world in buses, putting on free shows, working at music festivals, protesting injustices. In 1969, just when the Hog Farm commune decided to put down roots in New Mexico and buy land, we were flown to Woodstock to set up the festival. I had never worked so hard. Suddenly our village became a city of garbage bag tents and it was raining. I was here, there, everywhere, making enough granola for "breakfast in bed for four hundred thousand" and chaperoning "freak-outs" on drugs.

Afterward, I returned to New Mexico. For a while I lived out my childhood fantasies, riding horseback in the mountains. It was the most peaceful life I have known. Everything I owned fit into a saddlebag. Then I became pregnant with my second child, Mojo, which brought me back into the workforce.

There were always odd jobs, two or three at a time, to try to make ends meet. I made stained-glass windows but never charged enough to really make it a going business. One of my windows was donated to a local Catholic church, but most got traded or sold to friends. During the seventies I worked with

women friends as the "Mother's Mudders," doing adobe plastering. We started an ambulance service in our rural mountain community where none had been.

In 1978 I moved in with my current common-law husband, Alan. I guess because I have never officially married, that makes me a spinster grandmother. I just didn't see the point of it. My commitments and my spirituality are very personal and don't need to be sanctioned by anyone but me.

I got pregnant with my third child, Martin, and found it hard being on ambulance call twenty-four hours a day, seven days a week. I did it for four years without a break. I felt as if it was going to make me sick. It was 1985, and I went to the Hog Farm commune family reunion, laughed for four days, and came back cured!

Next I started a nonprofit subsidiary, The Laugh Staff, "humor for the health of it." First as stress relief for emergency medical technicians, it expanded to our local parade, the ski area where I put on an annual "clown clinic," and especially into antinuclear activism. A group of clowns has been known to "pro-jest" at Los Alamos, handing out Notices of Insufficient Fun and the Lifetime Deceivement Award. In 1997 I was arrested there and put in jail for handing out the Bill of Rights. What we need is, simply, everyone standing up and saying "NO!" to more nuclear weapons. I do, every chance I can!

Because of my early mothering experiences—first, not always being there for my daughter, and second, being a single mom with two kids—when Alan and I chose to have a child, Martin, I made a firm commitment that we would both be there for him. Martin is currently sixteen, only four years older than his nephew, my grandson—not the usual sequence of events! Martin and Abe sometimes go to the Hog Farm commune's summer camp, and they have sibling-like rivalries.

When my daughter and I are together, we seem more like members of the same generation, with sons so close in age. Sometimes I feel I may not have been grandmotherly enough with Abe; I was too busy still being a mom. I see my grandson only about once a year and communicate by phone, letter, and e-mail.

When people ask what we achieved in the sixties, I joke that one of our greatest achievements was never growing up. Of course, on many levels I am very responsible and therefore "grown-up." Yet I still feel like a kid. After all, we were the rock 'n' roll generation, and we're still rocking.

I grew up in a rural farm area outside Salem, Massachusetts. My father had a small business making hearing aids; my mother was his bookkeeper. In high school I was considered a beatnik. I worked for civil rights issues, and I marched on Washington in 1963 and heard Mar-

tin Luther King's "I Have a Dream" speech. I felt that I was the black sheep in my family, although now I think I was just walking in the footsteps of the grandmothers before me in my family. They included a Salem witch, an abolitionist, and a suffragette.

When I was thirteen, my paternal grandfather died. This was a great sadness for me because he was the kindest person I knew, and I was very close to him. He was a Unitarian minister and, as such, had a deep devotion to issues of social conscience.

After graduating from high school, I went to Goddard College in Vermont, where I studied art and philosophy—you know, really valuable things that will get you a job when you get out. I dropped out in my junior year to travel around with Djuna's father. During my early Hog Farm days, they nicknamed me "Oxyjean" because I didn't like the air in Los Angeles and carried an oxygen tank around in my car. I have never liked the word "hippie," but I'm proud of being part of the "alternative culture," which to me means working for solutions.

I did put in time at a straight job, working for a high-tech publishing company in the early nineties. It was a crash course in corporate America, and I learned a lot about computers and the global power players. I felt as if I was in corporate college. In 1996 I graduated—I was laid off, along with all the AT&T workers.

With money that I saved during those years, I was able to follow a childhood dream to have an art studio with all mediums to work in. My Art for the Heart studio is about fostering health through creativity. I do art after school with disadvantaged and at-risk kids as well as art at our local center for the developmentally disabled. Many of our kids are from the local Native American population.

It is as though I have dozens of grandkids and can give them all a little love and encouragement. If there is one piece of advice I want to share, it is that they should follow their hearts and their dreams.

I have seen many people doing what they want when they are about thirteen or fourteen, and then they get a career that is totally unsynchronized with their interests. It took me all these years to be doing what I have always loved—creating, teaching, and sharing art. I don't want my grandson to have to wait so long.

Annie
MCGORMAN &
Josephine
PELLEGRINO

Irish-born Annie McGorman, sixty-five, is a retired psychiatric therapist while Italian-American Josephine Pellegrino, fifty-one, is a traditional homemaker. Two-month-old Annie Pellegrino is Josephine's first grandchild and Annie's only granddaughter. (She has seven grandsons.) For McGorman, recently widowed after forty years of marriage, her namesake means renewal after loss. Pellegrino's husband, Frank, an actor and restaurateur, owns the hundred-year-old eatery Rao's in East Harlem, New York. The two grandmothers, who live within three miles of baby Annie on Long Island, New York, say they wish they could look at her twenty-four hours a day. What do they see?

McGorman: Black Beauty is what I call her because of her jet-black hair. She has blue eyes from my Irish genes. When I say Guardian Angel prayers for her, she smiles as if to say amen.

Pellegrino: I see my heart-shaped mouth and my son's dark hair. Once when I watched him fall asleep, with Annie lying on his chest, I cried. It was the identical pose I've seen in photographs of my husband as a baby with his father. I wish my in-laws were alive to meet Annie. She's just so beautiful.

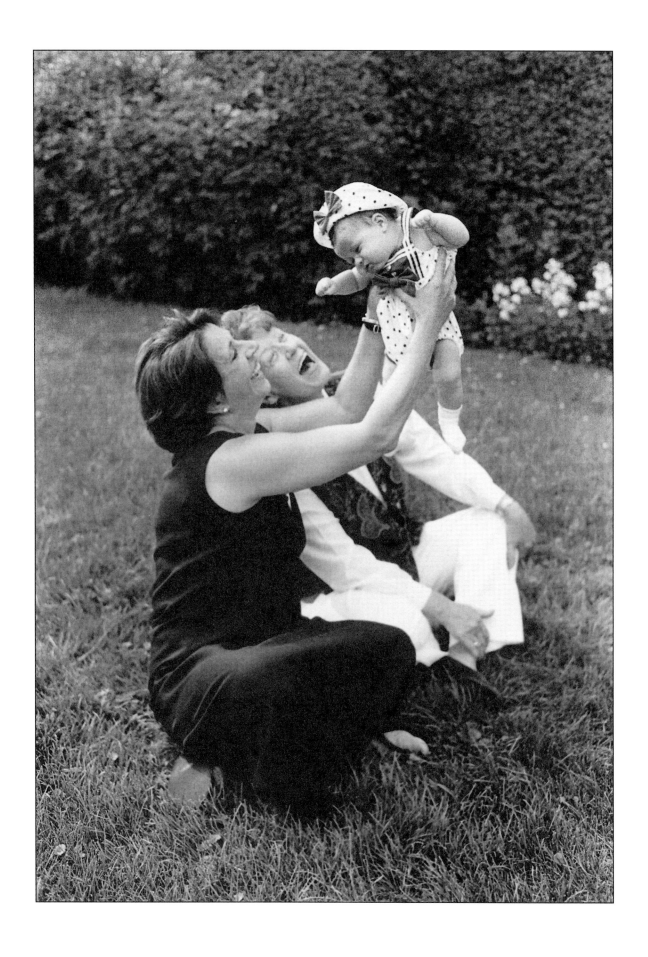

Acknowledgments

We would like to gratefully acknowledge all those who made *The Grandmother Book* possible:

Our sister, Ellen Burstein, whose gift of language and clarity of thought contributed to each and every inter-view in the book. She gave love, support, inspiration, and wisdom throughout. She could in every way be listed as coauthor of this work if it were not for her modesty.

Our sister and lawyer, Karen Burstein, for her usual generosity, brilliance, and rule of reason; our brother, Judd Burstein, and our sister-in-law, Laurie Lister; our niece, Hilary Lister-Fleischman, and our nephew, Devin Burstein, for their help and encouragement; and our brother, John Burstein, and his wife, Chrissy.

Casandra Jones, Senior Editor, for her deft line editing, and Robert Asahina, Editor in Chief, for his good humor, both from Golden Books. Above all, our St. Martin's Press saviors: Elizabeth Beier, Executive Editor; Gretchen Achilles, Director of Interior Design; and Lynda Castillo, Associate Director of Production, for their intelligence, enthusiasm, swift judgments, and commitment to excellence.

All the following people for their assistance and unfailing graciousness: Roz Abrams, Marilyn Adams, Katherine Altman, Priscilla Auerbach, F. J. Bain, Betty Begg, Jimmy Bergman, Bob Borum, Dora

Brave, John Broders, Sheila Brogan, Mallory Cangialosi, Bernard Chaillot, Bryan Crawford, Charlie Creasy, Chip Cronkite, Leslie Daubert, Margaret Dixon, Barbara Ann Evans, Nancy Farmer, Jane Farrell, Marjorie Fields, Eileen Ford, Peggy and Gene Frederic, Marilyn Goldstein, Barry Golson, Selma Gore, Sue Graham, R.N., the late Elizabeth Griffin, Mariana Gruia, Patricia Gurney, Judy Harrison, Wilma Hassell, Jodi Hersh, Claudia Holloway, Vera Irving, Colonel Rita C. Jacques, M.S.N., Sue Johnson, Ginny Kobren, Dr. Arthur Kornhaber, Dan Lafezzo, Jr., Gene Lucht, Michele Magazine, Marilee Mahoney, the late Mike McAlary, Pam McCauley, Sarah McClendon, Marie McCullough, Neil Ortenberg, Ann Pinkerton, Marrietta Pomeroy, Mildred Richards, Icie Rickman, Nora Roach, Pat San Pedro, Katherine Sartor, David Sikes, James Speller, Melanie Stone, Cosby Totten, Mercy Viteri, Diane Agostini-Whelan and Dr. Larry Whelan, Jill and Starker White, Diane White, and Dr. Mordecai Zucker.

In addition, the photographer would like to thank J. R. Martin and Frank Perez at Duggal Labs, New York City; Alkit Pro Camera Shop, New York City; the staff of the Latent Image Workshop, New York City; the cast and crew of *Law & Order*; the late-night gang at Elaine's (you know who you are); and Robert Sam Anson, Jamie Blank, Curtis Block, Audrey Davis, Mario di Pasquale, Edward Downe, Jr.,

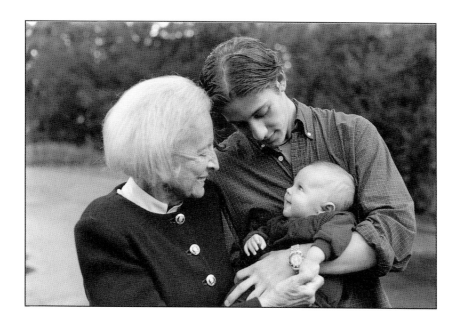

Charles Evans, Bruce Jay Friedman, Lydia Friedman, Michael Fuchs, Warren Hinckle, Carter Horsley, John Johnson, Carey Lowell and her grandmother, Pearl, the late Patrick Meehan, John and Tara McKernan, Fred Morton, Neil Leifer, Mari and the late Philippe Picard, Rosalie and the late Abe

Rotwein, C. J. Simpson, Alan Singer, Bert Stern, Gene Walsh, Ronald Winston, Leslie Yarmo, and especially Elaine Kaufman and Dick Wolf.

A very special thanks to Nanny's daughter and our mother, Beatrice S. Burstein, who is now herself a grandmother, with love and gratitude for all her encouragement, generosity at every turn, and belief in us and in our work. Finally, thanks to our late father, Herbert Burstein, a genius and a continuing force in our lives. We know he would be proud.

About the Photographer and Author

Jessica Burstein was the first woman staff photographer at NBC. As a freelancer, her work has appeared in publications worldwide, and she is the photographer for the critically acclaimed television series *Law & Order*. Her work is on permanent display at HBO's New York City headquarters and in the permanent corporate collections of Philip Morris and Chase Manhattan. She lives in New York City.

Patricia Burstein is an author and journalist whose work has appeared in many publications, including *People, New York, Ladies' Home Journal, Harper's Bazaar,* and the *New York Times*. She and her twin, Ellen Burstein, captured the attention of the national media with their book *Legwork*. She lives in New York City.